D1376507

EARLY MEDIEVAL ART

HANS HOLLÄNDER

UNIVERSE BOOKS
NEW YORK

English translation by Caroline Hillier

Published in the United States of America in 1974
by Universe Books, 381 Park Avenue South, New York, N.Y. 10016
© Chr. Belser Verlag, Stuttgart
English translation © 1974 by George Weidenfeld & Nicolson, Ltd., London
Library of Congress Catalog Card Number: 72-91633
ISBN 0-87663-166-9
Printed in Germany

50989

CONTENTS

Front of jacket: St. Mark. Trier. c. 800. Stadtbibliothek, Trier. MS 22.

Back of jacket: Symbol of St. Mark. Echternach Gospels. Ireland (?). c. 690. Bibliothèque Nationale, Paris. Lat. 9389, fol. 75, verso.

INTRODUCTION

Early medieval art is strange and remote; it is not immediately intelligible to us, for even its most persistent conventions have long since been discarded. If one is looking for originality, an unsophisticated and primitive expressiveness, or an archaic sense of form in the works of this complex and not easily definable period, one is doomed to disappointment. The most characteristic and significant elements were, in fact, based on scholarly speculation. Because of its clarity of pictorial form, early medieval art appears to be easy to understand: It is made difficult by the fact that the underlying concepts are very different from our own. But European art had its beginnings in this period of transition; at this time prototypes were created that would effectively serve as models for centuries and which are still present as traditional elements in the art of modern times.

The term "early medieval" is little more than a collective name. It does not describe a uniform style that developed within fixed limits. This is, in fact, often the case with period styles, but in this instance it is particularly true. "Early medieval" is merely a name for a long period of time that lacks unifying characteristics. However one tries to define it, the outlines remain blurred, and only the artistic centers are clearly discernible—Irish, Anglo-Saxon, Carolingian, and Ottonian.

The consolidation of the political states of Europe during the Middle Ages was a slow process, which reached a first high point in Charlemagne's empire and continued after the fall of the Carolingian monarchs, until Europe emerged during the second half of the 10th century with its political outlines more clearly defined. The early medieval period comes to an end with Ottonian art in the 11th century, for it was then, paradoxically, that an intensified exchange of ideas and techniques brought about a florescence and a continuous development of regional styles. It has become customary to limit the span of early medieval art to this period of protracted historical evolution that took place from the 6th to the beginning of the 11th century. There are good reasons for doing so.

The 6th century was especially rich in political hiatuses and the various trends of development that resulted from them. It was a century during which many things came to an end; moreover, here can be found the reasons why certain potentialities of the human consciousness familiar to the ancient world were neglected for 500 years, while other, pre-classical and Christian trends dominated man's thought. There were two turning points of particular significance. In the year 529 Justinian put an end to classical studies by closing the Athenian Academy. The decree, abhorrent as are all such retrogressive steps, prevented all further activity in this field throughout the Christian world. Scholars emigrated to Persia, in the heathen East—where, encouraged later on by Islamic rulers, study of the classical authors continued

unchecked. For a long time the new Europe remained cut off from these subtle researches; its intellectual life was dominated by pictorial world allegories, speculative world views, and endless metaphors and analogies. These aspects of early European thought were as important in art as in science; for the same concepts and ways of thinking were expressed in the paintings and architecture of the time.

In the same eventful year, 529, Benedict of Nursia founded his monastery at Montecassino, south of Rome, and set a new standard of stern discipline and communal work that was in marked contrast to the practices of the hermitlike monastic foundations. This was a radical break with the old concept of the supreme importance of contemplative leisure.

Both these events were symptomatic of the new age. One event signaled an end, the other a beginning. The Benedictine Rule and its new conception of work was certainly more important for the evolution of European culture than the imperial claims of later rulers. Monasteries were to remain centers of civilization and art as well as scholarly activity until the high Middle Ages. Only one thing was lacking: the rational and unbiased spirit of inquiry, which had flourished at the Athens Academy and would now flower only in the Arab world. This spirit of inquiry returned to European culture, enriched and further developed, only at the end of the early Middle Ages, through the Latin translations of penetrating commentaries and works by Arab scholars.

The period with which we are concerned, therefore, comprises about five centuries—about the length of time between Homer and Alexander the Great, or between Giotto and Goya. Yet one cannot compare this period with these and many other epochs in quantity or sustained quality of achievement, for the rhythm of history varies, and the artistic achievements of the early medieval period were realized under different and difficult historical conditions. The development of art during this period was more interrupted, less continuous, less sure than in other epochs of European history, and the significant high points more rare. Typical was a steady reception of forms already existing during the late antique period and a daring experimentation with metamorphosed forms, which, after a long tradition, tended to fail gradually until a new impetus, possibly the result of a productive misunderstanding, initiated a new beginning.

When there is little continuity, its value is enhanced. Because discontinuity was the outstanding characteristic of the era, there existed an intense and disturbing, sometimes disproportionate respect for tradition, which contributed to the obscurity (in our eyes) of the era, and which is in part responsible for our modern term "dark ages."

Christianity, gradually gaining ground across Europe, was, whatever was understood by its practitioners, a unifying link. Monasteries, whether Frankish, Irish, or

Benedictine, preserved traditions and learning, thought and beliefs from the past, and the monks who traveled abroad as missionaries spread them, variously transformed, into less cultured areas. Indeed, Charlemagne appears to have regarded this dissemination of learning as the first duty of the monasteries.

Christianity could only be taught through the written word, and the written idiom was the product of a long tradition of written communication. The writings of the Church Fathers contained, in their quotations and renderings, polemics, and refutations, elements of the heathen tradition, late antique philosophy, and heretical teachings that were accessible to those who knew their Latin. If anyone wanted to learn more, the monastery library was available to him, and here he could assimilate information that had not been current for a long time. What had been common knowledge since the time of Plato had to be discovered anew, and was greeted as a novelty, studied afresh, and fitted into the contexts available.

The idea of style, insofar as it refers to the continual creative output of an era, can only be used here in its most general sense—within narrow limits and in individual cases. One can, however, use the word "style" in its original sense, without its historical connotations, as the individual manner and way in which something is made, as the method by which with given materials a certain effect is created in a certain way—style in the sense of rhetoric, the way of fashioning something, a conscious use of artistic media and forms, of accepted formulas suitable for the task and for the full development of artistic skills and possibilities. Such artistic invention often involves the combination of preformed motifs and the addition of elements of diverse origin. There are important syntheses whose components are difficult to analyze, and there are possibilities for change, fusion, and pure innovation. Unity of style, however, and continuous development can only be found within the narrow circle of the workshop, where a certain approach was adopted. This older concept of style depends more on a conscious choice of elements than on an unconscious desire for expression, and it is free from "historical laws" and those morphological patterns which, when they are applied to history, are never appropriate, since they better suit the historical development of imagination and scholarship.

Forms do not change according to their own laws, but are affected by ideas, learning, the content, and the problem set. These powerful influences can clearly be seen in the art of the early Middle Ages. In major works of the time one finds a conscious link and close parallel between art and learning. In many cases, form is the product of thought.

During the early Middle Ages, the division between the different arts and their relative importance was quite different from what it had been before and would be later. Monumental sculpture was only a marginal art, occasionally nonexistent. Much

has, of course, been destroyed, but destruction has occurred in other times and was no less a factor in other areas of creative endeavor. The truth is that very little sculpture was produced. It was not that early medieval artists were unprepared to handle the medium: They were rarely asked to do so, for specific reasons that we will consider later.

There is no lack, however, of small relief sculpture in ivory and similar materials. Our knowledge of the possibilities and techniques of sculpture and carving in this period comes almost exclusively from this genre. Later there was bronzework, mostly in relief also—that is, three-dimensional pictures—but actual pieces of sculpture were very rare and only very slowly increased in number.

Mosaic, fresco, and the other arts allied to architecture were originally the most important and abundant. In the course of time, most of the works in these media have been destroyed, along with the buildings they decorated, and only a few examples remain intact. Some have been preserved by overpainting and came to light when restoration was carried out. Yet, even if all the frescoes and mosaics of this time had been preserved, one would still receive an incomplete and false impression of early medieval painting from studying them alone. Manuscript illumination, which served a different purpose, is not only the best-preserved art form of the time but was originally also the most highly developed. Until then it had not been so important, nor was it to be so in later periods.

Panel painting—the focus of pictorial imagination later on—was at most a sideline in the early Middle Ages, although the knowledge of its artistic possibilities can be seen in miniatures and ivory carving.

The most important contributions to art were made almost exclusively in the field of manuscript illumination. Here one sees most clearly which ideas excited the imagination of the time, what could be portrayed, why it was portrayed, and the means that could be found to execute it. Here one can really observe the kind of audacious experimentation of which artists of the time were capable. In frescoes, on the other hand, the forms are typical and of a size to suit the architecture. This can also be said of much early medieval manuscript illumination, because monumentality, or large-scale quality, was often stressed. Correspondingly, the architecture depicted in manuscript illustration points out the relationship between figure and architectural form. But there are nevertheless great differences between manuscript illuminations and frescoes. The former are much richer in inventiveness and, when they are concerned with texts that defy the ordinary type of illustration, often show a subtle daring. For example, the commentaries of the Church Fathers demand an ingenuity that narrative scenes, such as those in the Gospels, do not. The pictorial representation of texts that are essentially allegories or strings of metaphors called for a complex, intellectual manipulation of symbols with various layers of

meaning. Miniatures (the name does not here refer to the small format) must be the most significant works in any discussion of early medieval painting. Because they were an integral part of the books, of the highly prized texts, early medieval illuminations are an inseparable part of early medieval literature.

Architecture was another highly important art of the period. Again, few works have been preserved in their original form, yet in architecture the purposes and dominant ideas of the era are perhaps most clearly represented. It is more "contemporary," more closely linked to its time, and therefore more transient, because in architecture symbolic content can be handed on only to a limited extent. When the needs, aims, and objectives of a patron changed, buildings might be pulled down, converted, added to, or rebuilt, and much was destroyed. When this occurred, the original artistic principles were seldom taken into account. Because the alteration of a building involved a great outlay of materials and labor, it was necessary to calculate all the more exactly what had to be demolished and rebuilt and what could be left as it was. Cost, time, and convenience were more at issue than stylistic trends. Antiquated elements, if they still served their purpose, were preserved, and we thus find a curious mixture of styles in many buildings surviving from this period. Its "representative character" (G. Bandmann) renders this seemingly most durable art the most transitory; relatively unaffected by natural influences, it is all the more subject to historical changes. For these reasons we really know very little—not nearly enough—about the most important buildings of the early Middle Ages. The few that remain stand by lucky accident. A codex preserved in an ecclesiastical library had far more chance of survival. But architecture as a symbolical and richly representative art was in its own era precisely the most influential and important art form, and its characteristic elements were reflected in the pictorial arts, especially in manuscript illuminations, where they were copied with freedom; the meaning, however, remained identical.

Some forms of architecture are more lasting than others. A castle can become impractical because of a slight change in methods of warfare; a church, however, can withstand a change of faith. Very little is known about the secular architecture of the early Middle Ages. Nothing remains of Charlemagne's palace at Aachen, his "new Rome," but the Palace Chapel still stands.

HIBERNO-SAXON MANUSCRIPT ILLUMINATION

For the great majority of people who lived in western Continental Europe, the two centuries that preceded the rise of the Carolingian dynasty (500–700) were truly dark ages. There was little peace, no real social stability, and, at best, uncertain government. One historian has described the rule of the Merovingian dynasty in Gaul as "despotism tempered by assassination," and conditions were no better outside the sphere of influence of those unruly kings.

Artistically, the greatest achievement of these troubled times was the development of a complex linear ornament, which had its roots in the "animal style" of the barbaric tribes that moved into western Europe during the declining years of the Roman Empire. The style was based on the decorative use of animal motifs in a free abstract manner, modified to some degree by the interlace ornament popular in late antiquity. These designs were principally executed in metal, often with the cloisonné —or paste-inlay—technique, and frequently they are vigorous and complex.

However, there existed little enthusiasm during these years for the more permanent arts of civilization. From remaining examples of architecture, painting, and sculpture (except among the Viking peoples of Scandinavia), it appears that people were content with uninspired provincial formulas to which they adapted earlier art styles as, for example, in the building of churches. They also tended to elaborate decorative mannerisms, such as the curious interplay of letters and figures—in Merovingian decoration with its birds and fishes—a technique that had, in fact, already been developed in Irish monasteries as a variant on Irish styles.

Spain of the 6th and 7th centuries is more interesting, not least for its barbaric Visigothic architecture, which was, however, limited in range. Far more important for the future development of art are illuminations such as those in the Ashburnham Pentateuch (*Ills. 2, 3*), which ornamentalize a late antique use of color in narrative scenes with many figures. These vivid illustrations stand at the beginning of a special and—after the Arab invasion of Spain—isolated tradition in Spanish Christian art.

All these regions were culturally a long way from Byzantium, the old stronghold of antique pictorial traditions. Here, on the outskirts of the Byzantine sphere of influence, new artistic centers grew up. The outstanding importance of Ireland in early medieval art cannot be too strongly affirmed. Here new, non-classical forms emerged with real significance; they came in contact with various kinds of antique forms, to mingle in strange combinations.

Irish influence radiated principally from the monasteries, founded in ecclesiastical scholarships, through the paintings executed there. Admittedly, in the field of architecture Ireland's contribution was slight. Irish stone carving (*15*) is interesting as an early form of monumental sculpture, but its influence was only regional. One can

hardly overstress the influence of Hiberno-Saxon (that is, Irish–Anglo-Saxon) illumination, however. Its influence on the European continent was soon visible, though, of course, some aspects of the style did not catch on until Ottonian times.

The Irish played no part in preserving and handing on antique art forms, for Ireland had remained untouched by classical civilization. St. Patrick, the apostle of the Irish, and other 5th-century Christian missionaries to the Emerald Isle found an ancient tribal culture there; it was through Christianity and its texts that the Irish first came into contact with Roman civilization. During the 6th century, a number of monastic communities were established. St. Columba (c. 521–97) founded Derry, Iona, Kells, and Durrow. These foundations became important centers of classical learning; as a result, the Irish clergy were well educated and had great influence wherever they went. Their remarkable missionary zeal carried them far and wide. Toward the end of the century, the first wave of Irish missionaries reached the Continent. St. Columban (543–615) traveled to France with twelve companions around 590, and he founded, among others, the monasteries of Annegray and Luxeuil in the Vosges and Bobbio in Lombardy. One of his companions, St. Gallus (c. 550–645), was founder of the monastery of St. Gall, near Lake Constance. Irish monasteries and affiliated foundations formed quite a large network on the Continent by the end of the 7th century. At the same time they began to spread into England; during the 8th century Northumbrian monasteries were even more important than the mother foundations in Ireland, although the influence of the latter was more lasting. The Irish monks at home and abroad lavished their creative efforts on texts and books, on illumination and its ornamental structure. The Book of Durrow (4) is one of the earliest surviving works. It was made at Iona, where St. Columba had founded a monastery in 563, when he went as a missionary to Scotland. We find in it the same combination of ornamental motifs as in later manuscripts; indeed, the figures in this book show the beginnings of a trend which would culminate in the Book of Kells (20).

The basic forms of the rich and varied decorations that cover the pages of these books were not new. Every motif has a history; for the most part, they were the decorative motifs that had been used in metalwork—on clasps, buckles, brooches, shields, and sword hilts. One can see traces of Scythian motifs in the animal designs; the spirals are a very ancient and significant form of decoration; the lacertine designs are Celtic in origin; interlace was much used at this time in Germanic art. During the unsettled migratory period in Europe most designs traveled far from their original home, and the Christian mission increased their spread. One can even find Coptic motifs in Irish and Northumbrian manuscripts. All these different motifs were assimilated, and individual designs were reinterpreted with great subtlety. One can assume that the best artists had an extensive knowledge of all these types of design,

1 INITIAL PAGE. Gelasian Sacramentary. France. Mid-8th century. Biblioteca Apostolica, Vatican. Reg. lat. 316, fol. 132. The page unites a picture (cross with Lamb of God in the central medallion), with the initial, text, and ornamental motifs. Merovingian illuminations rarely had figural decorations. The inventive zoomorphic decoration with birds and fishes is very typical. Its origin is open to debate.

2 THE FLOOD. Ashburnham Pentateuch. North Africa or Spain. 7th century. Bibliothèque Nationale, Paris. Nouv. acq. lat. 2334, fol. 9. The 19 full-page illuminations of this codex are rare examples of the late antique style in the southwestern Mediterranean. Its place of origin is not certain, but the work stands at the head of a long line of Spanish illuminations. The illustration of the Flood shows Noah's Ark surrounded by the corpses of drowned animals and people (3).

3 JACOB AND ESAU. Ashburnham Pentateuch, fol. 25. The architectural settings, which show the remains of perspective constructions of older models, serve to divide the page into different scenes: Many of the most typical early medieval forms of architectural frame or representations of real architecture are used. With its simplification of antique prototypes for landscape, architecture, perspective, and figures, and its innovations (the banded background), the codex can be presumed representative of many unknown works that must have served as models for the new style of narrative illustrations in manuscripts.

4 ORNAMENTAL PAGE. Book of Durrow. Iona, Scotland. 7th century. Trinity College Library, Dublin. Fol. 111 a. Types of decoration include: spiral designs, interlacing, trumpet patterns. The framing decoration, derived from late antique borders, surrounds a picture that is decorative and abstract, though the circles can be taken to represent variations of medieval cosmological patterns.

5 ORNAMENTAL PAGE. Lindisfarne Gospels. Lindisfarne, England. c. 700. British Museum, London. Cotton MS Nero D. iv., fol. 26b. The page is covered with a knotted and interwoven spiral design with subtle refinements of the basic pattern. The cross is outlined with a heavier line; in shape, it resembles Irish stone crosses (15) and, like these, it has interlace work around central circles. This staggeringly complex page has a chiselled appearance.

6 SYMBOL OF ST. MARK. Echternach Gospels. Ireland (?). c. 690. Bibliothèque Nationale, Paris. Lat. 9389, fol. 75, verso. Sometimes the being conventionally ascribed to the evangelist (a lion for Mark, a winged man for Matthew, an ox for Luke, and an eagle for John) takes over on its own the place assigned to the evangelist, no longer as the bearer and vehicle of inspiration and as a manifestation of the Word, but instead identified with the evangelist.

7 INITIAL PAGE. St. Gall Gospels. Ireland. 8th century. Abbey Library, monastery of St. Gall, Switzerland. Codex 51, p. 7. The page shows the first words of the eighteenth verse of the Gospel according to St. Matthew: *Christi autem generatio*. The genealogy in verses 1—17 serves as a prologue to the text, with verse 18 as the real beginning. The latter, therefore, has a decorated monogram, the Greek characters Chi and Rho, revered at this time as the first two letters in "Christ." This monogram had developed (as O. K. Werckmeister has shown) from simple initials to this elaborate framework, incorporating the cosmological design of the Book of Kells.

8 SYMBOL OF ST. JOHN. Fragment of a gospel book. Probably Northumbrian. First half of 8th century. Corpus Christi College, Cambridge. MS 197, fol. 11. Instead of the mazelike geometrical background chosen by the artist who designed the ornamental page with the symbol of St. Mark (6), there are crosses surrounding the symbolical image of St. John. They point to the edges and corners of the page and probably also indicated the corners of the earth and the divisions of the heavens. In accordance with patristic texts, the crosses show that the gospel will be spread in all directions throughout the world.

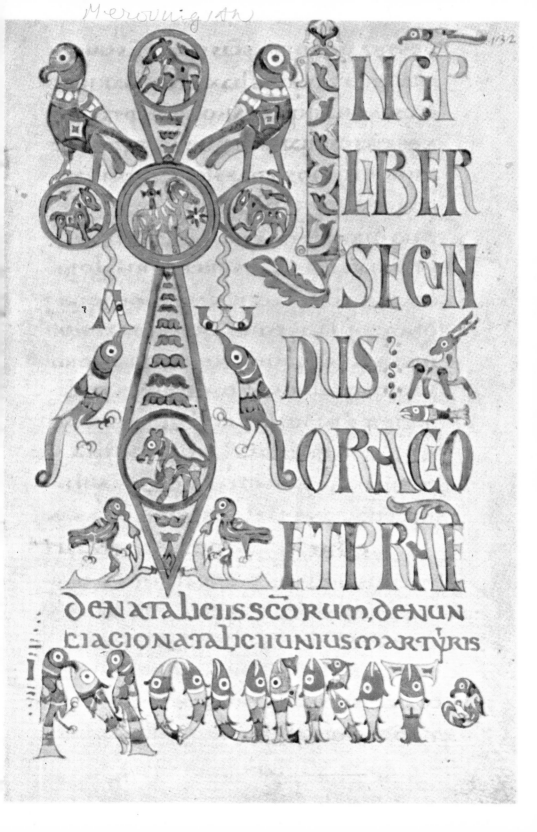

INGP
LIBER
SECN
DUS:
ORACO
ETPRAE

DE NATALICIIS SCORUM, DE NUN
CIACIONATALICIIUNIUS MARTYRIS

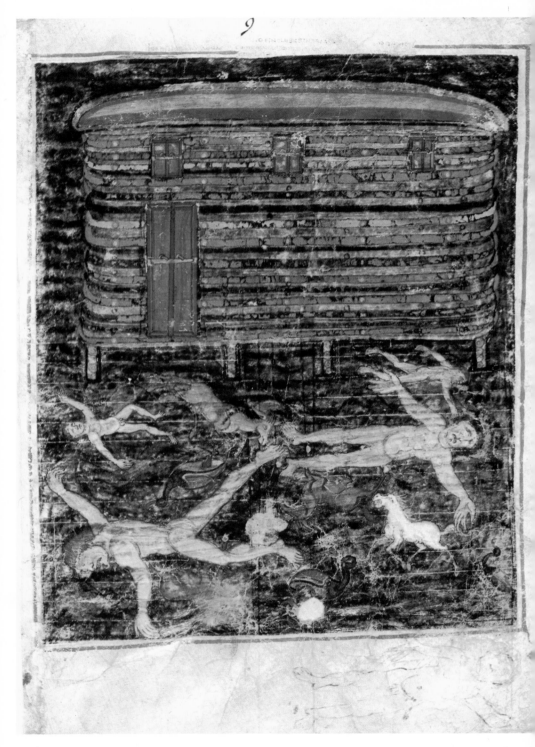

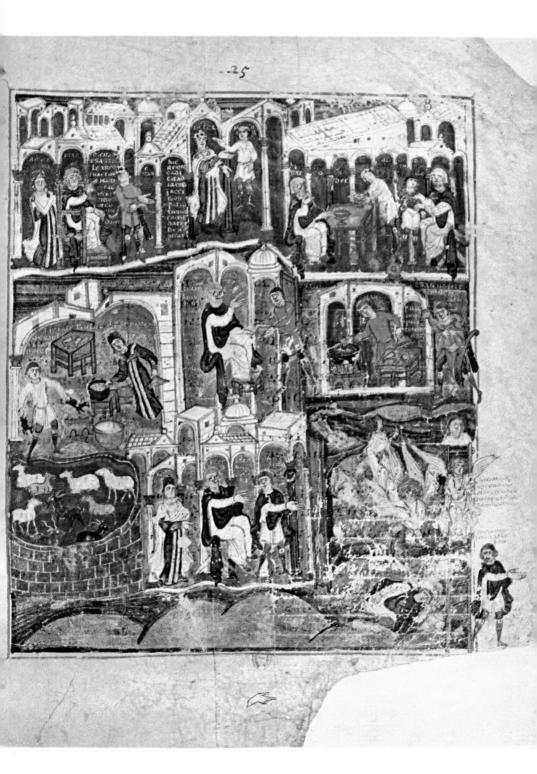

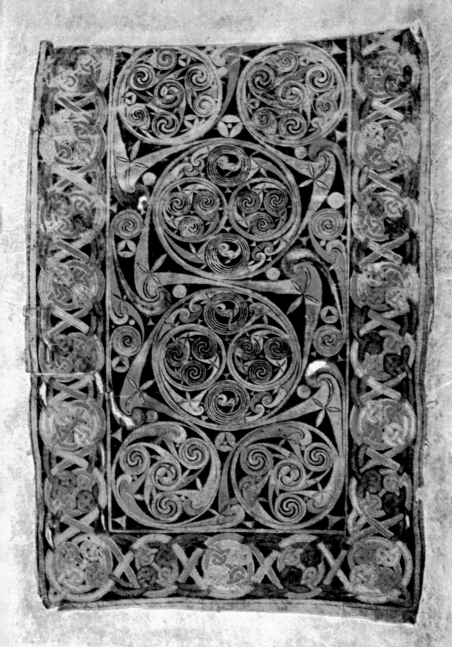

4

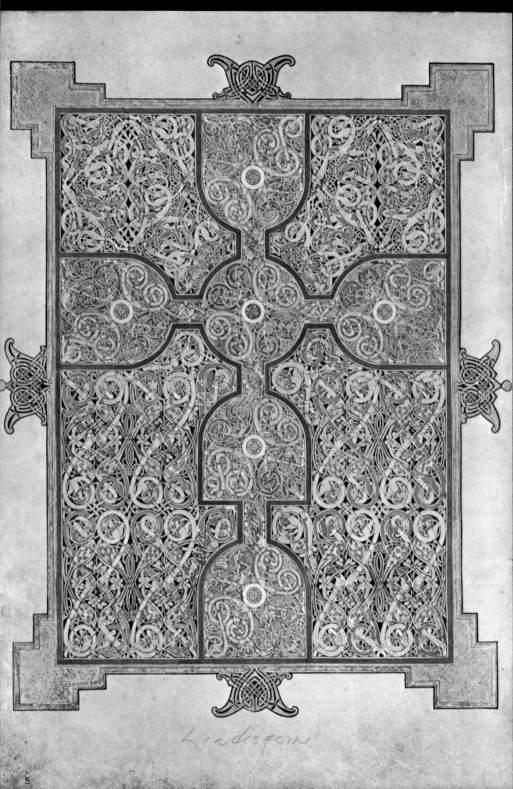

Lindisfarne

5

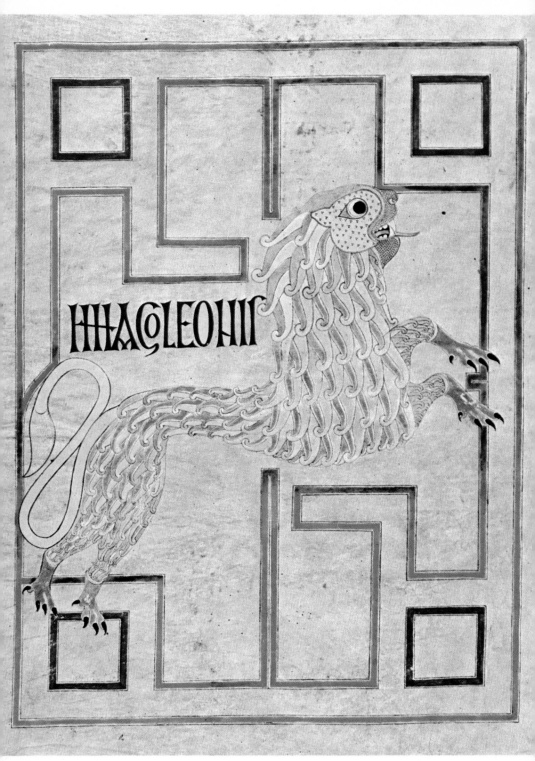

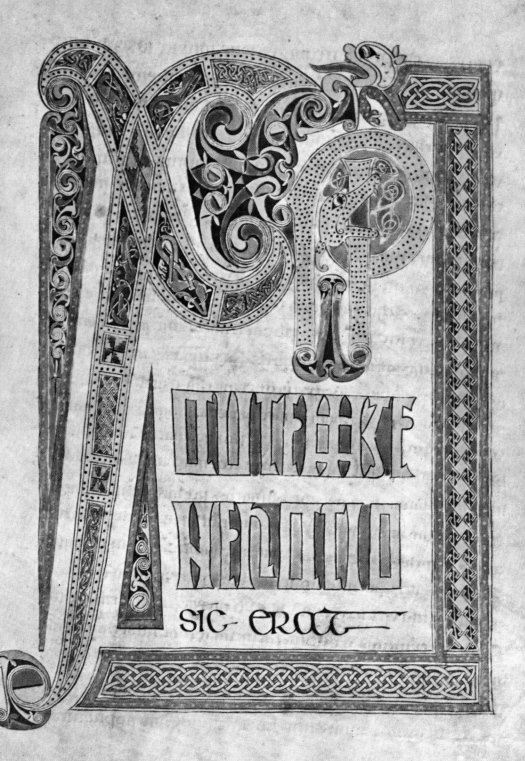

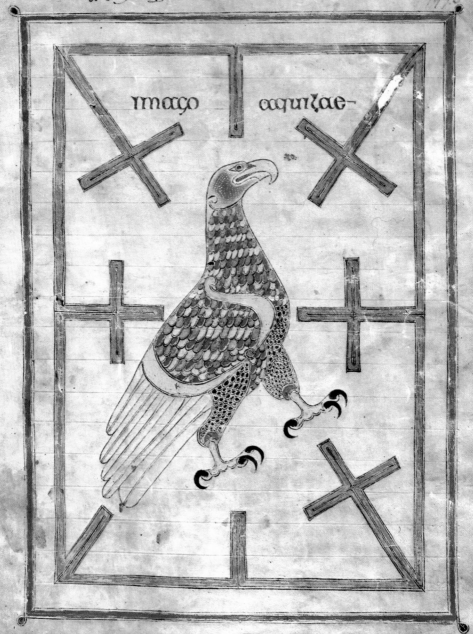

imago · aquilae·

and they made their own choice among them. There were endless possibilities for permutation, addition, repetition, division, and multiplication. One finds surrounds without centers, centers without surrounds, whirls, gyrations, patterns hovering in ornamental spaces, but never anything rigid, circumscribed, or architectural (forms like those in the Book of Kells [9] are wholly ornamentalized). Classical motifs such as acanthus leaves and meander patterns were, for the most part, avoided. The very fact that they were not included in the vast repertory of ornamental designs serves to illustrate the extent and limits of the possibilities open to the artists.

There are three different types of pages on which ornamentation runs riot: first the "carpet pages," on which patterns are woven almost as in a piece of fabric (4, 5). These usually have a cross in the center, which acts as part of the design but also indicates the nature of the book. Others are wholly decorative, showing interlaces, circles, and interweaving spirals within circles. In the range of these illuminations, from the Book of Durrow to the Book of Kells, the entire repertory of ornamentation was used.

There are also initial pages (7), with page-high variations on the first letter of the text. The decoration follows the shape of the letter, but plays variations upon it, and fills in spaces with minute repetitions and ramifications. The letters become richly imaginative designs to an extent that varies with the importance of the text.

Finally, ornament seizes architectural frames and figures. Here, almost irreconcilable elements are brought into harmony. Such architectural motifs as arcades, regardless of their meaning in a real building, are used to divide up the pages. Thus, in the Book of Kells supporting pillars become hanging ribbons (9).

The figures portrayed are part ornament, part human in form. Limbs and folds become cocoons of interwoven lines or bands (17, 20). From these abstract shapes, faces, drawn frontally in simple outlines, stare with large, hypnotic eyes, which regard the onlooker fixedly. To a large series (enumerated by E. H. Zimmermann) belongs the St. Gall Gospels, which was probably an 8th-century work originating in Ireland (17). In this and other manuscripts one can see traces of late antique prototypes in the outlines and gestures of the figures, even though they have become very linear. A Northumbrian copy of a page in the Codex Grandior of Cassiodorus (18) closely resembles its illusionistic late antique prototype. When, in turn, it was copied by the artist of the Matthew page in the Lindisfarne Gospels, this illusionistic element disappeared (19). The spatial elements of the picture and the feeling of perspective were ignored; the figure was stylized as regards form and movement, its outlines becoming hard and clearly defined, as if scored or cut. Matthew and the angel rising above his halo are not at all antique in character; their position relative to each other signifies their oneness. Opinion differs as to the identity of the person who peers forth curiously from behind the curtain.

Certainly the Ezra page of the Codex Amiatinus was not the sole prototype for the Lindisfarne apostle. The figures are similar only in type, and there exist countless other paintings of a seated scribe—St. Mark in the Codex Rossanensis (*12*), for example. The figure of an inspired apostle or prophet sitting sideways and writing is very common in Byzantine art, where it is sometimes accompanied by an inquiring figure (*11*).

From the St. Gall Gospels (*17*), through a few intermediaries, follow on the illuminations of the Book of Kells, which contains the most brilliant examples of Irish-Northumbrian figural representation (*20*). They too are ornamental, but with a difference. The usual decorative elements do not dominate the figures so that they become subsidiary to the ornamentation; rather, the figures are reduced to an ornamental shape without any spatiality and follow one of the rules of decorative design—symmetry. This symmetry helps to emphasize the effect of the great gazing eyes.

There is little that is comparable in Carolingian art of the 9th century. However, one can trace a connection with the so-called Reichenau school of paintings of the late 10th and early 11th centuries. In works of this school, carried out two centuries later under entirely different historical conditions, but with comparable vigor, there are traces of the Hiberno-Northumbrian style. Here are the frontal figures with huge eyes (developed, as must be mentioned, in the late antique period) and certain formulas that seem absurd at first, but which are a result of the combination of pictorial signs (*113*). Thus, the combination used in the Lindisfarne Gospels, "Matthew with a nimbus and angel (waist-high)," is found again in the Aachen Otto Gospels (*106*) and in the Gospels of Otto III. This kind of combination, with its sudden changes in the degree of reality, shows that pictorial signs were considered not so much as "forms" for compositions but as symbols bearing certain meanings that could be calculated. Similarities in the formulas point to a definite tradition, which probably owed its continuity to such libraries as that of the old Irish foundation at St. Gall, with its collection of "precedents," which again interested Ottonian artists.

How should one understand this art? Its subject matter was limited, but its stylistic possibilities were apparently boundless. There is no direct way to comprehend it. It is neither primitive nor archaic, and it is not purely decorative. (This has been emphatically pointed out, in contradiction to earlier theories, by O. K. Werckmeister.) It is, rather, extremely subtle and meaningful. The precise, carefully calculated transformation of idea into symbol in the large evangelist pages shows extreme rationality in the reduction of figures to signs, and one need hardly point out that the figures in the Book of Kells are perfect examples of the early medieval stress on the meaning of figures rather than on their organic form. While this emphasis can clearly be seen in the Book of Kells and the Lindisfarne Gospels, in general the interplay of elements makes the effect more contradictory and elusive.

What links were there between the decorative elements of heathen origin and the texts? The flowering of artistic creativity was no doubt due in part to the importance of holy books. They were regarded as rare, valuable, and admirable, and were therefore adorned with a rich repertory of ornamentation. But the illuminations should not be regarded as "decoration" in the modern sense of "secondary elements that can be dispensed with." Ornamentation was, rather, here as elsewhere, an integral part of the metamorphosis from reality to image, to symbol, to elementary form, and to artistic expression. Moreover, ornamentation had its own intrinsic significance.

It is quite possible that primitive and contemporary forms of magic played a part in the designs. Interlace and knotwork were used for a long time, probably until the Romanesque period, as symbols to banish demons. The richly decorated stemposts, mainpieces, and planks of Viking ships (16), which had patterns closely resembling those of Hiberno-Saxon work, were held to be talismans against sea spirits and evil powers. Irish crosses, their surfaces covered with interlace work (15), probably also had evil-averting powers, whether they were gravestones or boundary marks; in both cases, the symbols would have been appropriate. Certainly we can suppose faith in the power of these designs to banish evil, because such beliefs were still widely held. But it is doubtful that magic influenced the choice of design in manuscripts, although the full-page crosses (as, for example, in the Lindisfarne Gospels) have the same outlines as contemporary stone crosses, with this difference: In the latter the cross forms a frame for the decoration, whereas in the former the cross is contained within the whole design (5, 15). One could perhaps say that the initials served as stemposts to the text. There are obvious formal links, but historical sources give insufficient evidence that demon-banishing patterns were consciously used by Christians in the early Middle Ages, although they were widely current in heathen districts, and, in areas that became Christianized, their use continued.

All these kinds of decorative motif had, in any case, become conventional patterns and were used in a variety of ways. Manuscripts were illuminated in monasteries, which were not only centers of missionary activity but also centers of learning far removed from the realm of superstitious and primitive magic. One might suppose the artists to have been more naïve, heathen, and less learned than the scholars, but this was not the case. Books were often conceived, decorated, and written by a single person. Thus, Eadfrith, the illuminator of the Lindisfarne Gospels (according to a later colophon), was also the abbot of the monastery and a very learned man, some of whose writings have come down to us.

Long before the time when the Book of Durrow was made, Irish monks are known to have been of a speculative and literary turn of mind and to have studied classical literature widely. An early example of their work in Latin is the *Hiberna Famina* series of verse cycles, probably of the 5th or 6th century, which have a regular

9 CANON TABLE. Book of Kells. Ireland or Northumbria. c. 800. Trinity College Library, Dublin. MS 58 (AI 6), fol. 5 a. Canon tables list corresponding passages in the four Gospels in parallel rows in order to show the relationships between them. The purpose is emphasized by the architectural forms used— the pillars bearing the arch, which represents the cosmological unity of the Gospels. In the space between the columns correspondences are noted. In this case, the pillars are decorated bands, like hanging ribbons. Following the custom in canon tables, in the Hiberno-Saxon manner, the symbols of the evangelists are shown in the arches, in a densely ornamented design.

10 ST. LUKE. Gregory Gospels (fragment). Rome. End of 6th century. Corpus Christi College, Cambridge. MS 286, fol. 129, verso. The original codex probably belonged to the library that St. Augustine brought to Canterbury in 596. Derived from Roman models, it presupposes a long tradition of Roman illumination, of which few traces (a calendar of 354) remain: architectural portal motif and scenes between the columns (Mithras reliefs, triumphal arches). The figure of the apostle is rendered after the traditional Roman portrait of a poet (13).

11 JOHN CLIMACUS. Byzantine. 11th century. Biblioteca Apostolica, Vatican. Vat. cod. graec. 394, fol. 6, verso. The mysterious onlooker in the Lindisfarne Gospels St. Matthew page (19) occurs in a number of Byzantine works (especially in later paintings). The figure of the writer here is also similar to the Ezra of the Codex Amiatinus (18).

12 ST. MARK. Codex Rossanensis. Second half of 6th century. Museo del Arcivescovado, Rossano. Fol. 121 a. The earliest known representation of the inspiration of an evangelist. The apostle is seated sideways, following Hellenistic tradition. The fact that he is writing is a Christian innovation. The presence of Sophia (Divine Wisdom/Holy Spirit/Mary) accords with the classical tradition of an inspirational muse. This scene is a common one in early medieval art and appears in various forms (11, 18, 19).

13 VIRGIL. Detail of a Roman mosaic, showing the poet with the muses Calliope and Melpomene. 3 d century. Susa (Tunisia). A typical Roman portrait of a poet, who sits thoughtfully enthroned, in a frontal position. The papyrus scroll is one of his traditional attributes. This figure was a precursor of the evangelist figure (10, 14).

14 ST. MATTHEW. Codex Aureus of Canterbury. Canterbury, England. Second half of 8th century. Royal Library, Stockholm. A 135, fol. 9, verso. Belongs to the Italiante school of Anglo-Saxon illumination. Compare the figures in 10 and 13. The Roman prototype is still recognizable, but has been simplified and is now more frontal in treatment. The architecture is also in the traditional manner. This basic pattern for pictures of an evangelist was not further developed until the background architecture was given greater significance in Carolingian manuscripts.

15 AHENNY CROSS. County Tipperary, Ireland. 8th century. Height: 3.35 m. In basic shape and decoration, this is similar to the illuminated crosses in gospel books. In form and (possibly) underlying significance, the designs correspond to heathen Germanic ornamentation.

16 ANIMAL HEAD FROM THE OSEBERG SHIP BURIAL (TOMB). First half of 9th century. Viking Museum, Oslo. The purpose of the carved emblem was to ward off sea demons, and the "magic" interlace also served this end; here, as later in wooden churches, it is very subtly and artistically worked.

9

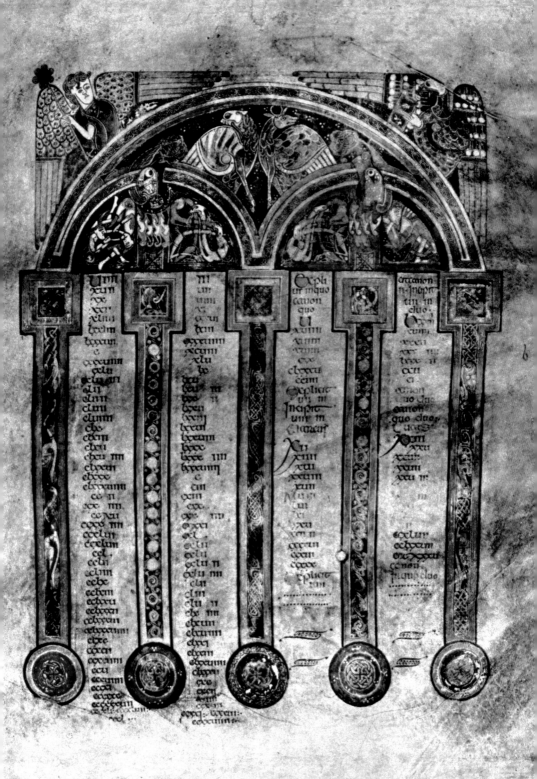

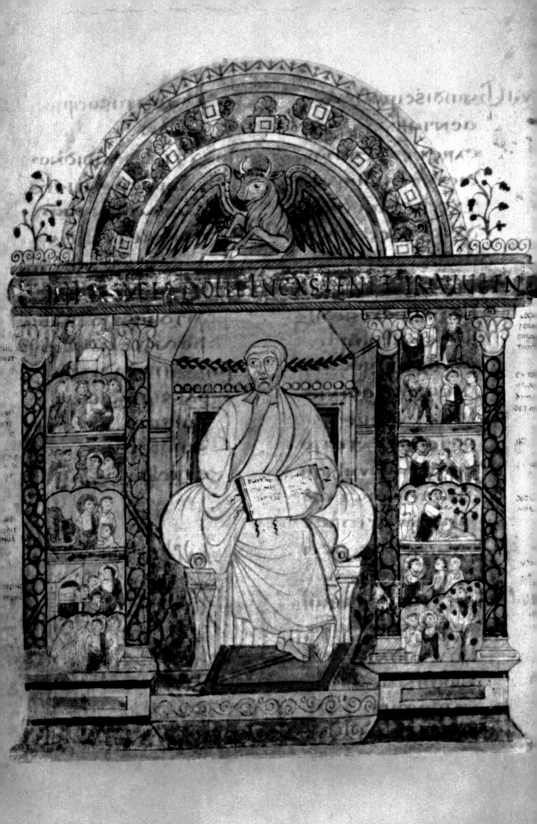

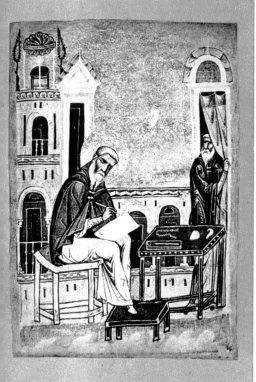

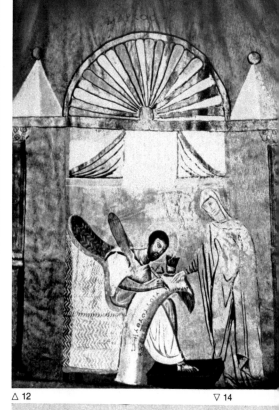

◁ 10 △ 11 ▽ 13

△ 12 ▽ 14

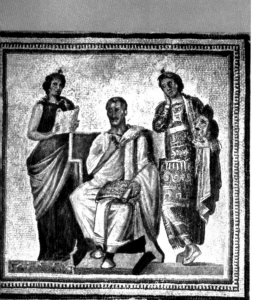

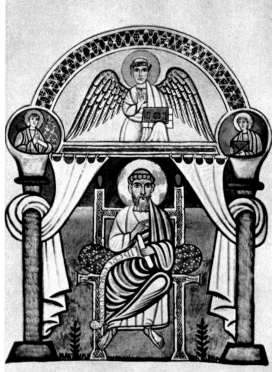

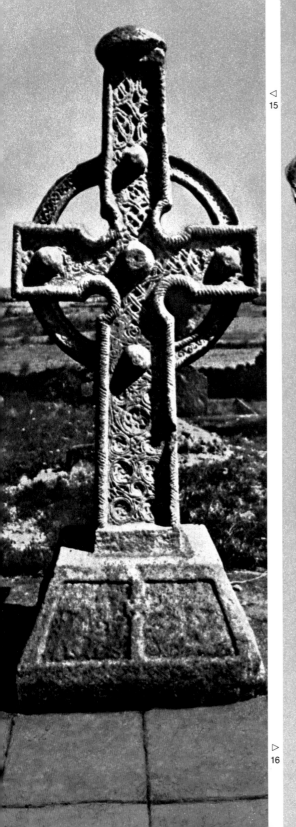

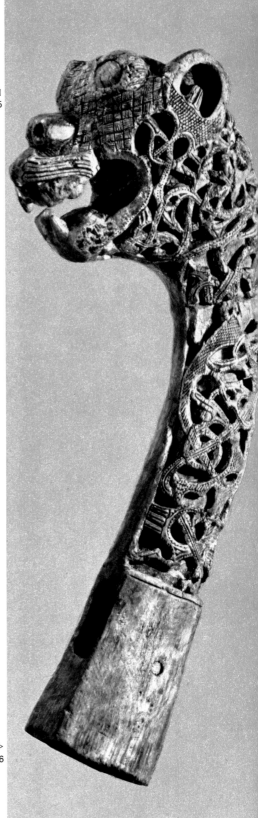

rhythm and resonance and are rich in alliteration and plays on words. They are intricately constructed—and incomprehensible, unless one knows the "code." In the 7th century, the Anglo-Saxon Aldhelm of Malmesbury (639–709) spoke against the heathen works of the Irish, who, to quote Ernst Robert Curtius, "mixed abstruse latinity with artistic self-indulgence," in a "mannered and often incomprehensible jargon," which Aldhelm occasionally used himself. Rossario Assunto speaks of a labyrinthine and tortuous aesthetic, and compares the *Hiberna Famina* to the illuminated pages of manuscripts—an apt comparison, for the seemingly obscure ornamentation followed definite rules, as did the "abstruse latinity" of these earlier poems with their highly ornamented prosody and complicated meanings. The rules for both seem to have been the same. They are not incomprehensible, but complicated, and, if the various key elements are not known, the whole appears obscure. One must consider that the art of illumination developed in close association with and along the same lines as Hiberno-Saxon Latin, the scribe and scholar being in some cases one and the same man. This northern latinity was free from classical rules, and yet refined and inventive. Hiberno-Northumbrian scholarship, culminating in the work of the Venerable Bede (672/3–735), greatly influenced Carolingian civilization.

V. H. Elbern and O. K. Werckmeister have demonstrated that monastic thought had its counterpart in the designs in manuscripts, since one can find cosmic geometry and biblical references in the number symbolism and frame patterns of the illuminations. Ancient eastern models of the universe and Greek variations survive in the circles and squares, rhomboids, and triangles, following the visions of Ezekiel, the Revelations of St. John the Divine, and the commentaries of the Church Fathers from Bishop Irenaeus of Lyons (2d century) onward.

There is a difference between the ornamental patterns and the geometrical shapes as such, which related to cosmology and the science of numerology (O. K. Werckmeister). However, the basic ornamental patterns, such as the interlace and spirals, were not affected by these meanings and remain far more ambiguous. If one wishes to regard them as magic signs, one can point to the many heathen equivalents that were absorbed by the Christian world. It is true that there is hardly any direct mention in the texts of the power to avert evil inherent in certain artistic shapes, but the doctrine of demons was a fundamental concept in the many encyclopedic works on the nature of the world. The geometrical patterns or diagrams of the macrocosmic structure refer to them. Within their forms, the ornamental shapes could be understood as allusions to the microcosmic structure. Allegorical cosmic geometry, labyrinthine combinations, and heathen-demonological meaning were mixed in varying ways. In the minds of the learned painter-monks they were probably inseparable, judging from the texts.

During the 7th and 8th centuries the old blind adherence to the classical world

ceased to be effective. The riddle-like paintings of the Irish and Anglo-Saxons point toward the Middle Ages proper. They were, if one may so phrase it, ornamented scholasticism; within their limits, they were both free and subtle. For the development of artistic trends on the Continent, the latinity of the Irish and Anglo-Saxons, their knowledge of tradition, and their scholarship were temporarily more important than their refinements in the field of decorative art. The Venerable Bede and his pupils, with their knowledge of literature, were typical of the age. They compiled vast encyclopedias, they were historians, and their view of the world comprised cosmological speculations and outlines and fragments of a comprehensive philosophy. These theories had a great influence on the European art of the early Middle Ages. Bede's model of the world, a baldaquin with the four-cornered earth and the four pillars of the world crowned with a dome, was oriental in origin, like so much else. For the artists it served as a visual architectural allegory of the world, for in other fields of knowledge the Ptolemaic cosmology, with the spherical earth at the center,

17 ST. MARK. St. Gall Gospels, p. 78. In the four corners (the four corners of the earth) are the symbols of the four evangelists. The evangelist portrayed in the center has no symbol. One can tell that he is St. Mark from the position of the illumination in the text. The whole design resembles a *Majestas Domini* (Christ in Majesty) representation. The highly stylized folds are reminiscent of late antique prototypes. The ornamental borders are more subtly executed than the figure of the saint, particularly the knotwork (at the top and bottom), the spiral decoration (in the lozenges at the sides), and the zoomorphic decoration (in the corners of the central side panels).

18 EZRA. Codex Amiatinus. Jarrow-Monkwearmouth, England. Beginning of 8th century. Biblioteca Laurenziana, Florence. Amiatinus 1, fol. 5a. A Northumbrian copy of the Codex Grandior of Cassiodorus. The careful reproduction of late antique illusionistic techniques (in the shadows and shadings) is interesting. This Old Testament figure writing in a book was probably the prototype for St. Matthew in the Lindisfarne Gospels (*19*); however, the type was fairly common (*11, 12*).

19 ST. MATTHEW. Lindisfarne Gospels, fol. 25, verso. An illusionistic late antique prototype

has been dramatically altered by flat coloring and linear rendering. Details suggesting that this miniature was not directly derived from the prototype of the Codex Amiatinus (*18*) are such additions as the sandal thongs, and, in particular, the inquisitive onlooker behind the curtain, a traditional Byzantine motif (*11*). This onlooker must derive from another work that closely resembled the Ezra picture. Another innovation is the visual joining of the evangelist to his symbol by his halo. The angel's trumpet represents the call of the gospel going out to the world.

20 CHRIST TAKEN PRISONER. Book of Kells, fol. 114a. This manuscript and the Lindisfarne Gospels are the most important examples of Irish-Northumbrian illumination. The Book of Kells is more richly decorated and is superior to earlier works in the subtle mastery of design. It is a major work at the end of its period, contemporary with the first Carolingian illuminations. Compare it with the St. Gall Gospels (*17*). The figures are similar, but the contrast between drapery and ornamentation has disappeared. The drapery and movements have an effect of greater immediacy, while at the same time being more decoratively arranged.

17

30

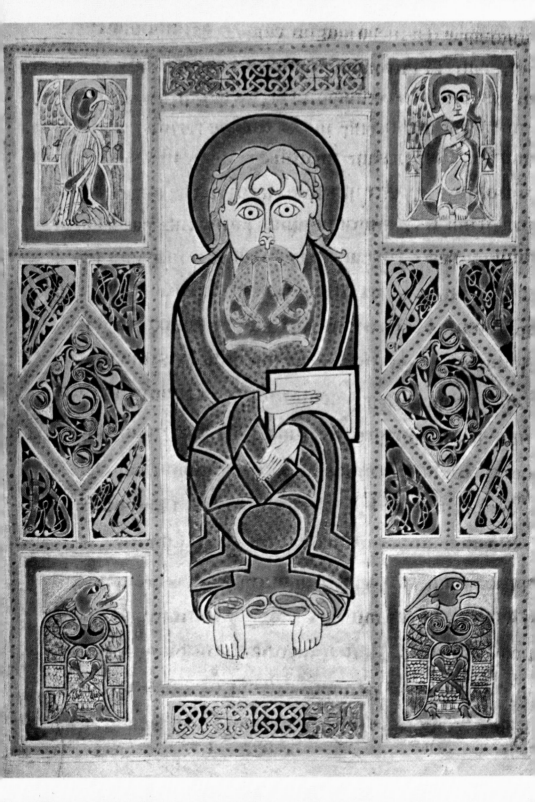

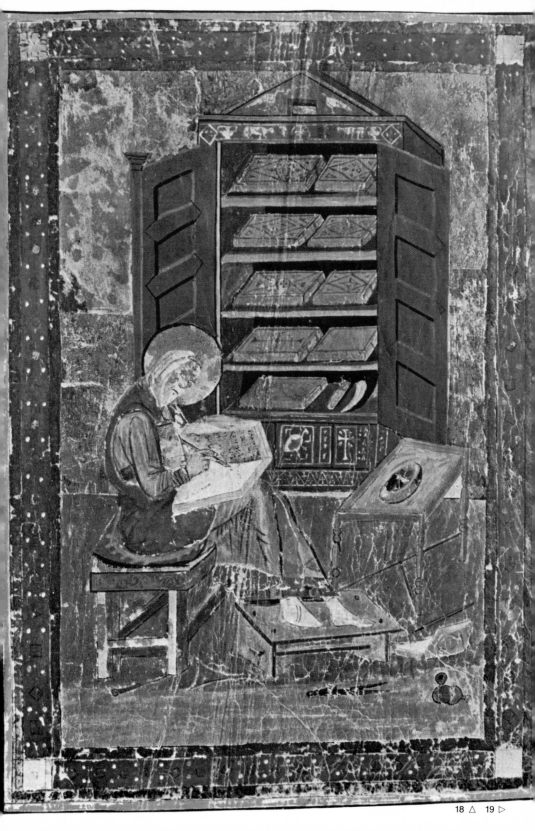

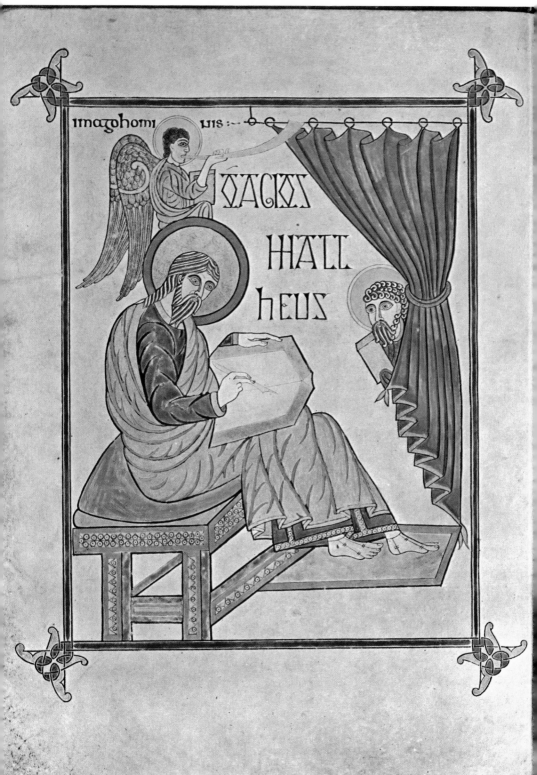

...also he prayeth to his Father, if it were possible
...of his passion to pass, otherwise if to...
...gives to be done

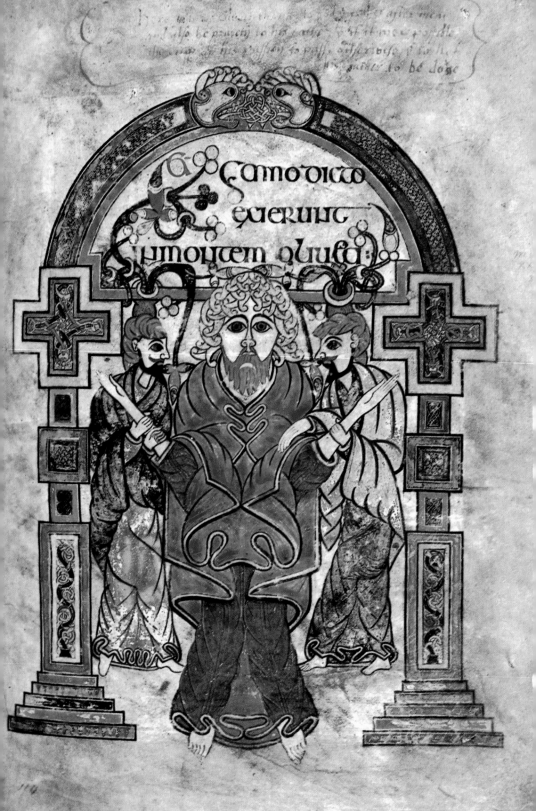

was well known. This trend in scholarly and literary thought, which began in Ireland in the 5th century and had its counterpart in the writings of the Church Fathers and the commentaries of such Spanish authors as Isidore of Seville (c. 560–636), formed the backbone of Carolingian scholarship and art.

The classicism of Carolingian art was also influenced by English trends. In Northumbria, Benedict Biscop (628–90), abbot of Jarrow-Monkwearmouth, was extremely active as a collector. He probably brought the prototype for Ezra in the Codex Amiatinus to England. A new phase of development began when the Benedictine St. Augustine arrived in Canterbury, sent as a missionary bishop by Pope Gregory the Great. It is known that he brought a number of valuable manuscripts with him. The fragment of a Gospels (10) that is now in Cambridge probably belonged to one of these codices. It is of immense interest because, with other early fragments, it may represent all that is left of a large library. In some ways the Gregory fragment is a typical precursor of early medieval illumination. The pictorial organization and figures in the St. Luke painting are in the tradition of Roman illumination, and the evangelist himself conforms to the classical prototype for a poet, current since Greek times and already an anachronism. Paintings composed of details of this kind were brought to the monastic libraries of the north. They served as a fund of artistic inspiration for the inventive local artists. Another example is the figure of St. Matthew in the Codex Aureus of Canterbury, now in Stockholm, which was based on a similar model (14). One can still detect the classical prototype of the poet in the portrait of the evangelist. Works of this kind were in turn to become prototypes for the Carolingian illuminations.

CAROLINGIAN CULTURE

Carolingian culture was not the result of an uninterrupted development. Of course, some of its characteristic elements were already present in architecture and paintings of an earlier date, and its scholarly foundations had long since been laid; but the rapid flowering under Charlemagne (768–814) was sudden and unexpected. The magnificence of this first bold, even rash, attempt to found an empire north of the Alps lies, above all, in the fact that it was undertaken under extraordinarily difficult circumstances and against all probability, rather as if one tried to build the towers of a castle while the foundations were still being dug in shifting soil. The unfinished building did indeed soon show rents in the fabric and rapidly collapsed after Charlemagne's death, but it left behind an important substructure that formed the new basis for European culture.

Although Charlemagne had not always been interested in the arts and sciences, during his reign he came to value them highly and promoted them as no one else had done for centuries. His interest was first awakened for practical reasons; later he was influenced by events and his own inclinations. His empire covered diverse ground: It included old Roman provinces and territory newly won from heathen peoples, spreading over almost all the west of Europe. The structure that had made the Roman Empire cohere was lacking, but the old network of monasteries helped to hold the Carolingian realm together, and Charlemagne valued them for their civilizing influence and gave them every support. Except for the monks, Charlemagne ruled over an empire of illiterates and barbarians, armed for war but otherwise backward compared to their neighbors of Islam or Byzantium. His reforms, therefore, were extremely wide-ranging, from defense and law-giving to weights and measures. The basis of all of them, however, rested in the means of communication, in writing and a knowledge of the Latin language, not yet generally current. Like so many of Charlemagne's programs, this was of limited effectiveness. One of the reforms we are still reaping the benefits of was the introduction of the Caroline minuscule script. Simple and easy to learn, it is also artistic, but less ornate than the Irish script and therefore more suitable for easy communication. It is the basis of modern lettering.

For a long time the emperor had no capital; the court followed Charlemagne's journeys and campaigns. However, the example of Rome and Byzantium had shown that a capital city was necessary for the stability of the empire, and about fifteen years after his reign began, Charlemagne chose Aachen in the north of his kingdom (now in northern West Germany). All the steps he took deliberately furthered three aims: to give the empire unity through compulsory standards, to improve means of communication, and to create a new capital.

The new spirit of Carolingian self-confidence was expressed in the phrase *renovatio Romanorum imperii* (renewal of the Roman Empire). Aachen was celebrated as the "new Rome," not because of its size, which was hardly comparable, but because it was the center of the *renovatio,* and contained in its palace the symbols of imperial power, ranging from details of architecture to the imported Capitoline she-wolf and an equestrian statue of either Theodoric, the great late-5th–early-6th-century Ostrogothic ruler in Rome, or a late Roman emperor. Aachen was a symbol for Rome, and symbols passed for reality. While the clearest visual expression of ideas embodied in the symbolism of texts was made in manuscript illumination, architecture naturally expressed the imperial claims.

Aachen was also the spiritual and artistic capital of the empire. In 781 Charlemagne had summoned the Northumbrian scholar Alcuin of York, whom he had met in Pavia, to his court. Like his Anglo-Saxon teachers and Irish predecessors, Alcuin was, by the standards of the times, a broadly educated man; he was also a brilliant one.

He has been called the spiritual ruler of Europe, for Charlemagne did everything to further the activities that Alcuin had been summoned to initiate. Alcuin was followed by other scholars—Irish, Anglo-Saxons, and Visigoths like Theodulf of Orléans. Dungal, an Irish monk of St-Denis, answered Charlemagne's queries about astronomy with quotations from Isidore of Seville; the king's geographer was Ducuil, whose geography was as fanciful as the astronomy of his fellow-countryman Dungal. The eager, almost childlike Carolingian curiosity about the nature of the world was in strange contrast to the semi-mythical, recondite abstractions with which the questions were answered.

In all the preoccupations and activity of the time, however, one can trace a rational element, which was expressed most clearly in the symbolic concepts and precise allegory. Alcuin was only one of many, and he was well suited to lead the way. Mathematics, it is true, was hardly touched upon (Arabian investigations in this subject had as yet no equal), but both Charlemagne and Alcuin were determined to base education on the seven liberal arts, and Alcuin wrote a manual for training the mind that contains a number of exercises that are still used today.

Although the term *renovatio* was current during Charlemagne's time, it is not quite exact; it expresses an aim and not the result. And one can also question whether the often mentioned "Carolingian renaissance" is an apt description of the facts. Neither phrase implies the entirely new and unforeseen end result of the cultural ferment. Just as the Italian Renaissance produced more than a rebirth or a renewal of classical civilization, the Carolingian attempt to resuscitate stylistic forms from the past led to fundamental changes. There was much talk of copying, and of the classics. A classical armory of styles was gathered together, but it inspired a creative impulse of a quite different kind.

CAROLINGIAN ARCHITECTURE

Very few buildings of the Carolingian period remain, and this makes it difficult to assess which elements were in the current style and which a deliberate attempt to re-create the past or to invent new forms. However, one can roughly divide stylistic details into three categories, although there are certain complications created by the effect of a particular purpose or architectural symbolism.

As in the other arts, a simplification of the earlier highly evolved architectural styles had taken place during the years when Europe was overrun by wandering tribes, and in the Merovingian era. In late Roman and early Christian architecture, the three-aisled basilica was the usual form of parish church. During Merovingian times, there was a preference for the simpler hall church, which was varied in a number of ways: a nave with a screened square chancel (Escomb [England], c. 700;

Kilianskirche, Höxter [Germany], c. 800); a nave with a semicircular apse or lower side chambers (Milan, Como [Italy]; Sursee [Switzerland], Silchester [England]); the two- or three-apse nave (St. Mary, Disentis; St. Peter, Müstail, Chur [Switzerland]). It is worthy of note that the hall church was still being built during Charlemagne's reign in the more remote district of Grisons (Switzerland). One form it took was the cruciform building with heightened central area (Mettlach, Neustadt-am-Main [Germany]).

Charlemagne's first programmatic building was the Palace Chapel at Aachen (*22, 28*). Begun in 792 and completed about 800, it was consecrated in 805 by Pope Leo III. His contemporaries compared the chapel to Solomon's Temple, just as they spoke of Charlemagne as a new Solomon or David. The building, with its domed octagonal central space, two-storied ambulatory, and triple-towered entrance or "westwork" (from the German *Westwerk*), was unusual, because centrally planned buildings were not common in western Europe. When employed, this type of building plan was generally confined to baptisteries (St. Gereon in Cologne, 4th century), chapels to the Virgin Mary (La Daurade in Toulouse, late 5th century), churches dedicated to the holy martyrs, sepulchers, reliquary chapels, and court chapels. The Palace Chapel at Aachen fulfilled some of these functions: It was the court chapel; it was to be used as a treasure house for state relics; the Virgin Mary was one of its patron saints; and it would be the burial place of Charlemagne. Yet it had a significance beyond this. It represented the power of the new empire. This was symbolized by the cupola over the octagon. The dome represented the

21 PLAN OF A MONASTERY. Abbey Library, monastery of St. Gall, Switzerland. MS 1092. The original plan dates from the early 9th century, and this copy was probably sent by Abbot Heito of Reichenau (803–23) to Abbot Gozbert of St. Gall (816–36) to help him plan the new monastery there, which was begun in 830. The drawing is the earliest known medieval architectural plan. A specific unit of measure, or module, equal to the width of the nave (12.86 m.), gives us the measurements of the building. Exact instructions as to the purpose of each building and some of the materials to be used are given, indicating the rational and all-encompassing manner in which this and other such communities were organized. In the center is the church. Above a hall crypt is a three-aisled basilica with an east transept, probably with a square crossing, a square chancel, and semicircular east and west choirs. The architectural system of proportion based on a square, applied in later medieval churches, seems to have been anticipated here. Every two pairs of columns in the nave formed a unit of space, a bay. The length of the crossing was a quarter the length of the nave, from which it was not entirely separate. The side aisles were half the width of the nave; the transepts were of the same over-all area as the crossing. The church was to have two towers at the west end. The other buildings for the monks led directly off the church—cloisters, dormitories, refectory, storerooms, kitchen, etc. Around this central core lay the abbot's house, houses for guests and servants (the latter probably built of wood), and also stables, barns, workrooms, sickrooms, schools, gardens, and a cemetery.

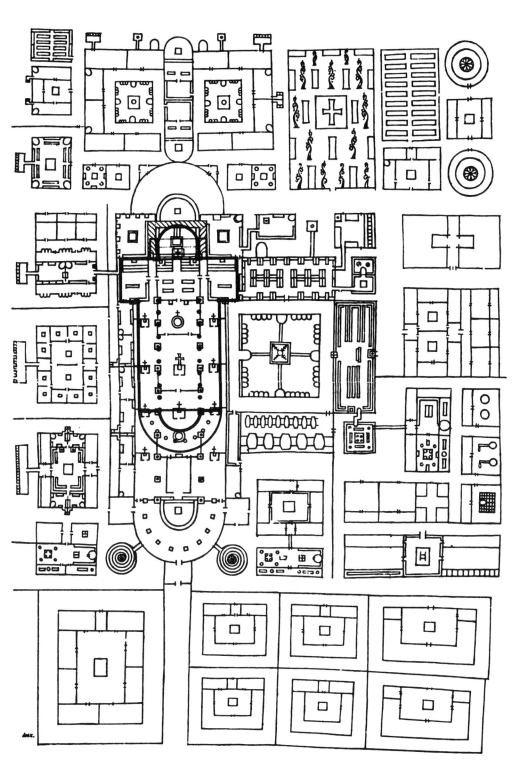

39

world, and the throne beneath was the seat of its ruler. The mosaics in the cupola originally echoed this theme, whether their subject was Christ Enthroned or the Apocalyptic Adoration of the Lamb (there is some doubt as to which). In any case, the sculptured emperor on his imperial throne in the westwork was the earthly counterpart of the central figure in the mosaic, either the heavenly king or his symbol, the lamb of the Apocalypse.

While in Italy, in 772, Charlemagne had seen palace chapels in Lombardy, which we know to have been dedicated to the Savior. In Pavia, there was a church of the Virgin Mary with a central plan. S. Sophia in Benevento, based on the Hagia Sophia in Constantinople, was one of the many palace chapels built on a Byzantine-style central plan, including Constantine's Octagon in Antioch, S. Lorenzo in Milan, the round church of St. George in Salonika, the church of Sts. Sergius and Bacchus in Constantinople, and S. Vitale in Ravenna. The westwork was an innovation in Carolingian architecture. It provided a link with the secular world, an entrance to the "Heavenly Jerusalem."

Another building of this period built on a central plan was Germigny-des-Prés near St-Benoît-sur-Loire (29), which has a square plan with apses at each side. The apse at the east end has two adjoining apses. Over the central space was a square tower. It reflects the influence of Spanish architecture more than that of the Palace Chapel at Aachen. The chapel to the Virgin in the abbey church of St-Riquier near Abbeville (also called Centula; 26, 27), however, more closely resembles the Palace Chapel. A twelve-sided ambulatory surrounded a hexagonal central space. The tower-like form of the exterior is linked with the symbolism of the Virgin Mary. The crypt and circular superstructure of the former cemetery chapel of St. Michael at Fulda (30, 31) date back to Carolingian times. The two-storied ambulatory was built in the 11th century.

The most important influence on the development of medieval church architecture was that of the late Roman basilican churches, especially old St. Peter's in Rome, begun during the reign of Constantine. The essential elements of this type of church—colonnades, three aisles, uninterrupted transept ("Roman transept") followed immediately by the apse—can be seen in the abbey church of St-Denis, near Paris (23), which was begun under Pepin, Charlemagne's predecessor, in 754 and completed during Charlemagne's reign.

This was followed by the abbey church of Fulda (791–819; 25) and Sts. Petrus and Marcellinus in Seligenstadt ([Germany], 832–40). Churches of this kind were not generally built after 1000, but the style was often adopted for the major buildings of Ottonian times. St-Denis was not only important as an example of a Roman type of church, but was also significant because, as the burial place of a saint (St. Denis), it was designed to imitate St. Peter's tomb in Rome. It had an annular crypt like

the one in St. Peter's. Annular crypts, which are semicircular and run either inside or outside the wall of the apse, with a gallery leading from the center of the semicircle to the chamber containing the saint's relics, or one adjoining it (*confessio*), were first used in the 8th century in Italy and later north of the Alps (for example, St. Emmeram in Regensburg [8th century] and Seligenstadt). Later developments were the passage crypt, whose chief corridor could be reached from the nave by stairs. Smaller corridors, branching off from the main one, led to the *confessio* (Einhard's Basilica in Steinbach [consecrated 827], *24, 32;* St-Médard in Soissons [c. 830]), and hall crypts, with several aisles, generally groin-vaulted, and larger in size and extent (S. Maria in Cosmedin, Rome; St-Germain, Auxerre; Fulda, *25*).

Double-choired churches were built in the Mediterranean countries as early as the 4th century. They became more widespread in the Carolingian era and were especially important for the development of Ottonian architecture. There were, for example, buildings with an east or west choir and a special liturgical choir in the west, such as St-Maurice d'Agaune, Switzerland (c. 787), Fulda, the cathedral of St-Jean, Besançon (second building finished in 814), and the Carolingian cathedral in Cologne (dating from the end of the 8th century to about 864). The plan of a monastic complex found at St. Gall (*21*), also shows a double choir.

There clearly existed a desire for more ordered architectural designs and greater unity among separate parts. With the double choir, different dedications of equal importance could be honored equally under one roof, instead of being housed in separate buildings. St-Riquier abbey was one of several highly organized complexes of churches.

The St-Riquier basilica (*26, 27*), which was begun by Abbot Angilbert in 790 and completed in 799, had two extremely important new features. The westwork, whose complex shape may have been an adaptation of the Palace Chapel at Aachen, is (like the three-towered Aachen model) a forerunner of all medieval towered west façades. (As an architectural form, the westwork did not allow for a central plan; it had to be linked to the main part of the church and was therefore rectangular.) The St-Riquier westwork also rose a story higher than the church proper, to allow for the entrance to the nave. Again as at Aachen, the west end of the St-Riquier church was dedicated to the Savior; it supports the theory that the chapels in the westwork of churches were court chapels for the emperor on his journeys. Later, westwork chapels were mainly included in churches that had a close connection with the court.

The westwork of the abbey church at Corvey (built after 873; *34–36*) is a key structure from the late Carolingian period because important parts of it have been preserved. The central part of the façade was built over a crypt-like vaulted narthex. Its central tower, flanked by towers at both corners, formed the triple-towered front.

Inside, the two-storied central space was surrounded by ambulatories, and in the western gallery there is a place for a throne; indeed, twenty imperial courts were held at Corvey between 889 and 1150.

Besides Centula and Corvey, there were westworks at Rheims Cathedral (second building 817–62), St. Servatius, Maastricht ([Holland], 9th century), Lorsch (774–9th century), Hildesheim Cathedral (consecrated 872), and the abbey church of St. Salvator, Werden ([Germany], westwork 875–943). The Carolingian gateway at Lorsch (*33*) was probably intended to serve the same purpose as a westwork. It so closely resembles a classical triumphal arch that certainly it was meant to mark the triumphal advent of the emperor (E. Lehmann) and was thus related to the Palace Chapel. The upper story may have been a chapel dedicated to St. Michael and therefore spiritual rather than temporal in concept, but even so the reference was indirectly to the emperor.

Another influential development was the cruciform east end of the abbey church of St-Riquier (*26*), with a tower over the crossing. It possibly derived from the central-plan churches of Merovingian times. One only finds this cruciform eastern end in churches that were conceived under court influence. The plan of a monastery at St. Gall (*21*) shows a similar arrangement at the eastern end of the church. This implies that the St. Gall plan was drawn by someone connected with the Carolingian court. In the late Carolingian period this type of church ceased to be built, though it became popular again in the Ottonian period. In its place came churches with transepts and lower side chapels at the east end (altar end); the chapels give the impression of being separate from the main body of the church (St. Alban, Mainz; Einhard's Basilica, Steinbach [*24, 32*]; St. Cornelius, near Aachen [begun 814]).

In the St. Gall plan (*21*), one can see the cruciform east end and a double choir. This copy of a plan for an ideal monastic complex was made about 820, probably from an original drawn during the reign of Charlemagne. The plan is intended as a model for Benedictine foundations—the perfect arrangement for a monastery, according to Carolingian ideals. It gives exact details of the churches as well as an idea of the cultural life of the monks and the civilizing activities of their monastery.

22 PALACE CHAPEL, AACHEN, GERMANY. Ground plan.

23 ABBEY CHURCH OF ST-DENIS. Near Paris. Plan. Begun during the reign of Pepin the Short, about 754, and consecrated in the presence of Charlemagne in 775. Based on Old St. Peter's in Rome. Three-aisled basilica with Roman transept and east apse. Two towers at the western end (an early form of westwork?).

24 EINHARD'S BASILICA, STEINBACH, GERMANY. Ground plan.

25 ABBEY CHURCH, FULDA, GERMANY. Plan. Begun by Abbot Ratger in 791; completed 819. Probably a columnar basilica with a vast Roman transept at the western end and a west apse (the first western choir in Germany), and also a semicircular east apse. Beneath the choirs were three-aisled hall crypts. The present church was built in the 18th century.

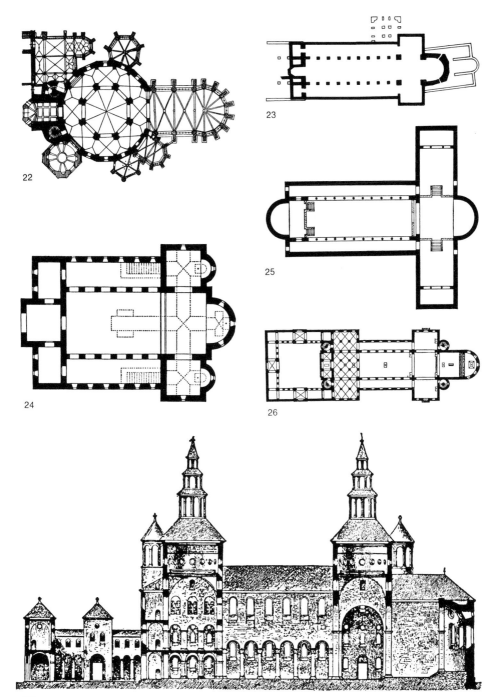

22

23

24

25

26

27

26, 27 ABBEY CHURCH OF ST-RIQUIER (CENTULA),
FRANCE. Ground plan (26) and elevation (27).
Built by Abbot Angilbert between 790 and
799. The 17th-century copy of an 11th-century
drawing of the great Carolingian basilica
shows a three-aisled plan with an east
transept and tower over the crossing, and a
long east apse between two towers flanking
the choir. At the west end was a triple-
towered westwork, which, from the outside,
resembled the eastern end of the church.
The westwork led to the ground floor of the
church through an entrance hall, or narthex.
Over the latter was a central room with a
two-storied ambulatory and its own altar.
Imperial galleries indicate that the church was
closely connected with the emperor.

28 PALACE CHAPEL, AACHEN. Of Charlemagne's
palace, which has been partly excavated, only
the chapel remains. The building was begun
about 790 by Odo of Metz, Charlemagne's
architect, finished about 800, and consecrated
by Pope Leo III in 805. The church was
dedicated to Christ and the Virgin Mary. It
has a central plan, with an octagonal central
chamber below an eight-part domical vault,
surrounded by a two-storied ambulatory with
sixteen bays. The slightly trapezoidal Carolin-
gian choir was later replaced by a Gothic
construction (1355–1414). In the central
chamber, eight piers, one at each angle of
the octagon, support arched openings into
the ambulatory. These arches are surmounted
by a molding and then by the gallery. In the
gallery arches, which are taller than the arches
on the ground floor, are two tiers of columns
with Corinthian capitals, which support
smaller columns. (The marble for these col-
umns was brought from Ravenna.) Beneath
the cupola, round-headed windows pierce
the wall. The westwork has not been pre-
served in its original state. The entrance
remains, however, with its archway and the
great niche above it, and the two semi-
circular towers on either side, with spiral
staircases. The central section, which was
tower-shaped, was made higher in the late
Gothic period.

29 ORATORY, GERMIGNY-DES-PRÉS, FRANCE.
Built as part of his villa by the Visigothic

Bishop Theodulf of Orléans, one of Charle-
magne's counselors and consecrated 806.
Around a central square, a domed compart-
ment with four piers, are eight smaller, almost
square, vaulted compartments, making a
larger square around the central one. On the
east side there is a principal apse with two
lateral apses; in the center of the other three
sides there are horseshoe-shaped apses. The
west apse was later demolished and replaced
by a small nave. The emphasis is on the
central compartment with its cupola, heighten-
ed on the outside by a tower. Fragments of
stucco and stone decoration, which are in the
Orléans museum, show Visigothic influence.

30, 31 ST. MICHAEL'S CHAPEL, FULDA. Of the Car-
olingian monastic complex of Fulda Abbey
only the chapel in the cemetery—which was
altered in Romanesque times—remains, built
820–22 by Abbot Eigil. It has a circular central
compartment and the surrounding ambulatory
is defined by eight columns joined by arches
(30). The crypt is unchanged (31): Arched
walls separate the barrel-vaulted ambulatory
from the central compartment, whose vault is
supported by a short, thick column with a
rough Ionic capital.

32 EINHARD'S BASILICA, STEINBACH. Consecrated
827. Over a barrel-vaulted passage crypt rose
a three-aisled basilica with a small apse and
a transept with low side chapels at the east
end. The side aisles were later pulled down
and the high arches of the nave arcade filled
in. The basilica has a flat wooden roof. Stein-
bach was originally intended as the burial
place of Einhard, Charlemagne's friend, but
later Seligenstadt (830–40) was chosen; the
latter also has a pillared nave, but is otherwise
a Roman basilica with an annular crypt and
a Roman transept at the east end.

33 GATEWAY, LORSCH, GERMANY. 767. Originally
part of the outer courtyard of the now wholly
destroyed abbey of St. Nazarius, this monu-
mental entrance was probably erected as a
"triumphal arch" for Charlemagne, who was
present at the consecration of the monastery
in 774. Particularly noteworthy is the articula-
tion of the façade: Above the three arches
on piers is a narrow entablature resting on
four semi-detached columns. The upper story

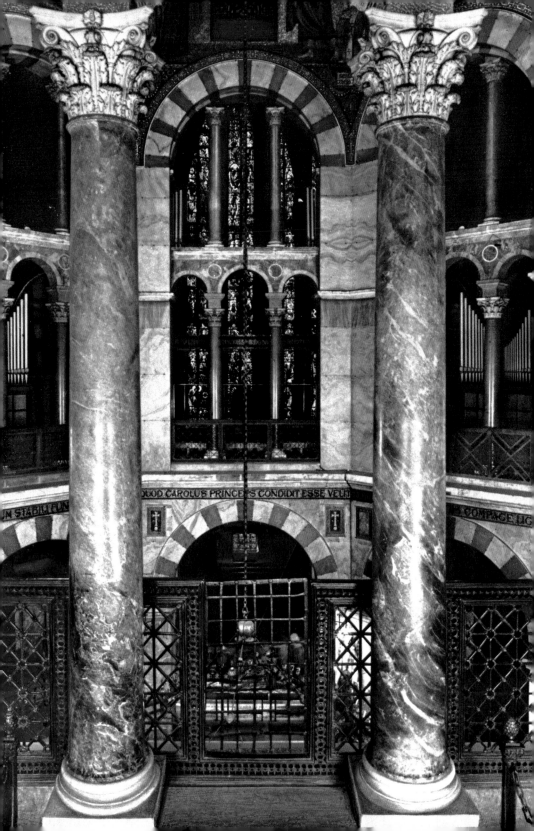

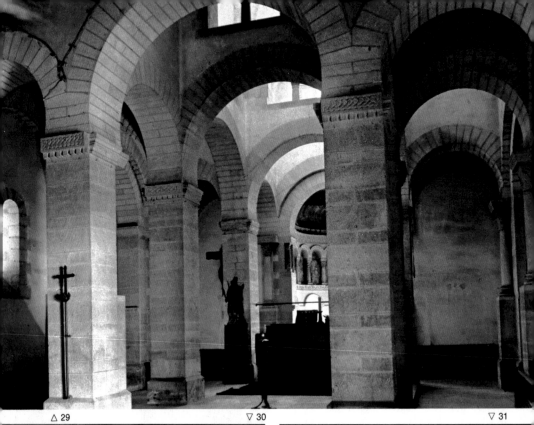

△ 29 ▽ 30 ▽ 31

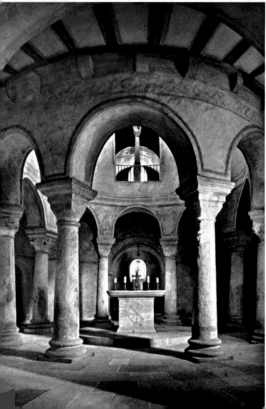

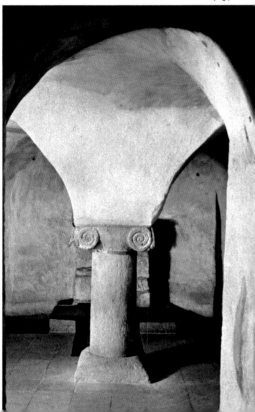

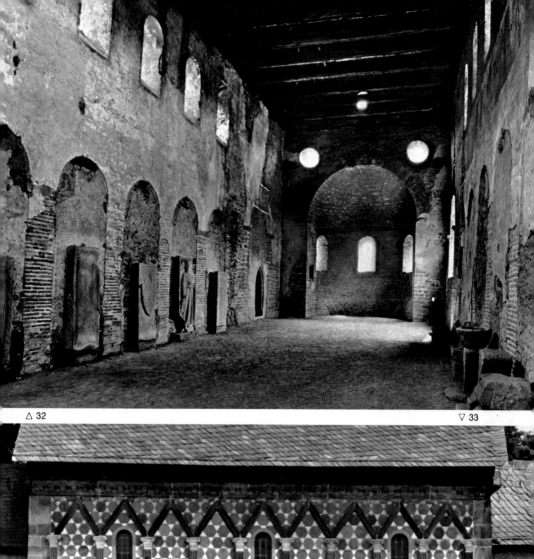

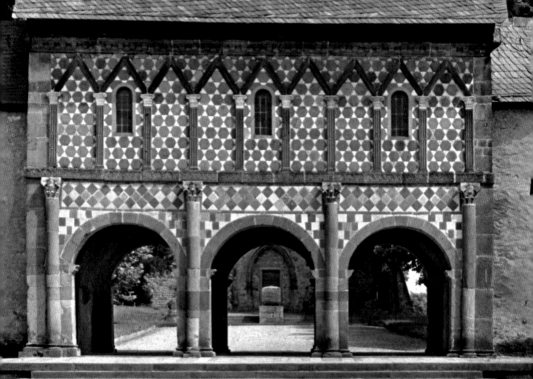

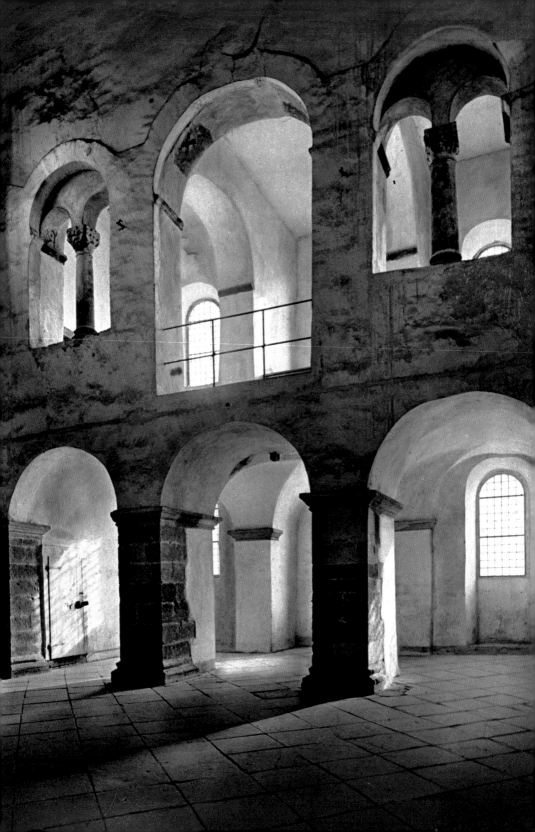

is decorated with flat pilasters, triangular gables, and small windows above the keystones of the lower arches. The chief features, however, are the brightness of the colors and the carpetlike pattern of the stones of the façade. (The roof is of a later date.)

34-36 ABBEY CHURCH, CORVEY, GERMANY. Given by Louis the Pious, Charlemagne's son and successor. Consecrated as *Nova Corbeia* (the new Corbie) in 822 and administered by monks from Corbie in northeastern France. *34*: Interior of the westwork showing the imperial gallery. *35*: West façade with cross-section of the open court, or atrium, which precedes the main entrance. *36*: Cross-section of the westwork.

The three-towered construction (later changed to a two-towered one) was begun at the west end in 873, and in spite of later alterations gives a good idea of a Carolingian westwork. (Nothing remains of the Carolingian monastery; the Carolingian church was pulled down in 1655 because of dilapidation, and was replaced by a Baroque church.) At the north and south sides of an enclosed porch, or narthex, with three arcades (the central one projecting forward) are two towers. Behind this is a square structure running through several stories, with a tower at the top. This "quadrum" is vaulted on the ground floor and has side aisles. The upper story of the quadrum has a flat ceiling and is surrounded on three sides by vaulted compartments with arches on heavy pillars. These compartments are surmounted by galleries with dividing columns in their arches (*34*). The central, larger arch is not divided. An arched wall on several levels divides the quadrum from an east chamber that originally joined the westwork to the church. Against this wall stood the altar of the westwork. Under Abbot Wibald (1146–58) the westwork was turned into a western choir and its external appearance was changed: The tower of the central part was removed and the lateral towers were heightened and joined by a two-story bell loft.

35

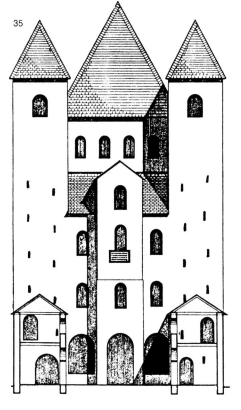

36

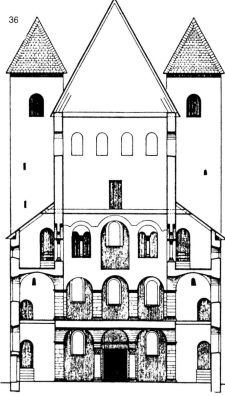

CAROLINGIAN MANUSCRIPT ILLUMINATION

The court at Aachen, the center of Carolingian art and thought, included writing schools and scriptoria. There the great manuscripts of the royal court were prepared, and these so-called court school manuscripts gave expression to much of the scholarly thought of Charlemagne's entourage. A precise use of artistic means characterizes their illustrations, not only the forms, colors, and arrangements of the central compositions, but also the details of the borders. Some of these works that are similar in style have been called the Ada group, after a lady mentioned as donor in the Ada Gospels at Trier (*39*). (It is not known who she was; she may have been a sister of Charlemagne.) In the works of the court scriptoria one can see the flowering of the Carolingian artistic renaissance—or rather the results of the educational reforms undertaken by Alcuin at Charlemagne's request.

The activities of the court artists who produced the Ada group of manuscripts reached a zenith about 800, and lasted until the death of Charlemagne (814). (The sequence of the works of this time has been definitively classified by W. Koehler.) The finest work produced by this circle, in its wealth of motifs, richness of thought, and artistic brilliance, is the Gospels of St-Médard-de-Soissons (*37, 38, 44, 45, 47*). It contains (according to Carl Nordenfalk) over 600 different decorative motifs, and the content of the full-page illuminations is as striking as their richly executed appearance. It was commissioned for Charlemagne himself and completed about 800, the year of his coronation as emperor.

The Ada Gospels is a little later in date. In addition to these two main works there are many related manuscripts, such as the Abbeville Gospels (*42, 43*), believed to have been given by the emperor to Angilbert, abbot of St-Riquier, and the Harley Gospels in the British Museum (Harley MS 2788). A late work, which shows to some extent a misapplication of the same ideas, but which also contains innovations, is the Lorsch Gospels (*49, 117*).

Earlier than all the preceding is the Evangelistary of Godescalc, named after its creator (*41, 46, 48*). It was commissioned by Charlemagne and made in 781–83; thus, begun in the year Alcuin was summoned to the court, it was the product of the first phase in the Carolingian revival, before the florescence represented by the Ada group. The Godescalc Evangelistary shows the influence of late Anglo-Saxon art and Continental trends that emerged from this school of painting. Hiberno-Saxon decorative motifs are used, but are kept in the background. The stylized plants are late antique in origin. The figures show a tendency toward fullness and realism. One can see from an illumination such as that of the Fountain of Life (*46*) that the artist had more than usual knowledge of Byzantine art. There are only a few full-page illuminations in the manuscript: a Christ in Majesty (*48*), portraits of the four

evangelists (placed at the beginning of each gospel), writing, meditating, and receiving inspiration (*41*), and the striking Fountain of Life. The pictorial program is limited, and the illustrations adhere closely to the texts.

The Evangelistary of Godescalc is the forerunner of the later court works, although a great accumulation of experience and development of technique were required before its potential could be realized fully. The earthy tones of the Evangelistary were later abandoned; colors became richer, more varied (comprising the whole tonal scale), and more "Byzantine." Brilliant red, deep blue, and clear shades of purple were used side by side, and sometimes an artist would select a bright emerald green. Also, and this was particularly important, architectural details that had not been a major element in the Godescalc Evangelistary were given particular significance by later artists of the court school: Architecture defines the shape of the pictures down to the smallest details, stresses their implicit meanings, and is above all responsible for the style of these visual allegories.

In the later manuscripts, too, the figures become more rounded, their movements are freer and their expressions more intense. There is plenty of space around the evangelists, and they are not cramped. Enthroned in solitary freedom, Matthew of the Abbeville Gospels (*42*) raises his arm in a graceful, abstracted way to dip his pen in an inkwell, meditating and writing as he listens to the voice of his angel, his alter ego. The incidental dipping of pen in ink becomes a princely gesture. The rendering of the movement was based on an antique gesture of blessing; indeed, all the significant expressive movements in these Carolingian manuscripts, including the signs of blessing made by the enthroned Christ, had their origin in rhetorical gestures and still kept their original meaning at the time.

Noteworthy in the later scripts of Charlemagne's court school and its successors was the skillful rendering of space, which went far beyond the mere use of classical perspective. It would seem that the artists of the royal court aimed at relating the picture space to the central figure, rather than to the onlooker. The lines only make sense from the point of view of the central figure, and this helps to stress its importance and gives it added significance. The complicated effect was not a simple misrepresentation of classical prototypes, but an intentional development and alteration of them. Indeed, in many cases, if one turned this "inverted" perspective around, one would not re-create the effects of antique perspective but, rather, in a rough manner approximate central perspective.

Interestingly enough, the differences between court-school painting, on the one hand, and late antique and Byzantine painting, on the other, are shown up all the more clearly because, in certain manuscripts, Carolingian artists did succeed in matching the classical ideal. Much has been written about this highly artistic and cultivated style with its extremely stylized figures. The young evangelists of the Ada

Gospels in Trier (39) have masklike faces and seem, behind the masks, to be very old. This was an artificial reconstruction of an antique effect. The Carolingian artists were not really reproducing the imperial Roman style, for the fundamental concepts were different, but their own conception of it. Antique precedents were used, particularly for details, but an antique picture was very rarely reproduced in its entirety (indeed, not a single unarguable case is known). The significance of reproduced objects changed in transit from one culture to the other, and this was also true of

37 ST. JOHN. Gospels of St-Médard-de-Soissons. Charlemagne's court school, Aachen. c. 800. Bibliothèque Nationale, Paris. MS lat. 8850, fol. 180. With its rich decoration, and because of the number and significance of the motifs, the St-Médard Gospels can be regarded as the finest work of the court school. This portrait of St. John shows the complexity of frame and architectural details that is typical of this group of illuminators—with the exception of the Godescalc Evangelistary. It is significant that the non-perspectival architectural forms are not contained by the framework, but soar symbolically up into the cosmologically important zone within the arch, the territory of the symbol of the evangelists. The upper and lower zones, though apparently separate, are united in the center. Details in the figure and the architecture derive from antique forms.

38 ADORATION OF THE LAMB. Gospels of St-Médard-de-Soissons, fol. 1, verso. An architectural allegory, inspired by the text of the preface to the four Gospels (*Plures fuisse . . .*), and visually based on the number four. These, and the Church, are represented by four columns, which are united by the drapery. On the entablature above is decorative vegetation representing Paradise, then the Heavenly Jerusalem, with the symbols of the evangelists and, above, the green Sea of Glass at the limits of the cosmos. It is significant that the architecture ceases here. The absence of architecture in the zone above indicates that the fourth zone, which lies above the heavens, is limitless: Here it contains the scenes from the Apocalypse and the Epiphany of the Lamb. The meaning of the picture is echoed in illustrations of the Fountain of Life (47). It clearly contains a mixture of late antique and Byzantine motifs.

39 ST. LUKE. Ada Gospels. Charlemagne's court school, Aachen. c. 800. Municipal Library, Trier. Cod. 22, fol. 85, verso. The book is named after *Ada ancilla Domini,* who is mentioned, in a poem added later, as the person who commissioned the manuscript (possibly a sister of Charlemagne). Her name was adopted for a whole series of manuscripts produced in the court workshops at Aachen. The "crystalline" (celestial) quality of the architectural forms in the zone of the arch is an interesting development in pictures of the evangelists. Rippling emerald green is used for water here (sometimes the color is purple—see 38—because the Sea of Glass was also "fiery"). The ox symbol of the evangelist fills the semicircular space above in an ingenious manner.

40 ST. LUKE. WÜRZBURG GOSPELS. FULDA ABBEY. Mid-9th century. Mp. theol., fol. 66. This work, later than those of the court school, shows many of the older motifs: for example, the combination of architectural and pictorial frames, clearly demarcated by the decorative pedestals, bases, and capitals (see 38); the continuation of the real architecture into crystalline heavenly architecture (see 39); the differentiation of the heavenly zones (see 38). The figure of the evangelist appears to have been derived from recent Graeco-Italian models. The heavenly ox, hurrying away, with one hoof on the evangelist's halo, whose strange attitude represents inspiration, is prefigured in Franco-insular works of the Merovingian period (Gudohinus Gospels, Autun MS 3 [E. H. Zimmermann]).

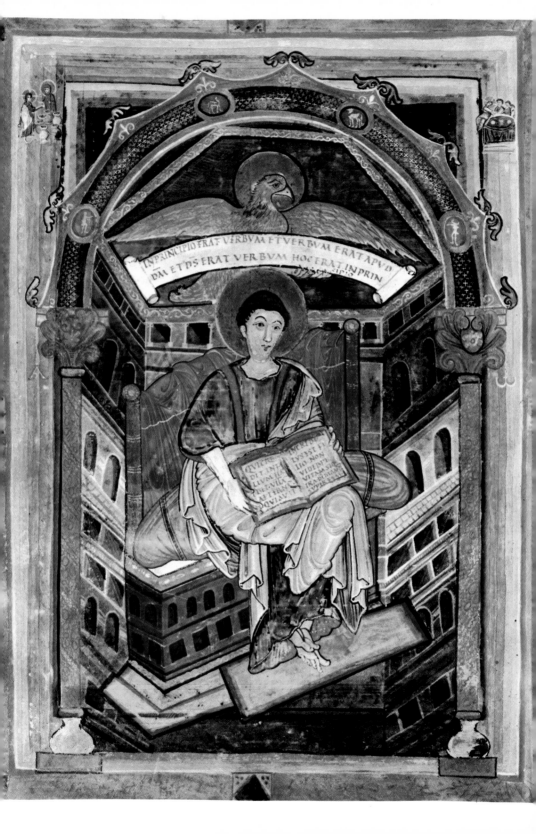

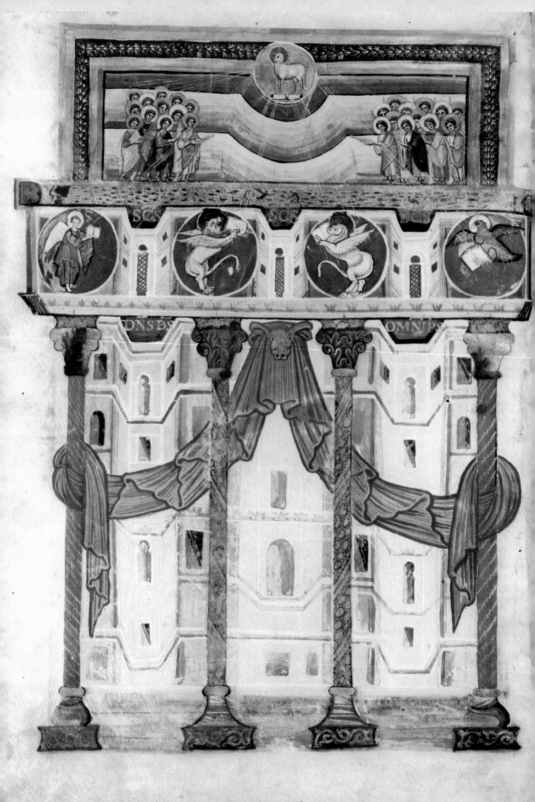

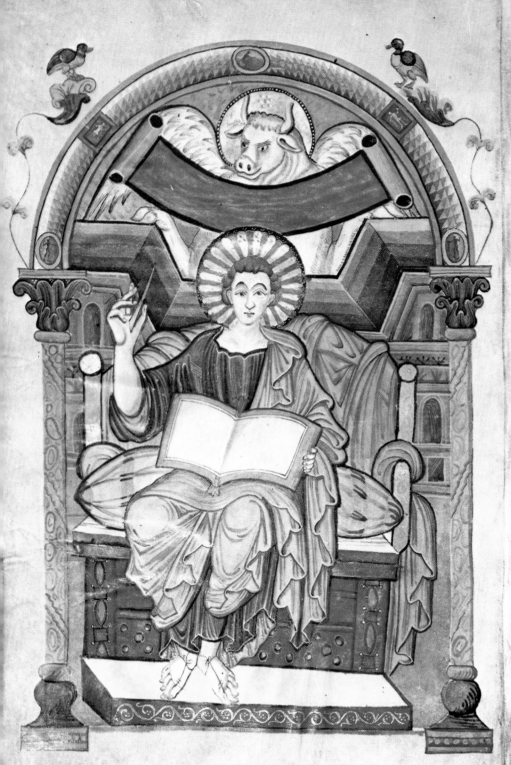

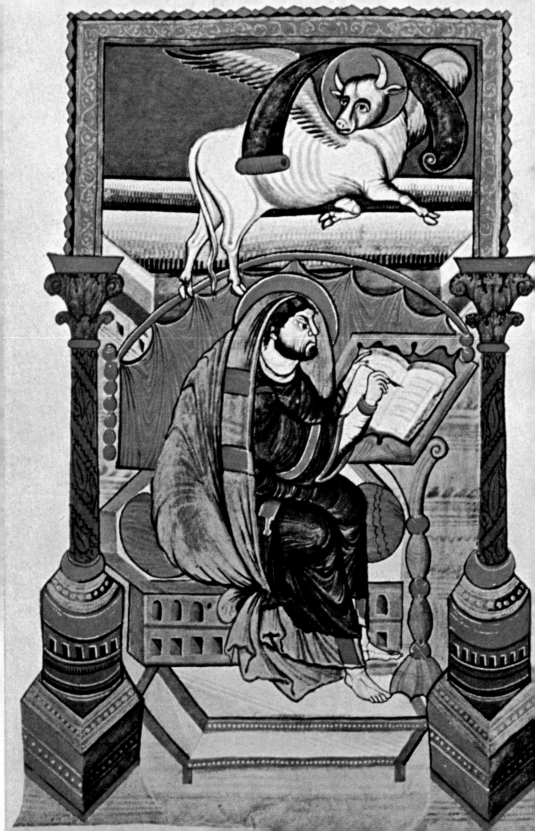

Byzantine motifs. Portraits of the evangelists resemble the antique formula for poet figures but they are differentiated from such antique paintings (which, up to the time of the Gregory Gospels [10], had great influence) by the activity that goes on in them—writing, or dipping a pen in ink. The classical poet meditated or perhaps carried on a dialogue with his muse, but was not active in any way. One of the critical factors in the evolution of European art (and this included the art of Byzantium) away from the art of antiquity was a new conception of work. It was this conception that helped to transform the old model of the poet into the new evangelist picture.

Up to this point, West European artists had been able to take developments in Byzantine art as models, but for some subjects this was no longer the case. For example, the concept of inspiration had altered in the West. While all variations in the representation of the theme were developed in the West in the early medieval period, in Byzantium the antique models continued to be closely followed and innovations were avoided. For instance, the representation of the evangelists with their symbols, which were regarded as highly powerful and spiritual manifestations of the divine being, was contrary to antique practice, as was the representation of Christ as the Lamb of God. In consequence, none of the new developments in the West was adopted in regions where antique norms were still alive (though antique forms were universally used as *models*), and in Byzantium the evangelist symbols were rarely depicted before the 11th century; neither were scenes from the Apocalypse. Yet just these subjects were the most important for the development of form and content in early medieval illumination.

In this context, pictorial architecture assumed a new role. A new way of representing figures was found, and colors were not chosen for such purely aesthetic reasons as "beauty" or "value," but because they carried significant meanings. Similarly, the architectural elements in the paintings had significance not necessarily related to their aesthetic function. The paintings of the evangelists in the major works of the court school are framed in architectural borders with pillars of classicizing design and richly ornamented arcades set with jewel-like medallions. This kind of portal composition had been used since late Roman times. The architecture determines the layout of the pictures: the symbolical beings in the arch above, and the evangelist below between the two pillars. In the background there are often further architectural details, quite separate from the framework as in the St-Médard Gospels (*37*), or the Trier Ada Gospels (*39*). Unless one knows the underlying concepts, these paintings seem to have grown out of a faulty interpretation of Byzantine ideas. This was far from the case: In these pictures every detail was significant. The arch was a symbol of the cosmos, the *sphaira,* or spherical form of the universe. Although the symbol of the evangelist appeared here, its place was beyond the spheres (the spheres were

real places in the cosmic order—the evangelist symbols came from a higher place). The background architecture also represents a particular place in the cosmos.

Evangelist portraits are found more frequently than any other theme in early medieval art, and, for long periods, they were often the only objects of figural representation. Their full significance was developed for the first time by Charlemagne's court school. All the full-page illustrations executed by this group of illuminators, even those that did not contain evangelist portraits, refer to this central theme, appearing as they did in the texts that explained how the four symbolical beings were related to the evangelists and their Gospels. The meaning of the visual symbols was fully corroborated by the texts.

The conjunction of the evangelists with their symbols was a theological problem long before it became an artistic one. Toward the end of the 2d century Bishop Irenaeus of Lyons, in his tract *Adversus Haereses,* tried to limit the number of Gospels to the four that were taken at that date to be genuine, and which were later canonized. Other attempts followed. In 410 St. Jerome summed up the essential points in his Commentary on Ezekiel and his Commentary on St. Matthew, which was used as a preface in the gospel books of the court school. The evangelist symbols stemmed jointly from the four beasts of the Apocalypse and the four living creatures of Ezekiel's vision. The basis of the symbolism was the number four, the old Babylonian number signifying the cosmos. To the four beings, who were regarded as the visible manifestations of God, could be symbolically juxtaposed concepts with a single significance that yet were fourfold. Irenaeus, for instance, mentioned the four corners of the earth and the four winds, compared the four pillars of the world with the four pillars of the Church, and claimed that the four who stood beside God's throne, in the form of a man, a lion, an ox, and an eagle, were the embodiment of the Logos (word of god). Since, according to him, these four beings referred to the Gospels of Matthew, Mark, Luke, and John, then these were the only four Gospels. Later, comparisons were also made with the four elements, the four seasons, the four rivers of Paradise, which flowed from the Fountain of Life, and so on. The Babylonian cosmological significance of the four beings persisted when they were allotted to the four evangelists, and the symbols of the evangelists thus remained what they had been: signs of the zodiac, constellations of the four seasons, and symbols of the four corners of the earth. They lost their exact place among the constellations when they became Christian symbols, but gained added significance through their relationship to the evangelists. (Since this relationship was above all a case of number symbolism, opinions differed as to the combination of the symbols with the single Gospels. For a long time these combinations varied and were discussed.) Later St. Jerome's interpretation was accepted; it was not clearer than the others, but Jerome was influential. For Ottonian iconology his arguments

concerning the combinations became important (for example, the connection between St. Luke and the ox).

The symbols themselves were not immediately acceptable. There were difficulties in choosing animal forms as the embodiment of God. In the Gregory Gospels (*10*) there had been an attempt to separate the beings from the saints by means of the architectural framework, as well as to point up their relationship. The painter of the Lindisfarne Gospels used an unusual arrangement on the page and the conjunction of evangelist and symbol by means of the nimbus, to emphasize the identity of the figures (*19*). Not until Carolingian times was there an attempt to combine all the different elements of meaning at once—poet portrait, mythical cosmology, and symbolical architecture—to represent the inspiration of the evangelist. The artists of the court school encountered various difficulties here, and some should be mentioned, since they served to make the paintings even more complicated.

Sometimes water appears in the arch above the saint instead of clouds (*43, 44*). This represents the "sea of glass, mingled with fire," of the Revelation of St. John. The Sea of Glass and the arch both represent a spherical, enclosed, limited cosmos. In another, older interpretation the arch is also the outermost sphere of the universe, the heavens with the fixed stars, and the realm of the signs of the zodiac (hence, the symbols of the evangelists). The Sea of Glass, the outermost realm, is "emerald-green, crystal," but fiery—and therefore often purple. Jerome was of the opinion (and quoted others to confirm his position) that this signified ice, "pure and clear water" frozen by "terrible cold." This explanation was very often repeated in Carolingian times, and the colors were interpreted along these lines: The crystal is emerald, but made fiery by the stars frozen into it. Isidore of Seville gave a daring explanation of these quasi-physical details in his major work *De Natura Rerum,* one of the most important sources for natural philosophy in the early Middle Ages. The extreme coldness of the frozen water, he said, ensured that it remained where it was and did not fall down; it also neutralized the heat of the stars and prevented the axis of the universe from becoming overheated during its rapid rotation. However strange this interpretation may seem, it is strikingly rational in conception. Within the axioms, such a philosopher as Isidore was free to speculate as he chose.

Since the cosmos was believed to be finite, one age-old speculation had been what lay beyond it. That there might be nothing was not considered a possibility: Because "nothing" has no existence, it must therefore be a fiction. The problem demanded an answer, and so theological speculation filled the loophole: Beyond the crystalline limits of the cosmos, the universe of concentric spheres continued with the *caeli spirituales,* or the hierarchies of angels, as described by Dionysius the Areopagite in accordance with older traditions. All this was well known to the teachers at Charlemagne's court and explains many of the peculiarities of their paintings.

41 ST. MARK. Evangelistary of Godescalc. Charlemagne's court school, Aachen. 781–83. Bibliothèque Nationale, Paris. Nouv. acq. lat. 1203, fol. 16. Named after the scribe Godescalc. Of great richness (the letters are of gold and silver on purple vellum), this book is the first major work of the school, yet different in conception and execution from subsequent productions.

42 ST. MATTHEW. Abbeville Gospels. Charlemagne's court school, Aachen. c. 800. Municipal Library, Abbeville. MS 4, fol. 176. The architectural frame and the handling of the figure, with its pliant gestures and chiaroscuro modeling, hark back to classical models. There are also suggestions of antique perspective in the treatment of the throne. The work is original in many ways. Compare it with the St. Matthew of the Codex Aureus of Canterbury, of perhaps fifty years earlier (*14*), a stiff version of the Roman image of a poet that is very different from this painting.

43 ST. LUKE. Abbeville Gospels, fol. 101 b. The manuscripts of the court school were all closely connected, and the slanted position of the throne appears in other evangelist pictures (the St-Médard Gospels, *37*). The pose of the evangelist is similar to that of St. Mark in the Godescalc Evangelistary (*41*). The picture in the arch belongs to the series depicting the Sea of Glass; here the heavenly water is visualized literally, as a real sea.

44 ST. MARK. Gospels of St-Médard-de-Soissons, fol. 81 b. A variation on existing models (see *41, 43*).

45 CANON TABLE. Gospels of St-Médard-de-Soissons, fol. 11 a. The tables are arranged under decorative arches that rest on capitals imitative of the classical acanthus leaf. The ornamental area above contains a representation of the Fountain of Life (*47*).

46 THE FOUNTAIN OF LIFE. Evangelistary of Godescalc, fol. 3 b. The first Carolingian treatment of the Fountain of Life theme, based on Byzantine models. The text of the preface to the Gospels applies here also (see *38*). The Fountain of Life is an allegory of the four Gospels, which are represented by the four rivers of Paradise (flowing from a single source, and enriching the world).

47 THE FOUNTAIN OF LIFE. Gospels of St-Médard-de-Soissons, fol. 6. It is significant that this motif appears twice in the St-Médard Gospels, here and in the canon table (*45*). It is also echoed in the representation of the Adoration of the Lamb. The picture has been enriched with some architectural details that are not in the Godescalc Evangelistary, and the boldness and deftness of execution show what mastery the court artists had attained in a short period of time. The great exedra behind the fountain is clearly Byzantine in form.

48 MAJESTAS DOMINI (CHRIST in MAJESTY). Evangelistary of Godescalc, fol. 3 a. Christ enthroned in Paradise, before the walls of the Heavenly Jerusalem.

49 MAJESTAS DOMINI. Fragment of a gospel book from Lorsch (Lorsch Gospels). Court school. c. 810. National Library, Bucharest. Pag. 3 b. Christ as Lord of the Universe sits enthroned in a circular mandorla, which represents the sphere of the stars. The symbols of the evangelists, which were originally signs of the zodiac, are set at right angles to one another and refer to the four corners of the earth and the four seasons of the year. The whole design has cosmological significance. It also denotes the unity of the four Gospels.

50 THE FOUR EVANGELISTS. Codex Rossanensis. Second half of 6th century. Museo del Arcivescovado, Rossano. Fol. 5 a. (Prototype for a Lorsch Gospels page [*49*].) The circle with the four evangelists in medallions has the same meaning as the Lorsch page, and indicates, as does the inscription, the ecclesiastical teaching of the unity of the four Gospels and their cosmological interrelationship.

51 JUPITER AS COSMOCRATOR. 2d century. Villa Albani, Rome. Marble. Also a prototype for the Lorsch Gospel page (*49*). Jupiter sits enthroned, encircled by the signs of the zodiac, which represent the *sphaira,* or spherical universe, themselves supported by an Atlas figure.

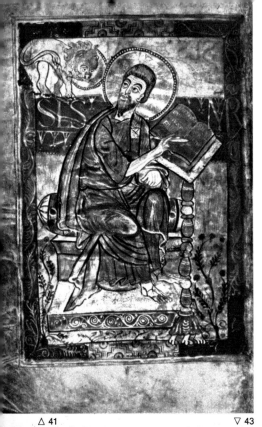

△ 41 ▽ 43 △ 42 ▽ 44

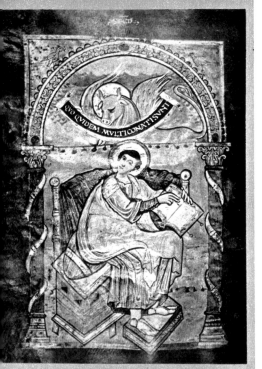

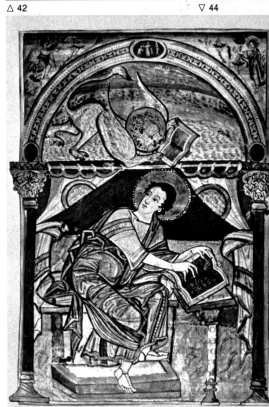

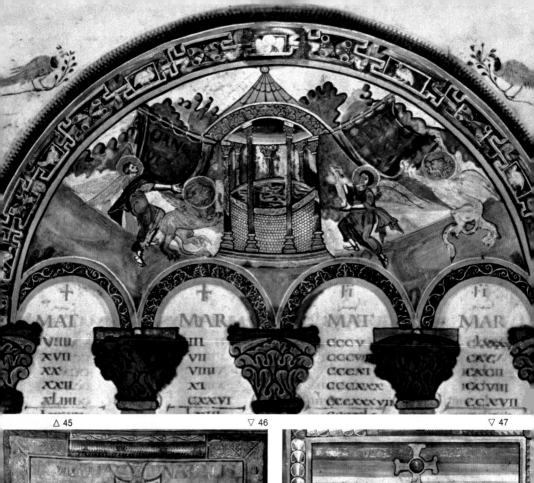

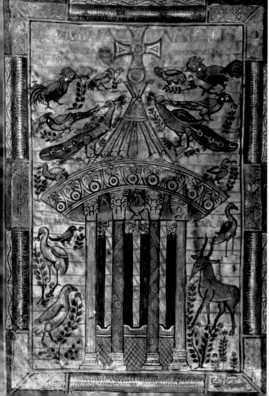

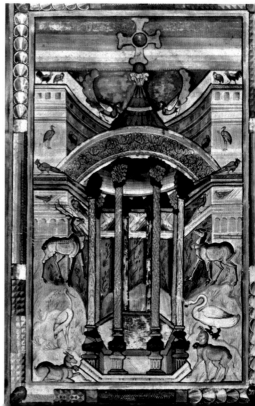

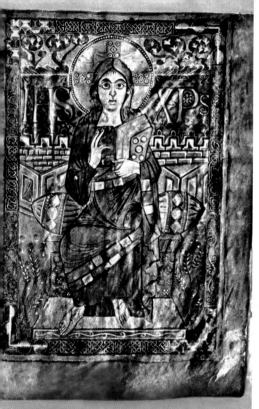

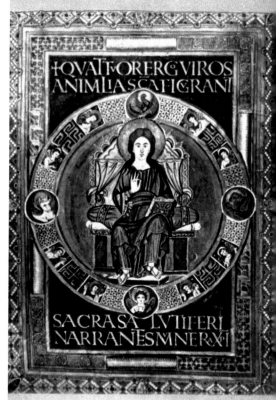

△ 48 ▽ 50 △ 49 ▽ 51

△ 52

REMIAE IACCEIDE TION

▽ 54 △ 53

SILUARUM IUMENTAIN · TESTAMENTUMEUPEROSTUU; QUANDORAPIAT ET
MONTIBUSETBOUES: TUUEROODISTIDISCIPLINĀ NONSITQUIERIPIAT:
COGNOUIOMNIAUOLA ETPROIECISTISERMONES SACRIFICIUMLAUDIS
TILIACAELI ETPULCHRITU MEOSRETRORSUM · HONORIFICAEBITME ·
DOAGRIMECUMEST; SIUIDEBASFUREMCURRE ETILLICITERQUODOSTEN
SIE SURIERONONDICĀTIBI BASCUMEO ETCUMADUL DAMILLISALUTAREDI;

The number four also represented a vertical division of the four different zones of the universe. Jerome listed them thus: the zone below the earth, the earth, the heavens, and the place of those who "dwelt above the heavens." As the Sea of Glass was the outermost limit of the real universe and, on the other hand, the transcendental place of—for example—the "heavenly paradise," he quoted as a proof for its existence the "water, that be above the heavens" of Psalm 148, which also corresponds to the heavenly ocean. This contradictory arrangement had a decisive influence on the artists of the court school. The architectural forms in the evangelist paintings divided and defined the different zones and made their hierarchical order clear. The arch surrounded the area of the evangelists' symbolic beings, and in some cases, following late antique prototypes, a sea landscape was added in the arch to represent the Sea of Glass. What is new here and in similar instances is the combination of a definite literary interpretation of the universe with the meaning of the holy text that was being illustrated, using accepted motifs.

The Adoration of the Lamb page in the Gospels of St-Médard-de-Soissons (38) is a masterpiece of the court school. Few other paintings express so clearly the spirit of Charlemagne's court, few have such moving and ceremonious expressiveness (Florentine Mütherich). It has been called the quintessential Carolingian architectural painting, with aesthetic and intellectual affinity to the Palace Chapel (Wolfgang

52 CHRIST WITH THE FOUR EVANGELISTS. Gospels from Xanten, Germany (Brussels Gospels). Palace school. c. 810. Bibliothèque Royale, Brussels. MS 18723, fol. 166 v. This Brussels gospel book belongs to the group named by Koehler after the Coronation Gospels of Vienna. Characteristic features of this group are illusionistic landscapes, frames like a panel painting, painterly style. This *Majestas Domini* can be seen as the counterpart of the Lorsch page (49). Here again the number four is all-important: Christ as the Logos sits enthroned on a sphere and inspires the four evangelists through their four symbolical beings, who are on high mountains above a landscape that symbolizes the world.

53 THE ASCENSION. Illustration of Psalm 64. Utrecht Psalter. Rheims. c. 835. University Library, Utrecht. MS 32. The Utrecht Psalter, the major work of the Rheims scriptorium, developed the trends initiated by the palace school. The sketchlike pictures are, to a greater or lesser extent, free paraphrases and variations of late antique psalter illustrations. The Ascension of Christ as a "journey through the spheres" corresponds to the Carolingian theory of the universe. The world is represented by the landscape. The borders of the earth and the limits of the cosmos are one and the same; Christ, as victor over the lion and adder, is about to soar across this boundary and into the zone beyond, which contains sun, moon, and the signs of the zodiac.

54 NATHAN BEFORE DAVID. Illustration of Psalm 50. Utrecht Psalter. The prophet Nathan accuses King David of murder. In order to win Bathsheba, the king had sent her husband, Uriah, to his death. The prophet is certain of the truth; the king draws back at his violent accusation. In the landscape are scenes illustrating the words of the prophet. The artist's psychological insight is striking; the reactions of the men are portrayed with a few sure strokes. Another interpretation of this scene is shown on a Rheims ivory book cover (84).

Schöne). These two outstanding achievements in Carolingian art, created at the same time and in the same place, do indeed belong together, though in other manuscripts, too, architectural details and frames echo the live architecture.

The St-Médard Adoration page is contained in the introductory text to the Gospels (Jerome's Commentary on St. Matthew). The top of the picture refers to the passage in the Apocalypse that St. Jerome had quoted because of the reference to four living creatures, for the commentary is concerned with the Gospels' being four in number, and every detail of the picture, every sign, in combination with other signs, echoes this theme. The four pillars, united by drapery, represent the four Gospels and their unity. They correspond to the symbols of the evangelists, the four beasts of the Apocalypse, on the architrave above. The relation of pillar and Gospel had already been made by Irenaeus in reference to church architecture, but the meaning also included the unity of the world. In the same context Irenaeus speaks of the Logos, with its fourfold aspect, as the *artifex omnium,* the creator of the world. There are many such early medieval formulations. In one commentary on the Apocalypse—formerly attributed to Alcuin, but in fact a didactic précis of a work by Ambrosianus Authbertus—the cosmological significance of the four beings is pointed out; but it is said afterward that, in a more universal sense, they could represent Ecclesia, the Church. These and other architectural allegories of the world (including the Venerable Bede's conception of the world as a baldaquin, with four pillars and a dome) have many variations and origins, but all the most important points were known to the court painters and expressed in the St-Médard Gospels. In the Adoration of the Lamb miniature we find three picture zones, the three upper zones of the universe. Below, in the background is Ecclesia, the Church—which also corresponds to the world—with its four pillars in front. Above, is the sphere of the four symbols of the evangelists, with the Heavenly Jerusalem and the Sea of Glass (a narrow strip with fish and waterfowl). Then comes the *super caelos* beyond the heavens proper, and in this zone, which has no architecture and no architectural frame, above the purple heavenly spheres, the Adoration of the Lamb is depicted. The Lamb, higher still, appears in a medallion superimposed on the frame, for it does not even belong to this place beyond the heavens. The painting is a picture of the universe with the hierarchical order of the different zones, and also represents the Church as an architectural universe. The treatment shows an appreciation and exact knowledge of all the relevant symbolism.

Consideration of the literary sources (which are important here) makes clear that the composition represents a baldaquin, a centrally planned building like the Palace Chapel. The representation is diagrammatical, however, without perspective or space; all the objects are on the same plane. The architecture has been unrolled across the painting. The building that represents the universe ends with the Sea of Glass, and

what follows could not be represented by means of architectural forms. In place of the usual arch, there is a frame that rests on the architrave. There may have been several reasons for this choice. Many of the paintings of the court school have a rectangular frame with arches. But it is significant that, in this case, the symbolically important arch has been omitted. The frame here represents the limitless space beyond the spheres of the universe, which cannot be defined architecturally. In the early medieval period, the number of possible ways of framing a picture were numerous and varied, and the border of a painting and the way it was defined gave an indication of its meaning. In Carolingian times, this type of frame always indicated that the picture was a sector of a larger space. A similar combination of frame and pillars is found in the paintings of evangelists executed by the scriptorium at Fulda (40), the only important workshop active in the middle of the 9th century to copy the style of the court school.

Background architecture was developed in the Ada Gospels (39) and related works. In this Trier manuscript the architecture is striking, and has been called a misinterpretation of Byzantine prototypes (A. Boeckler). It is separate from the framework and forms, within the arcade, a unified space, thus canceling out to some extent the division between the lower zone and the zone in the arch. Tall buildings curve back into the pictures from each side in sweeping or broken lines, forming wide niches like town squares that serve as a background to the evangelists on their thrones. They begin below as real architecture, but when they reach the arch they change. The colors lose their materiality, becoming crystalline and transparent, and are refracted like rainbows into shades of purple and emerald. Heavenly and temporal architecture correspond and lead into one another; the earthly buildings become crystalline structures when they reach the sphere of the evangelist symbols.

This was an innovation, and it developed from the subject matter. There had been no earlier prototypes. The architecture of these painting echoed some of the characteristic details in Byzantine art, such as the exedra, throne, and backdrops with corner projections and curving central shapes, but in eastern painting the architecture was always of the actual world and stood free in the landscape. The Carolingian painters knew these earlier works very well but had their own reasons for changing the formula. The invention of a corresponding worldly and heavenly architecture was an idea conceived by the court school from a close study of the texts, and the court artists adapted earlier prototypes to convey their meaning.

The same process can be seen elsewhere. In the St-Médard Gospels the Fountain of Life theme appears twice—as decoration of the canon tables (the table of concordances in the four Gospels), and as a separate miniature, which is richer in color and follows the text more exactly (45, 47). Like the Adoration of the Lamb, the theme is taken from the preface to the Gospels: the Church as the Fountain of

Paradise, from which four rivers—the water of life, of the Holy Spirit, of inspiration, and of baptism—flow toward the four corners of the earth. Springing from a single source, the streams also represent the four Gospels and their unity. A title that was often used in the early Middle Ages and for Christ in Majesty paintings from Tours was: *quattuor hic rutilant uno de fonte fluentes* (from this one source flow the four rivers). The same idea of the original unity of the four books had long been portrayed in the architectural frames of canon tables. It was further stressed in the St-Médard Gospels by the details in the arch, the symbols of the evangelists in dancelike movement above the Sea of Glass. Here the Fountain of Life is placed on the Sea of Glass, its proper place in the hierarchy. In yet another canon table the Ascension is shown, with Christ, who has passed the Sea of Glass, appearing beyond its borders.

These paintings are intricately wrought, unified in thought and design; in them details both old and new were brought into play. The allegories are all-embracing, vast webs of metaphor and symbol. The paintings of the court school echoed the

55 ST. MARK. Coronation Gospels (also called Vienna Gospels). Palace school. c. 800. Schatz-kammer, Vienna. Fol. 76b. The works of this group make an interesting counterpart to the works of Charlemagne's court school. Closer to the classical tradition, they are more painterly in style and without architectural allegory. It is not known where the artist came from, but he was probably Greek or Italian. In accordance with Byzantine tradition, there is no symbol for the evangelist, the landscape is illusionistic, and the frame resembles that of a panel painting. The evangelists are differentiated from each other by their positions, gestures, and occupations. The palace school continued after Charlemagne's court school; the style was retarda-taire, however, and not typical of the time.

56 THE FOUR EVANGELISTS. Aachen Gospels. Palace school. c. 800. Münsterschatz, Aachen. Fol. 14b. The place of the evangelists is the world. Accordingly, they appear in a land-scape, which follows late antique prototypes: a terraced landscape with a high horizon. The painting belongs to the same group as the Vienna Coronation Gospels and shows the direct influence of the Hellenistic style; the artist may have come from Italy. The four evangelists with their symbols also represent the four corners of the earth. The difference in the temperaments of the four men is clearly shown.

57 ST. LUKE. Ebbo Gospels. Rheims. Before 835. Bibliothèque Municipale, Epernay. MS 1, fol. 90, verso. The Ebbo Gospels, the most painterly and freely drawn work of the early Middle Ages, derives in style from the Vienna Coronation Gospels (55) but is thirty years later in date and painted in an even more intense and powerful way, far outstripping the Aachen Gospels (56) as well. It is contemporary with the Utrecht Psalter (53, 54), to which it is related in style.

58 MAJESTAS DOMINI. Gospel book. Tours. c. 830. Württemberger Landesbibliothek, Stuttgart. II, 40, fol. 1b. The Stuttgart Gospels was an early work of the Tours school, and its formal elements derive from late antique models. The clumsiness of the details is surprising, given the skill demonstrated by earlier scriptoria, but the work introduced an idea that was to be developed further: For the first time in a Carolingian scriptorium the Christ in Majesty picture, presented as an allegorical view of the universe, became a leitmotiv. The mandorla is elliptical here because the sphere it represents is made to fit a rectangular format.

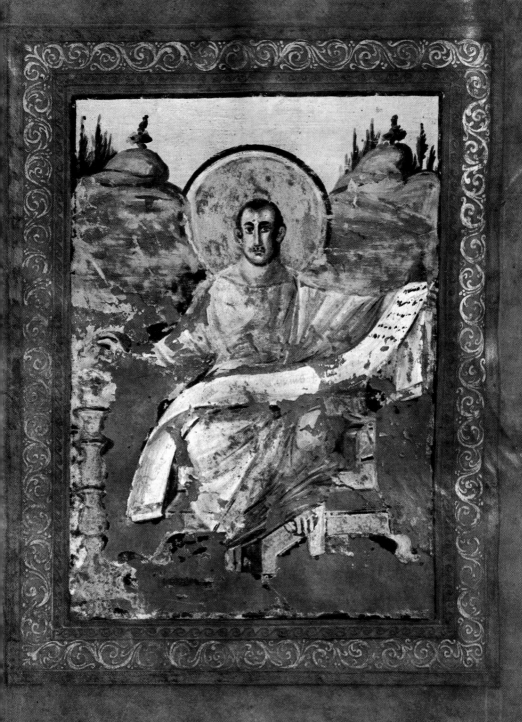

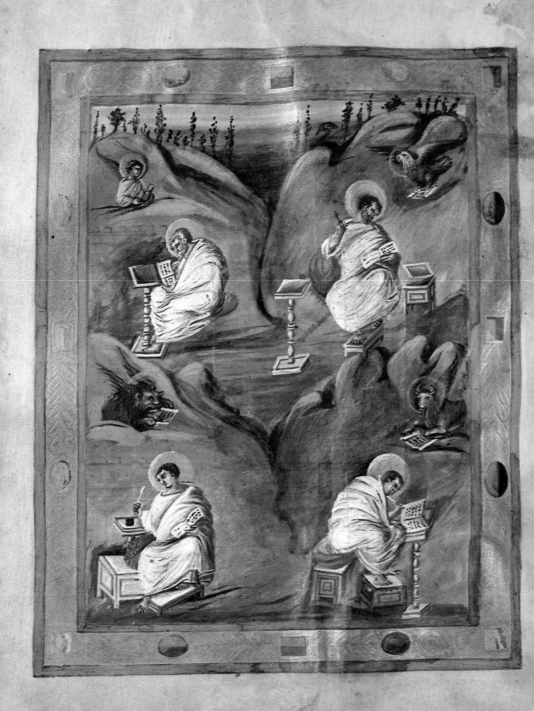

56

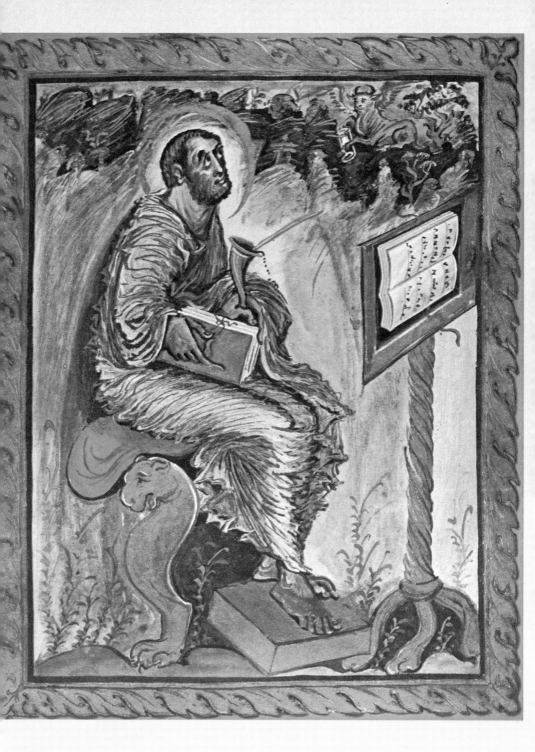

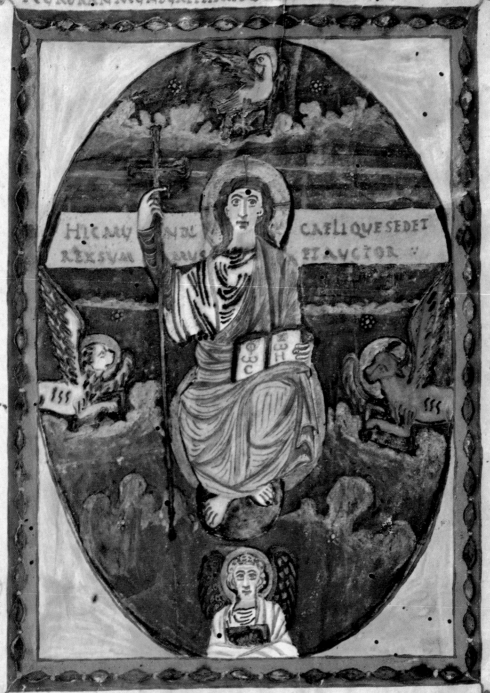

HIC AVI___DI___ ___CAELIQVESEDET
REKSVM___ARVS___ETAVGTOR

scholars' vigorous complexity of thought as formulated in texts and commentaries.

After Charlemagne's death the activities of this group of scribes appears to have come to an end. There is hardly any trace of their influence in the art of the following decades. It was not until Ottonian times that their ideas became important again artistically, and then these were the object of productive misinterpretation and fundamental alteration. However, Alcuin's most promising pupil, Hrabanus Maurus, a man with an encyclopedic mind, was chosen as abbot of Fulda in 822 (in 842 he gave up his office as abbot, but continued at the monastery until 847), and the scriptorium at Fulda Abbey was, up to the middle of the 9th century, the only one that did follow creatively in the steps of the court school. The Würzburg Gospels executed there contain a St. Luke (40) that shows the influence of both the St-Médard and the Trier Ada Gospels. It was perhaps based on a later work than these, which has since been lost.

In the works of Charlemagne's court school some of the subjects one might expect to find are curiously absent. The *Majestas Domini* (Christ in Majesty), later so important a theme, is only found in occasional instances. Prototypes were known but used only in special cases. The subject appears once in the Godescalc Evangelistary (48), then does not reappear until much later in the Lorsch Gospels (49), where it takes a quite different form. In the Coronation Gospels group of manuscripts, which are different in style from the works of Charlemagne's court school, only the Brussels Gospels has a Christ in Majesty (52), and this is also a later work. In all three cases the Christ in Majesty picture refers to the four Gospels, although the composition is different in each case and there is no common tradition linking the three. Avoidance of the theme is attributable to Carolingian art theory. One of the conclusions of the *Libri Carolini* (written at the Carolingian court in response to the decrees of the Byzantine Council of Nicaea in 787) was that the likeness of Christ could not be portrayed, since he had shown himself only through the Word. The tract, composed by Theodulf of Orléans but representing the official view of Charlemagne and his scholars, reflects the attitude of the West to the Byzantine iconoclastic controversy. Both extremes in the controversy were blamed, and the *Libri Carolini* deplored the extravagance of the image-worshippers as well as the iconoclasts. Seeking a balanced view, Theodulf defined the special purpose of paintings and rejected their alleged supernatural powers. He maintained that a painting of Venus could be very like a painting of the Virgin Mary—similar in form and color, with only the inscription indicating whether it was a picture of a heathen goddess or the Mother of God. Paintings, therefore, were not holy objects; they existed to depict figures and events, to refresh the memory, and to formulate thoughts. The extent to which they succeeded in doing these things depended not on the intrinsic holiness of the subject but on the skill of the artist.

But the *Libri Carolini* attacks idolatry above all else. The main objects of idolatry are pictures of Christ, the Virgin, and the saints, and none of these three themes is much in evidence in Charlemagne's time. There are exceptions—ivory carvings, for instance—but the monumental sculptural image, which most readily lent itself to idolatry, was absent during the Carolingian era. In illuminations, only the four evangelists were regularly portrayed. These are indeed pictures of holy figures, but they are not icons. They exist to reinforce the texts. There is great emphasis in the *Libri Carolini* on the pre-eminence of the word and the text.

The tenets of the *Libri Carolini* were disputed once again in 825, at a Frankish synod in Paris. The resulting verdict, the *Libellus synodalis parisiensis,* relaxed their strictness and widened the range of what might be represented, without lessening in any way the importance of text and thought. This compromise echoed current trends. The range of visual themes rapidly increased, first in Rheims and then at Tours, where the *Majestas Domini* was given a central place in the texts—still as allegorical picture only and not as a holy image.

In the last decade of the 8th century, the Coronation Gospels (also called Vienna Gospels, *55*) were executed in the same region as the products of the court school and probably in Aachen itself. In this and similar manuscripts (by a group of artists traditionally and confusingly called the palace school) we find the continuation of a late antique style that had remained intact and which was reproduced with great virtuosity. W. Koehler considers that artist of the Coronation Gospels must have come from Italy, where, however, paintings in this style were no longer made, or Byzantium, which seems more probable. In any case, he must have learned the techniques displayed in the Coronation Gospels in a place where tradition was still alive and where he could study works of the past: perhaps in one of the old provinces of the empire. The fact that in this work the evangelists are shown without their four symbols points to a Byzantine origin. The nichelike architecture he prefers is also Byzantine, and it was a Byzantine custom to give the miniature the appearance of a panel painting by adding a painted frame. In the St. Mark miniature, the frame is highly elaborate, with a double border separated by a frieze of acanthus leaves.

A few other works of this group are different in conception though they have the same characteristics—landscape, painted frame, classicizing details, and illusionistic effects. Among these are the Brussels Gospels (*52*) and the Aachen Gospels (*56*). The picture of the evangelists in the latter is unusual, because all four are shown on the same page. The illusionistic effect achieved by the artist is even more powerful than in the Coronation Gospels. Figures and landscapes are linked by a subtle arrangement of color and tone. There is nothing else like it in Carolingian art. Although it is possible that landscape paintings in this tradition had been created from the late antique period until this time in western Europe, one has to go back to the 6th-

century Ravenna mosaics to find anything remotely comparable. There are also 5th-century mosaics in S. Maria Maggiore in Rome with this same painterly appearance, and the late 7th-century frescoes in S. Maria Antiqua, Rome, and the 8th-century cycle in S. Maria di Castelseprio near Milan indicate that in the mosaic art this painterly style lasted for hundreds of years. The Aachen Gospels is in this tradition. Since the symbols of the evangelists are also portrayed, one might conclude that the artist came from Italy rather than Byzantium. The psychological subtlety of the figures is as striking as the effective transformation of a late antique terraced landscape; all repetitiveness is avoided, and it almost seems from the figures and gestures of the evangelists that the artist wished to depict the four temperaments as well as the four evangelists, thus combining two not dissimilar lines of thought.

The Palace school style appears to have become extremely influential later in the century, after Charlemagne's death, in Rheims, where Ebbo, who had been a servant at the Carolingian court and later imperial librarian, was archbishop from 806 to 835. The painter of the Ebbo Gospels, which was executed in Rheims about 835, must have known the work of these illuminators well, as his style is very similar, although he has a strongly individual streak. In the painting of Luke (57), as in the other three pictures, the shape of the frame is similar to that of the evangelist figures in the Aachen Gospels, as is the panel-painting effect and also the treatment of the landscape. Again, the figures and background combine to make a harmonious whole, and the subtle transitions surpass the earlier Aachen Gospels. The central figure and landscape are full of movement, swirling and storm-tossed, painted with sharp, closely packed brushstrokes. The drapery whips around the figure from ankle to shoulder in a multitude of quivering folds. The halo and landscape seem wracked by intense vibrations. At the top of the painting the landscape melts into flame, and trees, mountains, and clouds all merge together. The nimbus also melts into the scenery, and the symbolic ox appears in the distance like a product of the chaotic tumult to inspire him. The sketchlike quality of these unusual works, their painterliness, and the skill and subtlety with which nuances of expression are conveyed are very different from the calculated style of works of Charlemagne's court school. In the Carolingian period different trends could persist simultaneously.

The Utrecht Psalter (53, 54) resembles the Ebbo Gospels so closely that they have been attributed, with good reason, to the same master. There is a marked difference between the Ebbo Gospels and the Coronation Gospels, but that between the Utrecht Psalter and late antique psalter illustrations, which the artist must have known, is still greater. The scenes and details of the composition are based on a 5th-century cycle. The artist must have studied the old psalters, sketching the essentials but changing or omitting much of the detail, while keeping more or less to the original compositions.

The Utrecht Psalter illustrations are drawn in rapid pen-and-ink strokes, as if quickly tossed off with a minimum of effort but with great skill, the moving pen deftly rounding the figures and bringing them to life. This sketchlike style, and the individuality of these illustrations, are as unexpected as the painterly subtlety of the Ebbo Gospels.

The cycle of drawings does not only illustrate the text of the psalms, which would be difficult to do. Narrative pictures are the exception, although there are scenes depicting important events, such as Nathan Accusing David (*54*); here the King recoils from the accusation that he had sent Uriah, Bathsheba's husband, to his death. For the most part, however, the illustrations are a paraphrase of the text, metaphorically representing the allegories and parables referring to Christ and noting the typological correspondences between the psalms and the New Testament. (One of the aims of the Church Fathers from the time of Irenaeus had been to show the unity of the Old and New Testaments.) Thus, the illustrations are visual formulations of an allegorical commentary on the text.

Christ always appears in a mandorla that surrounds him almost like a vehicle as he appears in the world, traverses it, and leaves it on his ascension (*53*). The role of the mandorla, its function as a surround, almost like a magnetic field, was based on

59 MAJESTAS DOMINI. Bible of Count Vivian. Tours. 845–46. Bibliothèque Nationale, Paris. MS lat. 1, fol. 330b. One of the major works of the Tours scriptorium, typical in its manner of depicting figures and in its iconography. In the corners of the painting (symbolizing the corners of the earth) are the four evangelists, and, in the medallions, four prophets. In the spandrels between the rhombus and mandorla are the symbols of the evangelists, and Christ as Cosmocrator sits enthroned on the heavenly spheres within a mandorla. Thus Christ is the center of the world and at the same time is enthroned above the world. The different symbols spreading from the center outward and the double meaning of various related symbols (mandorla and heavenly spheres) are interesting. For the derivation of rhombus with medallions at the corners, see *64*.

60 KING LOTHAIR. Gospels of Lothair. Tours. c. 850. Bibliothèque Nationale, Paris. MS lat. 266, fol. 1b. The work was executed after or on the occasion of the reconciliation between the Emperor Charles the Bald and his brother in 843. In the picture of the enthroned king

the stress is on his role as ruler. His attitude and gestures and the symbols of his power are decisive factors in the composition.

61 ST. MATTHEW. Gospels of Lothair, fol. 22b. The paintings of the evangelists in this manuscript belong to the type that commences with the Stuttgart Gospels. The high stone throne that derives from the Ebbo Gospels (*57*) is set before a heavenly landscape, bordered by clouds.

62 GENESIS SCENES. Moutier-Grandval Bible. Tours. c. 840. British Museum, London. Add. MS 10546, fol. 5b. The Moutier-Grandval Bible is closer in style to the Stuttgart Gospels and that circle than to the Bible of Count Vivian. The Genesis scenes are based on an earlier tradition (with 6th-century prototypes). The scenes depicted begin with the Creation of Adam and end with a scene showing the activity of Adam and Eve after they have been expelled from Paradise. These cycles were of particular significance in Ottonian times; the artist who designed the bronze doors at Hildesheim Cathedral must have been conscious of this tradition (*140, 141*).

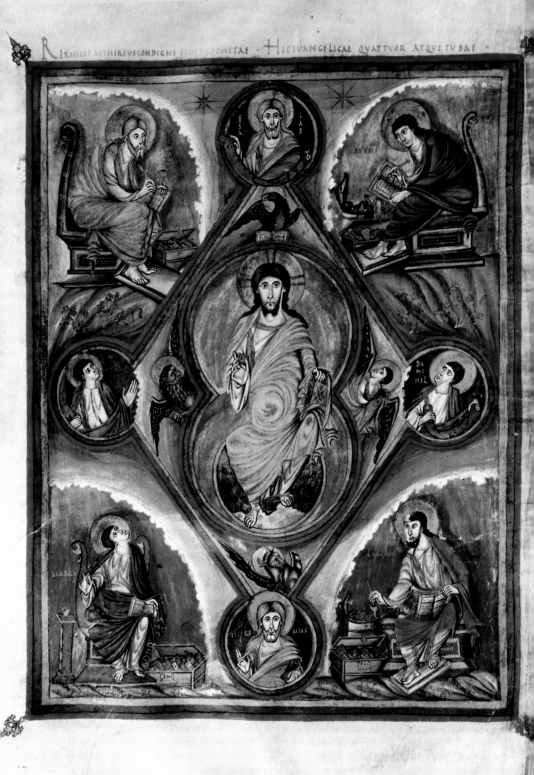

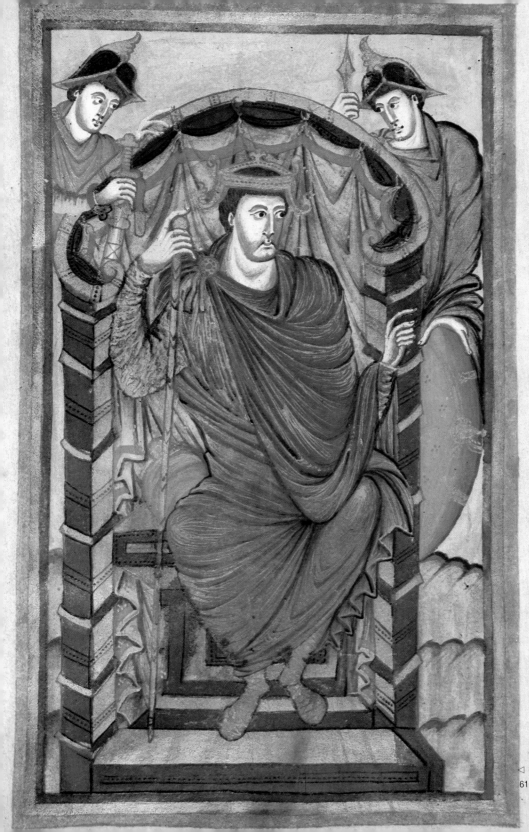

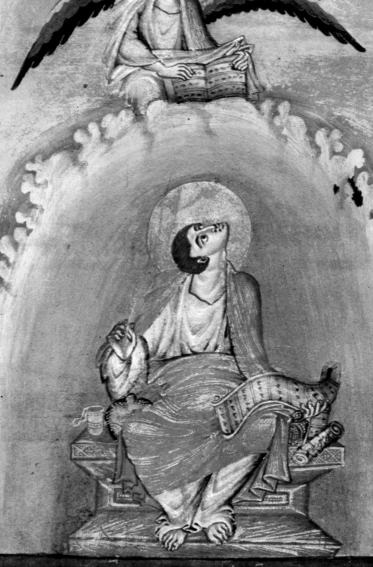

HOC MATTHEVS AGENS

HOMINE GENERALIT IMPLET

late antique precedents, as in the Moses scene of the mosaics in S. Maria Maggiore in Rome, in which the stones of the pursuers rebound from the prophet's mandorla, and in the scene of the three angels appearing to Abraham in the same church. In Carolingian art the mandorla was a motif that could have different meanings, ranging from a symbol of the cosmos to the field of force and space around a figure. It was similar to the nimbus, which in pictures of the evangelists was painted as a circle of light, representing a spiritual zone; when touched by the creature that inspired the evangelist, it conveyed to him the "divine spark." Various pre-Christian elements contributed to the origins of the Christian mandorla and nimbus, such as the *imago clipeata* (picture in a medallion) and also elements from the East, for the mandorla appeared in Buddhist paintings at an even earlier date.

In the Ascension scene from this psalter, which follows the traditional conception of the theme, the world is shown as a landscape with mountains and valleys surrounded by the spheres, which are represented by a circle with sun and moon and the signs of the zodiac. Christ crosses this boundary, the borders of the cosmos. All differences in the composition apart, this follows the painting of the Ascension in the St-Médard Gospels, an indication that the conventions of the court school were still alive. The Ascension is a heavenly journey, a rising up to and crossing of the heavenly spheres. Very old ideas of mythical cosmology and ecstatic states of consciousness are involved (W. Bousset: *Die Himmelsreise der Seele,* 1901).

The dates of this psalter and of the Ebbo Gospels are not known for certain. Opinions vary, and dates ranging from 820 to the middle of the 9th century have been suggested. The most judicious choice might be a date between 825 and 835, but not later: The style of the Ebbo Gospels was soon traceable in the work of the Tours scriptorium, while the Rheims style differed sufficiently from the styles of Charlemagne's reign to suggest a small lapse in time. It also seems likely that the work was undertaken while Ebbo was Archbishop of Rheims.

The influence of the Rheims school was long lasting and variously reflected by other workshops. As late as the 10th century, illuminations based on the Ebbo Gospels were created, among which are works undertaken at Corbie, France. Most of these lack brilliance and are of no great significance, and some show a mixture of influences—that of Fulda as well, for instance. A. Boinet has traced long series of such works and shows how the Rheims style eventually became raw material for Ottonian artists, who transformed it. The school did have a strong direct influence on that of Tours, however, although the successive styles of the latter are clearly distinguishable from that of the Ebbo Gospels. Toward the year 1000 the Cologne school developed this painterly style still further, while at the same time the Winchester school in England was adopting and developing the sketchlike style of the Utrecht Psalter.

The influence of Rheims was felt until the middle of the 11th century. One can find traces of the master of the Ebbo Gospels in some Anglo-Frankish manuscripts—for example, in an important manuscript now in Amiens (*147*). These, in their turn, influenced French Romanesque sculpture. No other work of the 9th century made such a lasting impression. But the differences between the works deriving from this same source are striking. Different aspects of the Rheims paintings were copied in different places: In Tours the figures and their gestures and attitudes were all important; in Cologne the stress was on the painterly style and less on skillful draftsmanship; in England the artists concentrated on the sketchlike effect, on dynamic form, and on elegance of line. In each case, one quality received special attention, and it was often stressed and modified by intervening works. There were also counter-influences from other sources.

The different styles of the Carolingian scriptoria were dependent on tradition—on differing views of the universe and of pictorial composition—and on the size and quality of the monastic libraries—the texts and paintings to be found there. None of the great scriptoria changed styles during its period of peak achievement, which did not usually last for more than twenty years. These artistic centers were islands that formed and developed individually while maintaining a brisk communication with others.

Several of the great Carolingian scriptoria had represented the universe by means of architecture or landscape, with a wealth of metaphor, symbol, and artistic references. The school of St-Martin in Tours concentrated on cosmic geometry; frequent elements in the paintings were geometrically stylized cosmic symbols—the globe and the sphere, the mandorla, and the square. As in the Rheims school, there was little emphasis on architectural detail. The borders of Tours paintings are filled with motifs of other kinds. Artistic activity was late in starting here, commencing only in 830 with the Stuttgart Gospels (*58*), but the major works were executed in the late 840s and slightly later. The Tours workshop was dominant in the second half of the 9th century. Its influence was felt far into the Ottonian period (particularly in Cologne and Echternach).

The manuscripts of the Tours group were illuminated at St-Martin in Tours, one of the large monasteries of the Carolingian realm. Alcuin became abbot of St-Martin in 776, but continued to spend most of his time at Aachen and did not move permanently to Tours until 801, where he died three years later. But he had paved the way for future developments by bringing one of his pupils, Fridugisius, to Tours. Fridugisius was also an Anglo-Saxon. He became abbot of St-Martin in 807 and chancellor to Louis the Pious in 819. He died in 834. He was clever and sharp witted, one of the first to dare to question the limits imposed by his teachers. He also seems to have taken pleasure in expounding ingenious and intricate theories. But M. Manitius writes, "At times the theories of Fridugisius were very sound, but they

went against the accepted scientific and religious ideas of the time." Under this abbot, who does not quite fit into the picture of the increasing dogmatism to which art was subject after Charlemagne's death, the foundations were laid for a blossoming of art at Tours. After a series of beautifully executed manuscripts, the first illuminated manuscripts were painted. Fridugisius was followed by the lay-abbots Adalhard (until 843) and Vivian (until 851), both Frankish counts connected with the court. Under Abbot Vivian the monastery also had connections with Charles the Bald, and the trends begun there were continued in his court school at St-Denis. In the entourage of this notable ruler Carolingian scholarship moved forward from the encyclopedic, compilatory stage of its early beginnings to the achievements of John Scotus Erigena, the learned Irishman and scholastic philosopher. The art of Tours shows interesting relationships to his thought. (Work at this scriptorium ceased unexpectedly. Norsemen, who had already burned and sacked other towns on the Loire, put an end to its activities in the year 853.)

The first manuscripts of the scriptorium, which followed late antique prototypes closely, were inferior to those of earlier centers. One of the motifs most often used as a central illustration for the evangelistaries and bibles is the *Majestas Domini*. There is one in the early Stuttgart Gospels (58), which has all the characteristics of later renditions of the theme: the great mandorla fitting into a rectangular frame, the symbols of the four evangelists, and the blue background of the opening heavens, like the *aperti sunt coeli* of Ezekiel's vision, *coeli* here referring to the *caeli spirituales* mentioned earlier. (Though St. Jerome stressed that the difference between *caelum* and *firmamentum* should be respected, in works of art the opening of heaven [*caelum*] was always represented as an opening of the sky [*firmamentum*].) This Christ in Majesty became a model for future variants of the theme. Other treatments—such as Christ enthroned on the earth, the mandorla as a sphere against a starry sky—are older in origin. They are derived from such representations as the Vision of Ezekiel in the apse of the 5th-century church of St. David in Salonika.

The symbols of the evangelists stand around the mandorla, forming a cross with the figure of Christ. They denote both the Gospels and the four directions of the earth, and the mandorla is the symbol of both a circle and a sphere, so that the latter is represented twice in the painting. Christ as Cosmocrator, *Rex summus et auctor mundi et coeli* (king of earth and heavens), sits enthroned on another sphere and is thus both within and outside the world. This complex and paradoxical arrangement echoes contemporary philosophical arguments about God's place in the universe, to which John Scotus Erigena later made a penetrating contribution.

The Christ in Majesty theme was further enriched and varied at Tours. The works immediately following the Stuttgart Gospels were little different in style and used similar arrangements. The figures were based on late antique prototypes, but the compositions

63 St. Luke. Dufay Gospels. Tours. c. 850. Bibliothèque Nationale, Paris. MS lat. 9385, fol. 91 b. The unusual frame of this and the other three evangelist illustrations represents the unity of the four Gospels, for the four circle segments together make up an entire *orbis terrarum*, or globe of the world. The idea for this unusual construction probably came from the evangelist pictures in Count Vivian's Bible (59). There are several other instances of a segmented globe with similar significance in late antique and medieval art. (See, for instance, 65.)

64 Diagram of the World. Astronomical manuscript. Salzburg. c. 818. Austrian National Library, Vienna. Cod. 387, fol. 1341. The similarity to the composition of the Christ in Majesty in Count Vivian's Bible (59) can clearly be seen, and the symbolism is the same in both cases. Here, the inner square represents the earth divided into the three continents—Europe, Africa, and Asia—with circles at the corners indicating compass directions. The medallions enclosed by triangles are labeled as the four elements—earth, air, water, fire—with their properties (cold, dry, damp, hot). The diagram represents a medieval view of the world. It could be turned into a Christ in Majesty painting by adding Christ and the allegory of the four evangelists.

65 Diagram of the World. c. 1100. Tractatus de Quaternario. Gonville and Caius College, Cambridge. MS 428, fol. 22, recto. The illustration belongs to a series of cosmological allegories based on the number four and represented by a quartered circle. Although it was executed in the high medieval period, the illustration was certainly based on early medieval prototypes (see 63).

66 Poet and Muse. Detail of an ivory carving. Gaul. 5th century (?). Musée du Louvre, Paris. 29 x 7.5 cm. The complete composition included the nine muses with poets in three panels, of which two have been preserved (the poet shown here is perhaps Herodotus, the muse Clio). The intense attitude of the poet foreshadows the Tours evangelist paintings (61, 63).

67 David as a Cosmic Musician. Bible of Count Vivian, fol. 215, verso. A counterpart to the Christ in Majesty in the same Bible. (See also the Stuttgart Gospels' Christ in Majesty, 58.) David (= Christ = Orpheus) is both ruler and musician. Two warriors (Crethi and Plethi) accompany the ruler, as four musicians accompany the harp player. Their positioning is similar to that of the evangelists in Christ in Majesty paintings, the whole composition of which is also very much the same.

68 Adoration of the Lamb. Codex Aureus of St. Emmeram of Regensburg. St-Denis (?). c. 860. Staatsbibliothek, Munich. Clm. 14000, fol. 6, recto. A work influenced by Tours, with similar details and cosmological symbols. Contemporary maps of the stars are closely linked to this painting (69).

69 Map of the Stars. St. Gall. A 10th-century copy of a Carolingian prototype. Abbey Library, St. Gall. Cod. 250. The composition is reflected in the Adoration of the Lamb in the Codex Aureus of St. Emmeram (68).

70 King David. Psalter of Charles the Bald. Court school of Charles the Bald. St-Denis. Between 842 and 869. Bibliothèque Nationale, Paris. Cod. lat. 1152, fol. 1, verso. As in the David page in the Bible of Count Vivian, the king is accompanied by four figures, mentioned in the inscription. The number alone makes clear reference to Christ with the four evangelists. Painterly style, as at Rheims and Tours.

71 Gregory the Great. Sacramentary of Charles the Bald. Court school of Charles the Bald. St-Denis. c. 860. Bibliothèque Nationale, Paris. MS lat. 1141, fol. 3. The Pope, inspired by the dove of the Holy Ghost, is dictating. The composition is similar to that of the Codex Aureus of St. Emmeram and typical of this scriptorium.

72 Christ in Majesty with Seraphim. Sacramentary of Charles the Bald, fol. 6. The figure of Christ was clearly influenced by the Tours school (see 59). This and other related works of the court school of Charles the Bald at St-Denis were prototypes for the ivory carvings of Tuotilo at St. Gall (87).

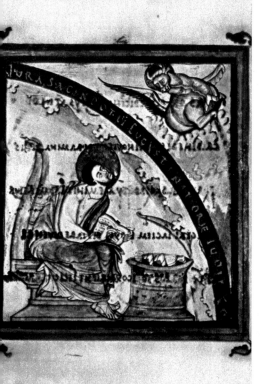

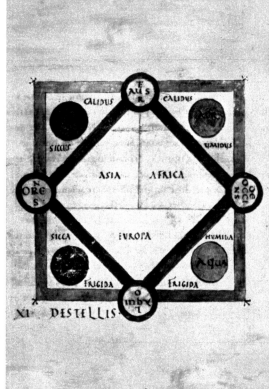

△ 63

▽ 65

△ 64

▽ 66

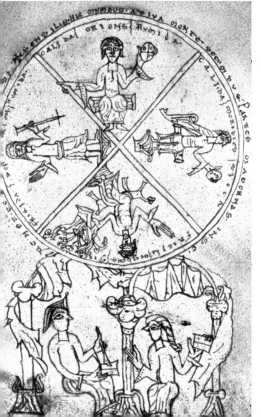

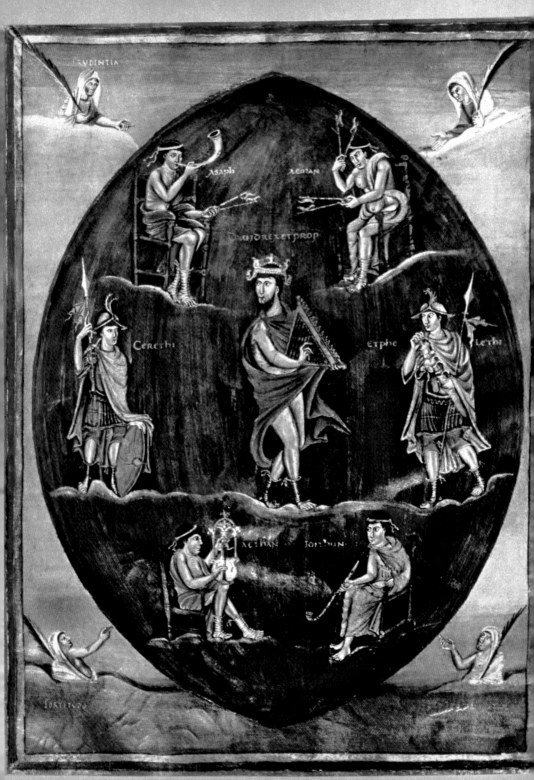

OMNIA QVAE PRAESENS TELLVS PRODVCIT ALENDO
ET MARIS HAEC IACLES LIMBO CIRCVMVENIT AMPLO
AGNE DM SOLIO TEMET VENERANTVR IN ISTO
CANA CATERVA CLVENS NATVM ET VENERABILE OFON
COETVS APOSTOLICVS SERTIS CAELESTIS
LAVDAT ADORAT AMAT DEVOTO PECTORE IN
ET PRINCEPS KAROLVS VVLTV SPECVLATVR A
ORANS VT TECVM VIVAT LONGEVVS IN

68

△ 69 ▽ 71 △ 70 ▽ 72

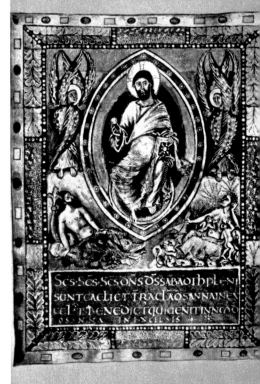

themselves were based on contemporary ideas. In the 840s the major works of the scriptorium were executed: the Moutier-Grandval Bible, the Lothair Gospels, the Bible of Count Vivian, and the Dufay Gospels. In the Christ in Majesty painting of Count Vivian's Bible (59), the armory of symbols was enriched. The great rhombus with medallions at the corners, contained within the rectangle of the painting, was based on an existing diagram of the world, as can be seen from an astronomical manuscript executed at Salzburg a few decades earlier (64). There, the world is a square resting on one of its angles, with the four directions and the four elements contained in medallions, the paired properties of the latter beside them. The diagram presented possibilities for enriching the symbolism of the Christ in Majesty. Half-length figures of four prophets are shown in the medallions, closely related to the symbols of the evangelists. The evangelists themselves sit writing or meditating, surrounded by clouds in the four corners of the painting—"at the four corners of the earth." The paintings of the evangelists in the Dufay Gospels (63) are of the same type and depict these same ideas: The four segments containing the figures together form a complete circle, and each segment represents one area of the earth.

Such diagrams continued to be made for a long time (65), but it is interesting that they were introduced in the 9th century to support theories about the rank and place of the Cosmocrator and the evangelists expressed in patristic allegories. Within the square of the page representing the world differing ranks were also indicated, culminating in the center. There sat the enthroned Christ, who embraced all and was contained within all. The contemporary view of the universe was the reverse of these pictorial presentations, for it corresponded to the Ptolemaic planetary theory: In this view the cosmos was a group of concentric spheres, all with the same center, the innermost being the earth, the others being transparent, the whole system contained within the sphere of angels and holy spirits. Yet scripture and the geometry of the universe interlocked to form a framework (in reverse) each for the other, and in these diagrams the transposition of thought into symbol was complete. But there were other components in the concept. In Count Vivian's Bible, the Dufay Gospels, and the Lothair Gospels, the geometrical frameworks are filled with figures that are greatly advanced over earlier manuscripts as regards form and movement. The encircling folds of drapery and background details, such as the stone or chairlike thrones, are effectively based on details from the Ebbo Gospels. These Tours manuscripts, with their stronger color contrasts, reflect Byzantine techniques of coloration, and the figures of Christ also resemble Byzantine (half-figure) representations of the Panto-crator. The shapes of the bearded evangelists' heads and their manner of wearing their hair resemble those in the Codex Rossanensis (50), a manuscript of the 6th century. The themes and forms developed by the Tours workshop were of great variety. In the inspiration of the evangelist the saint is portrayed with a passionate

intensity (61), and other subjects reappeared in differing interpretations. The David page of Count Vivian's Bible (67) is an outstanding example. David, in the great blue mandorla that fills the frame, moves across the center on a ridge of clouds almost as if he were dancing. He is accompanied by four musicians, and two guards stand at his side. Their names are given and the inscription reads: *David, Rex et Propheta* (David, King and Prophet). The four musicians represent the "broad symbolism of the number four" (H. Steger), and the warriors indicate the ruler's rank. The composition resembles that of a Christ in Majesty painting. The musicians have taken the place of the evangelists in the four corners of the earth. The virtues in the spandrels represent the virtues of the ruler, but also, more importantly, the four temperaments and their harmony, engendered by the effects of music. David had always been linked to both Christ and Orpheus and is here a prototype for Christ. The painting shows him as the musician of the universe, who becomes one and the same with Christ, the creator of the harmony of the spheres.

Paintings of David as king, prophet, poet, and musician were quite common in the late Carolingian era. Charlemagne, himself the friend of poets and scholars, had been called by the name of David by his illustrious circle. (This habit of giving special names to the members of the court school was a custom of the Anglo-Saxon monasteries that Alcuin had introduced when he came over to France and which continued there until the 15th and 16th centuries.) But during Charlemagne's reign there were no paintings of the ruler in the guise of David, and later Carolingian paintings referred to the ruler directly.

Other innovations of the Tours school were the introduction of paintings of rulers (60) and of allegorical narrative cycles (62). Portraits of rulers had been made earlier in the 9th century, possibly including representations of Charlemagne, although, apart from those on coins, no indisputable examples have been preserved (the statuette of a rider from Metz [81] may be an exception). Portraits from the Tours school include a painting of Lothair in the Lothair Gospels (60), a portrait of Charles the Bald in Count Vivian's Bible, and, from St-Denis, a scriptorium that followed that of Tours, a painting of Charles the Bald in the Codex Aureus of St. Emmeram.

These paintings are all very different, and none of them is a portrait from life (the figures and faces were based on models). That in Count Vivian's Bible, showing the monks of St-Martin at Tours presenting the bible to King Charles the Bald, is a dedicatory picture, while that of Lothair concentrates on the enthroned figure of the Carolingian ruler and his two vassals. Strong and ingeniously arranged color contrasts emphasize the power of the figures—blue and red dominate, interspersed with gold, black, and white—and the geometrically shaped throne serves as a frame to the figure of the king.

The paintings of rulers had little in common with the allegorical views of the

universe. It was not until the Codex Aureus of St. Emmeram was executed that a painting of a ruler under his baldaquin was directly connected with its counterpart on the opposite page, in this case, Charles the Bald with an apocalyptic scene of the Adoration of the Lamb. The emperor sits on his throne, surrounded by vassals and personifications of the provinces, and looks across at the scene from the Apocalypse (68). This is very different from the earlier version of the scene in the St-Médard Gospels. Here there is no hint of an architectural world symbolism. The setting for the elders of the Apocalypse corresponds to the geometrical idea of the universe current at Tours. In this instance, there is a clear resemblance to maps of the stars, paintings of the spheres with inset constellations, and the signs of the zodiac of the much-copied Aratus manuscripts (69). The universal implications of the scene are made clear by the composition.

With this painting a long tradition neared its end. It had begun with the allegorical architecture of the St-Médard Gospels and Charlemagne's court school, and continued until the time of Charles the Bald's court school, which followed the Tours school. After that there were few new developments. At most, as can be seen from the Codex Aureus, the Tours models were simply adopted—at St-Denis and probably also at Rheims and Corbie (Charles's court school has been variously located at Corbie, St-Denis, and Rheims, all of which boasted important scriptoria).

The Christ in Majesty in the Sacramentary of Charles the Bald (72) has details resembling both the Tours type of arrangement of this subject and the style and modeling of the figures of the Codex Aureus. This type of composition was later adopted at St. Gall for ivory carvings in particular (87), and none of the other characteristic elements of the Tours style was completely abandoned.

Originally, in addition to the rich varied manuscript illuminations, there must have been an equally extensive, if not equally brilliant, series of monumental paintings—wall decorations in fresco and mosaic. Carolingian churches were certainly painted. Real architecture, with symbolic meaning, framed the pictures, just as painted architecture surrounded the illuminations; and elements of real buildings (domes, columns) had the same significance as the images and signs in the paintings. A church without colored decoration was incomplete. There are contemporary accounts of these rich paintings, gleaming with gold, and the inscriptions that have been preserved give an idea of the range of the cycles. The contemporary accounts are magnificent exaggerations, and it remains uncertain whether the paintings corresponded with the inscriptions. Very little has been preserved from the time of Charlemagne. Fragments of fresco at Lorsch of about 800 (74) show a technical mastery of form and the subtle shaping of part of a face, of which only a small piece with one eye remains. The similarity to works of Charlemagne's court school is evident, and there is a knowledge of classical forms

that would have been passed down via Byzantium. The Lorsch fragment clearly confirms this.

There were also large historical paintings at Aachen, which have been destroyed. The mosaics in the cupola of the Palace Chapel are no longer in existence. A drawing of the 15th century gives a rather unreliable guide to them. Opinions differ as to whether the scene depicted was a *Majestas Domini* or an Adoration of the Lamb.

The only complete (slightly altered) Carolingian mosaic is in the oratory of Theodulf of Orléans at Germigny-des-Prés (*75*). In the apse of this church there is a mosaic of the Ark of the Covenant with seraphim; one can tell from its architectural position that it stands in place of a Christ in Majesty, to symbolize that which could not be shown. The iconographic context of the Ark, which has a definite significance in the *Libri Carolini,* is as complex as the various styles of portraying it. The mosaic is in the manner of the court school. Details in it closely resemble the Abbeville Gospels

73 THE FLIGHT OF ST. PAUL. Fresco. St. Patroclus, Naturno (Tyrol). 9th century (?). In this detail St. Paul is shown fleeing from Damascus, being lowered from the town wall. A primitive rendering of a narrative scene, far removed from the subtlety of the Carolingian court. It is interesting, however, in showing the unevenness of Carolingian artistic development. The decorative border at the bottom is far more skillfully handled than the figure.

74 FRAGMENT OF A FRESCO. Lorsch. Beginning of 9th century. Darmstadt, Landesmuseum. Part of a figure, showing an amazingly accurate knowledge of the antique tradition of painting. In manuscript illumination the Vienna Coronation Gospels are comparable. Comparison with *73* reveals that the Carolingian Renaissance was limited to the narrow circle of the court.

75 THE ARK OF THE COVENANT. Apse mosaic. Oratory, Germigny-des-Prés. 799–818. The only entirely preserved Carolingian mosaic, it was part of a scholarly program of decorations that adorned the villa and oratory of Theodulf, Bishop of Orléans. In accordance with the tenets of the *Libri Carolini* there is no picture of God in the center, only a symbolical device. The figures are somewhat similar to those in illuminations of the court school.

76 THE HEALING OF THE DEAF MUTE. Fresco.

Church of St. John the Baptist, Müstair (Grisons), Switzerland. 9th century. Part of an extensive narrative cycle. Details of the architecture and framework are still recognizably derived from Roman frescoes. Works of this kind were important for the development of Ottonian painting (see *127*). The composition enhances the narrative effect and the significance of the figures, with the main action taking place in the center and Christ larger than his disciples. The gestures and movements (especially Christ's healing hand) explain the scene, while the faces and figures, based on prototypes, have little dramatic effect.

77 THE STONING OF ST. STEPHEN. Fresco. St. Stephen's Chapel in St-Germain, Auxerre, France. Before 859. This is an interesting composition, unlike any others of this date: an asymmetrical sketch representing a town with the stone throwers, recedes into the background on the left, and, on the right, God's hand appears in an empty space. Stephen, almost on his knees, struggles toward it. The details, especially the faces, have a feeling for character that is lacking in most contemporary works (see *76*). One can only find a similar expressiveness in the miniatures of the court school of Charles the Bald.

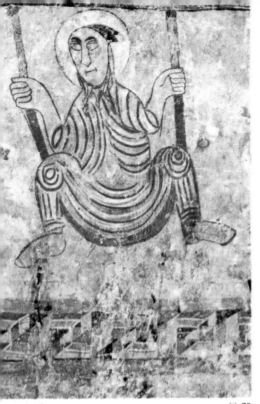

△ 73

▽ 75

△ 74

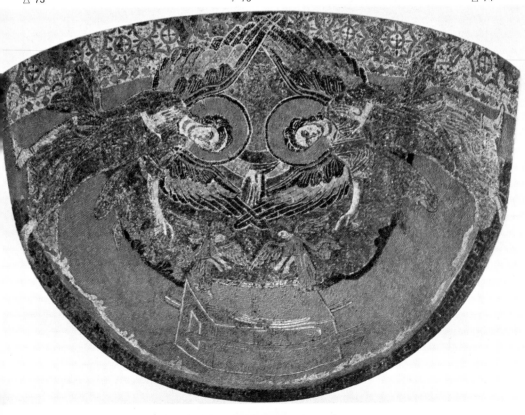

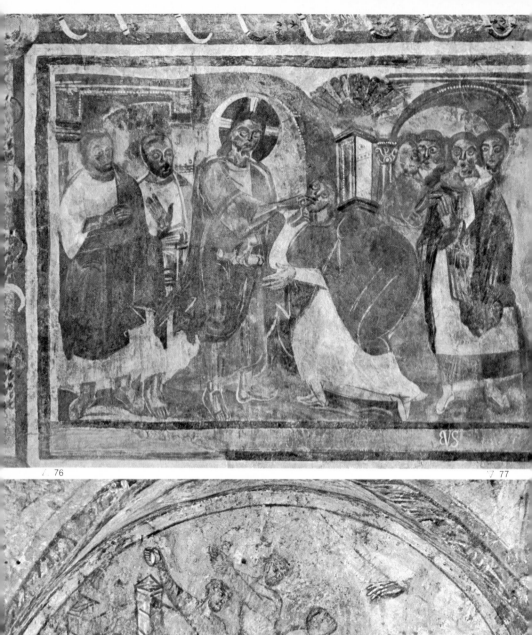

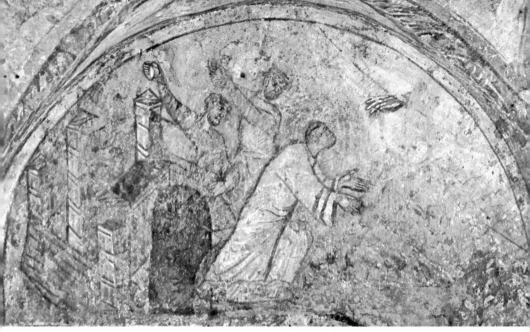

(*42, 43*). One can also trace a resemblance to Roman and Byzantine models, and the whole composition probably owes much to the Spanish origins of its scholarly patron. Nothing remains of the rest of the mosaics (the few remaining fragments were destroyed in the 19th century). However, it is known that in Theodulf's magnificent villa adjoining the oratory there were paintings of the four seasons and of the seven liberal arts.

From these few remains and descpritions, one can assume that monumental paintings followed the same pattern as illuminations of the court school, if—as was the case with Theodulf—the patron was closely attached to Charlemagne's court. One can also assess to some extent what went on elsewhere. There are 9th-century frescoes at Müstair (*76*), Malles (Tyrol), Naturno (Tyrol; *73*), in the crypt of St. Maximin in Trier, and (prior to 859) in the chapel of St. Stephen in St-Germain at Auxerre. This Roman tradition had remained relatively unchanged for a long time and lasted through the 9th century and later. These works formed a varied background to the main line of development. The most complete cycle is at Müstair. It derives from both local traditions and Early Christian art. This type of painting concentrated mainly on narrative scenes with subjects from the lives of the saints and miracles from the Gospels, which had been used only as background motifs or in an allegorical context by the painters at the Carolingian scriptoria. The long narrative cycles of Ottonian times, therefore, are almost exclusively related to the fresco painting tradition.

CAROLINGIAN SCULPTURE AND METALWORK

In the year 801 Charlemagne had a great equestrian statue brought from Ravenna to Aachen. It has not survived. It may have represented either Theodoric or a late Roman emperor, and there were many reasons why it was brought to the northern capital and set up there, some of which are still a matter of dispute. But it is clear that the monument was part of the king's conception of Aachen as a *Roma nova*, a new Rome. It is possible that monuments of this size were made at the court. The technical means and ability were there. The superbly executed bronze doors (*140, 141*) and bronze screens of the Palace Chapel were made in a workshop at Aachen, and it would certainly have been possible for the court smiths to undertake both large and intricate casts. These screens and doors were designed while the chapel was being built to fit in with the over-all plan. Later the workshop demonstrated an amazing ability to reproduce classical patterns in their designs of ornamental foliage. No sculptured figures have survived, except for lion-head door knockers (*78*). They show the same tendency toward organic form.

Opinions differ as to the date and subject of a statuette generally referred to as a rider from the cathedral in Metz (*81*), which is now in the Louvre. Held to be an equestrian statue of Charlemagne, the piece may have been made from memory or from life, though it may be a later idealized likeness. It is considered to date from around 810 or around 860. If the earlier date is correct, it was probably made at Aachen; if the later, probably at Metz. It is not uniform in style, although the pieces of the cast were made to fit each other. The classical manner of the horse suggests an early date, but the appearance of the rider is contradictory. The thoughtfully and carefully modeled face could well be a portrait.

Monumental works in stone, probably not of major significance, must also have existed. Fragments found during excavations at Lorsch have brought to light a foot with a Carolingian type of laced sandal, the fragment of an angel, and the head of a large stone figure (*79*), the most important piece. The large, softly yet precisely modeled face, which shows Carolingian receptivity to classical works, resembles the fresco fragments at Lorsch and the figures of the Trier Ada Codex.

Other existing pieces of large-scale statuary and sculpture of this period are not typical of Carolingian trends and in some cases may be of a different date. The stucco statue of an emperor in Müstair, which, according to a late Gothic inscription, is a portrait of Charlemagne, and certainly from other indications must be a Carolingian ruler, was probably made in the 9th century, but it is too provincial to give an idea of mid-century figural styles in general.

The stucco figures at S. Maria della Valle at Cividale in northern Italy are of

uncertain date and can give no clear indication of this type of work in 9th-century Europe. Architectural figure sculpture seems to have been rare or non-existent. Cult images do not seem to have been made, although they were to become among the most important artistic projects.

The sculptural output of the early Middle Ages must be judged mainly from small carved panels. These reliefs decorated ivory book covers and diptychs, as well as small vessels of ivory or similar materials (walrus tusk, for example). They were closely connected with the work going on at the scriptoria. Their format and purpose were also closely related, and they were often similar in style and iconography to the illuminations. Indeed, most of the pieces can be attributed to one or other of the scriptoria. (The survey that A. Goldschmidt gives in his important work on the subject has not been superseded, although a few interesting modifications and additions have been made. The work is highly recommended.) One group of carvings is associated with the court school of Charlemagne (*82, 83*). Among its major works are the fine ivory book covers of the Lorsch Gospels. On the front Christ triumphant is shown as victor over lion and basilisk, accompanied by two archangels; on the back is the Virgin enthroned between two saints (*83*). The two sides are linked by continuous narrative scenes dealing with the birth of Christ in a frieze at the bottom. In the border at the top of each side are angels with a medallion (or *clipeus*), in which are a cross and the half-figure of Christ. Both form and composition are late antique in style. The figures, too, with their softly rounded forms and complicated drapery shown in relatively flat relief, are reminiscent of Early Christian and Byzantine works, based on various prototypes of different styles and origins. But the structure of their bodies resembles that of the evangelists in the Trier Ada Gospels. The artists at this workshop attempted, here with successful results, the closest likeness they could to late antique models. The sequence of their work shows how they approached this goal step by step, beginning with pieces that artistically were not far removed from the Godescalc Evangelistary and progressing in a similar way to the bronzes of the Palace Chapel (according to W. Braunfels's chronology).

It is characteristic of this group of ivory carvings, however (and this also applies to the masterpieces described above), that the models were taken almost exclusively from other ivory work. Apart from details of the figures' forms, there are few similarities to the pictorial combinations of the court school. Similarly, the border decorations of ivory diptychs were very rarely copied by the illuminators. In illumination there was a much greater transformation of prototypes. On the other hand, there were no complicated allegories in the ivory carvings, such as the Fountain of Life or the Adoration of the Lamb. The two art forms seem to have been separate at the beginning and, at first, to have developed separately.

This changed during the following decades. Ivory carvings were probably made at

78 LION-HEAD DOOR KNOCKER. Palace Chapel, Aachen. c. 800. Bronze. The doors and screens of the Palace Chapel are marvelous examples of highly skilled Carolingian bronze casting. This lion's head exemplifies the craftsmen's desire to reproduce classical patterns as exactly as possible and to combine realism with striking ornamental designs.

79 FRAGMENT OF A HEAD. Lorsch. c. 800. Landesmuseum, Darmstadt. Sandstone. 22 x 13.5 x 10 cm. The only large piece of Carolingian sculpture that has come down to us that, despite its condition, shows a mastery of antique form nearly matching that of contemporary ivory carvings. The fragment of a fresco at Lorsch (74) is nearest to it in style.

80 CIBORIUM OF ARNULF. Portable altar. Belonged to Arnulf of Carinthia. Rheims (?). c. 870. Residenz-Schatzkammer, Munich. Gold, enamel, and precious stones. 59 x 31 x 24 cm. Based on the baldaquin, a freestanding vaulted canopy on columns over an altar. Built in three tiers, it is a sculptural variation of the symbolic arrangement shown in the St-Médard Gospels (38). Here cosmic architecture and the Church are supported by four columns. In the gabled roof, among other motifs, is the Lamb of God.

81 EQUESTRIAN STATUE OF CHARLEMAGNE (?). Aachen or Metz. 9th century. Musée du Louvre, Paris. Bronze. 24 cm. high. A controversial work: ·Its date and place of origin are not established. Metz is only taken to be the place of origin, as the Carolingian workshop there seems the most probable source. Although all the details (dress, moustache, fleur-de-lis on the crown, shape of the sword) indicate that this is the portrait of a Carolingian ruler, and although it was certainly made in the 9th century, there is nothing to indicate for certain that the rider is Charlemagne. The features are not individualized, as is true of the figures in paintings of Charles the Bald's court school. As there are only two likely dates, c. 810 (W. Braunfels) and c. 860 (W. Koehler), and as the figure is certainly a Carolingian ruler, it could only be Charlemagne or Charles the Bald. Portraits of rulers only became common during the reign of Charles the Bald and the statuette resembles these paintings in some respects, so it is possible to assume that the figure is, in fact, that of Charles the Bald. A suggestion put forward by Braunfels, that the statuette was cast in 860 after an original model made in 810, seems very likely, in which case the figure would represent Charles the Bald but be based on an earlier prototype of the time of Charlemagne. The surprisingly classical form of the horse would strongly suggest an early prototype, and would have been a possible style for the first decade of the 9th century. It should also be pointed out, however, that the horse may not be Carolingian at all.

82 CHRIST TRIUMPHANT. Book cover. Court school of Charlemagne. Beginning of 9th century. Bodleian Library, Oxford. Ivory. 21.1 x 12.4 cm. The young Christ is shown treading on the lion, dragon, adder, and basilisk at his feet. Scenes from the Gospels are given around the edge. The iconography and details of the carving are based on late antique ivory diptychs, and show an amazing sureness of touch, elegance, and technical mastery.

83 MARY WITH JOHN THE BAPTIST AND ZACHARIAS. Back cover of the Lorsch Gospels. Court school of Charlemagne. c. 810. Victoria and Albert Museum, London. Ivory. 38.5 x 27 cm. The Lorsch book cover is the greatest known example of Carolingian ivory panel carving. The figures are precisely modeled in a fairly flat relief based on 5th-century Byzantine models, which the artist must have known extremely well.

84 NATHAN BEFORE DAVID. Book cover. Rheims. c. 860–70. Bibliothèque Nationale, Paris. Cod. lat. 1152. Ivory. 11.2 x 8.8 cm. The painterly Rheims style is here carried over into ivory carving. High relief with almost fully rounded figures and deep undercutting makes strongly contrasting shadow and light. The subject is taken from the Utrecht Psalter (54), and the details were altered to suit the medium of relief carving. The narrative is divided into three bands: the main scene at the top, Uriah's corpse in the middle, and the parable of the ewe-lamb below.

△ 78 ▽ 80 △ 79 ▽ 81

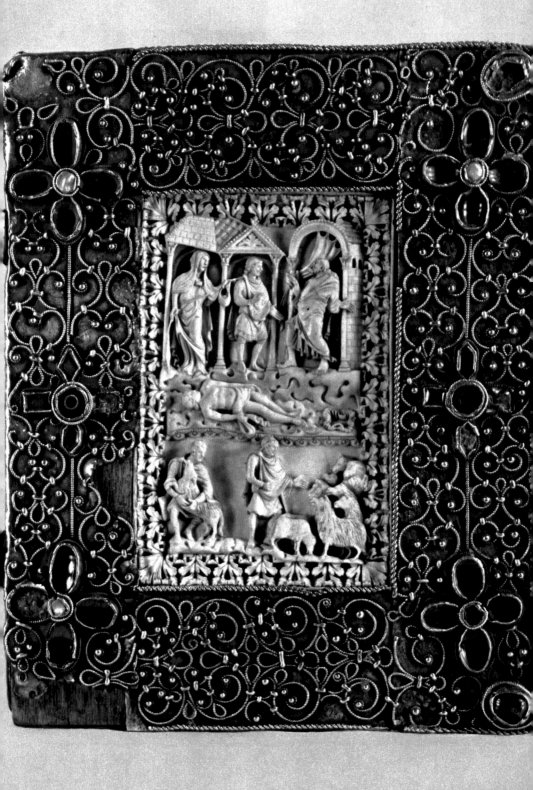

all the most important Carolingian scriptoria—at Metz, Tours, Rheims, and St. Gall—and a group of carvings based on the Utrecht Psalter was executed at Rheims toward the middle of the century. Thus, Nathan Before David (54) was adapted in an ivory relief on a book cover now in the Bibliothèque Nationale (84). The free and allusive form of pen drawing, its spacious stroke, and the nervously executed gesticulating figures could not possibly have been reproduced in ivory, so the artist concentrated on the architectural aspect of the composition and on translating the vivid gestures into a more limited but still convincing type of movement. The technique of overlapping and the undifferentiated backgrounds serve to make the figures stand out as if they were pieces of sculpture in the round. The prototype was not merely copied; it was changed, and a different significance given to the scene. The impetuous strokes of the Utrecht Psalter have been smoothed and controlled, and the aggressive, spidery prophet has become a heavy figure, culminating not in an accusing pointed finger but in a rounded belly—a forceful mass. The movement is stressed by the parabolic border of Nathan's garment, which swirls around him from ankle to the listed shoulder. It is almost a caricature; shoulders, head and gestures, belly, and forward striding foot all express the righteous anger of the prophet, who is quite sure of his ground and angrily thunders forth his accusation.

Other ivory carvings in the same group similarly follow the Utrecht Psalter (85). They all probably originated in Rheims, since the psalter was executed there. But the lapse in time between psalter and ivory carvings is difficult to gauge, since the dates of the Utrecht Psalter are uncertain; however, one can estimate the date of the ivories because of the similarity to the psalter, and also because its style of psychological characterization, almost distorting in its expressiveness, reached its peak between 860 and 870. This trend can be seen in the paintings of the Tours school of about the middle of the century, in the powerful plasticity of the Christ in Majesty painting in the Bible of Count Vivian, and in the attitudes of the figures in the Gospels of Lothair. The Nathan carving was the cover of a Psalter of Charles the Bald.

The whole group of carvings based on the Utrecht Psalter was associated first and foremost with the Tours school and its followers in St-Denis. From St-Denis the way led to St. Gall. The old Irish foundation was a center of continuous artistic development. It had remained faithful to the old style of insular illumination for a long time, and was still a stronghold of learned studies. It produced some artistic stimuli, but remained rather in the background during Charlemagne's reign. The innovations of Charles the Bald's workshop were taken up, but St. Gall did not add to them. The staying power of the long tradition and a series of great abbots assured an exceptional position for the monastery up to the end of the 9th century, however. Some particularly fine ivory carvings were produced there. Some works executed about the year 900 are attributed with a degree of certainty to a monk of St. Gall named Tuotilo (who

is mentioned by Ekkehard in his *Casus Sancti Galli*), including two book covers (*87*). These panels are different from others produced at St. Gall and at the other workshops. The effect of light and shade produced by the undercutting is created by a technique similar to that used at Rheims and Tours, but the relief is more even and background and surface decoration together form a united whole. The composition, and in some cases the iconography, of the carvings echo Charles the Bald's workshop at St-Denis and related workshops. Details of decoration are the same, and, iconographically, the Christ in Majesty is a carved version of the Christ in Majesty painting in Charles the Bald's Psalter. Once again the ivory carvings are influenced by the manuscripts.

Apart from the masterpieces of Tuotilo, the monastery of St. Gall remained more a center for the transmission of traditions than for innovation. Less is known about the role it played later, but it certainly remained prominent, and the old traditions, including the Carolingian, were carried on there. St. Gall was one of the many bridges between pre-Carolingian, Carolingian, and Ottonian art, and it had a great influence on the Ottonian workshop, formerly called the Reichenau workshop.

In addition to ivory carvings, other work was executed at St. Gall, particularly gold work. According to contemporary accounts, this was rated as one of the leading arts, for highly important church vessels and altar decorations were made of gold. Just a few works of this kind have come down to us, in a state of partial preservation, and they can only give an imperfect idea of the actual range of early medieval gold and jeweled artifacts. The single altar covering in precious metal that remains is the golden *paliotto* of S. Ambrogio in Milan (c. 850). It is particularly interesting because of its extensive iconographic program and the mixture of late antique and early medieval elements. It is one of the missing links between the post-classical era and the works of Charlemagne's court circle. (There is not space here to illustrate the cycle of scenes on it in full, and to show a part only would not give a true idea of its art-historical significance. The reader should therefore consult the books I have recommended on this subject.)

Precious book covers were also produced by Carolingian workshops. Often the valuable materials and the jewelry sufficiently indicated in themselves the importance of the contents. More than one reliquary casket, made of gold and set with jewels, is a simple box and appears rather barbaric at first glance; but one should not be deceived. In fact, the gold had a spiritual significance: It was a symbol of light, of the brightness of the Heavenly Jerusalem, and the jewels were equally symbolic. Some of the stones are of quite common quartz, but each stone and its color had a meaning. One has only to remember, for example, how often the names of stones are used for colors that describe the splendor of the heavenly realms in the Apocalypse. Emerald green, for example, was the color of heaven and of the crystalline Sea of Glass. So the choice of materials was not determined by taste alone. The precious stones also had magic pro-

perties and healing powers. All these meanings were also taken into consideration in the rare pieces that showed figural representations.

Figures seem to appear later in Carolingian metalwork than in other media, and they follow the miniatures. The few existing works of this type were made in the time of Charles the Bald. The most important is the cover of the Codex Aureus of St. Emmeram (86). It has a Tours type of Christ in Majesty in the center, surrounded by the four evangelists and scenes from the life of Christ, in a style that aims at the clean lines of a drawing. When it is seen from the side, the borders are like the skyline of a town, with domes of precious stone; the artist clearly meant us to understand that this is a *Majestas Domini,* surrounded by the Heavenly City.

Another work of the same period, which has been preserved at least as far as the basic design is concerned, is the ciborium of Arnulf (80), a portable altar in the shape of a baldaquin, or canopy. The Lamb of God appears in one of the four gables of the roof. One is reminded of the architectural world symbolism of the court school, as shown in the Adoration of the Lamb of the St-Médard Gospels.

Only a few of these precious works remain. Most were destroyed early because of their value. Yet we could probably not learn a great deal more about the art of the Carolingian era if we *did* have a complete inventory of metalwork. It was not a sphere rich in innovation; the major trends of the period were not initiated in metalwork, carving, or sculpture—but rather in the field of manuscript illumination.

85 ILLUSTRATION OF PSALM 24. Cover of the Prayerbook of Charles the Bald. Rheims. c. 870. Schweizerisches Landesmuseum, Zurich. Ivory. 11.2 x 8.8 cm. Like the book cover in *84*, this offers a variation on a theme in the Utrecht Psalter. The dynamic action of the figures makes this a free and ungeometrical design. While still part of the Carolingian tradition, the painterly relief style is very different from the Lorsch cover (*83*).

86 MAJESTAS DOMINI. Book cover of the Codex Aureus of St. Emmeram, Regensburg. St-Denis (?). c. 870. Staatsbibliothek, Munich. Cod. 14000. Chased gold with pearls and precious stones. The Christ in Majesty follows the Tours manuscript style (note the position of the legs and diagonal folds of drapery; see *59*). The four evangelists are shown in the side panels, and there are scenes from the Gospels above and below. The technique allowed for only low relief, with no under-cutting.

87 MAJESTAS DOMINI. Book cover. Ascribed to Tuotilo. St. Gall. c. 900. Abbey Library, St. Gall. Cod. 53. Ivory. 32 x 15.5 cm. The St. Gall ivory carvings attributed to the monk Tuotilo are among the last masterpieces of the Carolingian era. Nothing similar was produced at St. Gall before this date. In sharpness and clarity the composition is a more disciplined version of the painterly Rheims style, but the high relief and deep undercutting to give light and shadow are there. The acanthus scroll panels above and below the main scene are also very finely executed. There is an over-all resemblance to earlier ivory carvings, but also a close resemblance to the illuminations of Charles the Bald's court school (St-Denis), from which the artist took his models. (See *72*.)

HIC RESIDET XPC VIRTV

TVM STEMMATE SEPT S

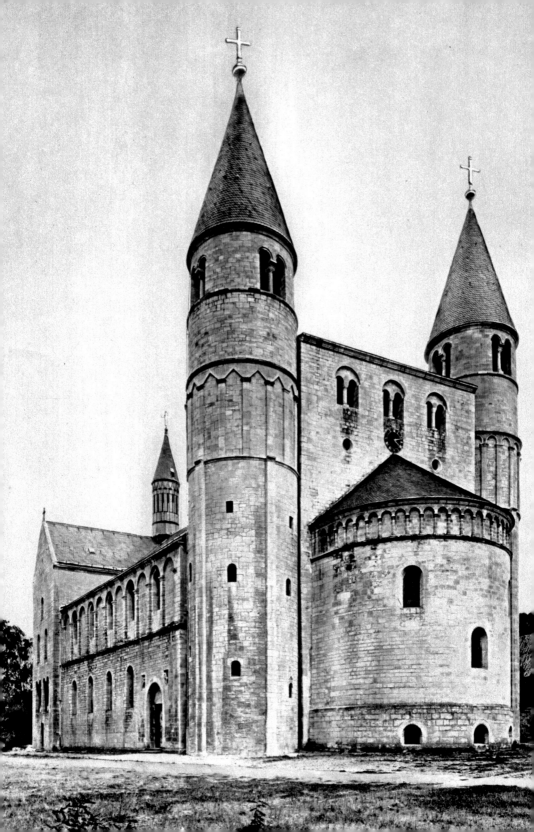

ART AROUND THE YEAR 1000

For a long time political events prevented a further development of the promising Carolingian trends in art. The Carolingian empire fell apart and Europe subsided into feudalism. Building and painting naturally still went on, but during the last quarter of the 9th century nothing particularly new was accomplished in these fields. Despite the copying and compilation at such monasteries as St. Gall, ideas were misunderstood or quickly forgotten. If one looks at the illustrations in Boinet's *La Miniature Carolingienne,* it becomes only too clear how rapidly the edifice that had been painfully constructed during eight decades fell to pieces, and how, when inspiration was lacking, the formulas were also forgotten. The more costly enterprises such as elaborate architecture were brought to a standstill for a century because of unfavorable conditions.

But by the second half of the 10th century, attacks upon Europe from without at the hands of Vikings and Magyars had been warded off or endured. A new imperial tradition had been born in the east of the Carolingian realm, which claimed the heritage of Charlemagne. The fact is that the kingdom inherited by Charlemagne's grandson Louis the German, though poorer than the lands to the west held by the emperor's other heirs, was also the strongest and most stable socially. While France and Italy experienced a century of civil unrest, Germany was lucky in her leaders. At the beginning of the 10th century the Saxon kings began strengthening Germany's borders and looking outward, and Otto the Great (936–73) became the most powerful monarch in Europe, controlling his territory, like Charlemagne, through family alliances and the Church. In 961 Otto was called into Italy to restore order and there was crowned emperor, claiming to be the successor of Augustus, Constantine, and Charlemagne. His son and grandson, Otto II and Otto III, were less successful, but subsequent rulers maintained the empire with brilliance until the middle of the 11th century. Under the Ottonian dynasty it was possible to concentrate once more on cultural things.

88 St. Cyriakus, Gernrode (Saxony), Germany. Founded as a convent in 961 by the Margrave Gero. Altered in the 12th century (west choir and west towers heightened). Three-aisled nave. Originally there was a flat wall at the west end, flanked by two towers with spiral staircases at the termination of the side aisles. At the east end there is a transept that extends from the nave but is slightly out of alignment with it, and a square chancel with a semicircular apse over a hall crypt. The interior support system is interesting. Piers and columns alternate in the nave, with the effect of dividing it into two compartments. This idea is repeated in the gallery above, with a central pier and two side piers between two series of five columns; the arches formed are paired by wall arches above them. This pattern is not carried on into the window area. (See especially *91.*)

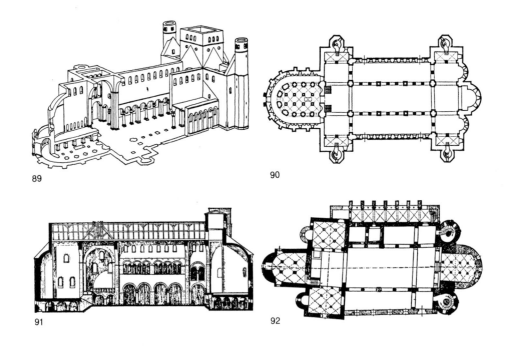

89

90

91

92

89, 90 St. Michael, Hildesheim, Germany. Longitudinal section and ground plan.

91, 92 St. Cyriakus, Gernrode. Longitudinal section and ground plan.

93-96 St. Michael, Hildesheim. Begun about 1000 by Bishop Bernward of Hildesheim as a three-aisled church with transepts and choirs at the east and west ends. The west choir over the crypt, Bernward's burial place, was altered, and the east apse was removed in the 14th century. The evenly balanced arrangement, with its similar east and west ends, gives a tight-knit appearance to the building from the outside (93). There are square towers over the crossings and at the ends of the transepts there are polygonal stair towers with rounded upper sections. The rational division of architectural space, based on clearly related and proportioned measurements, was used at Hildesheim for the first time. The square of the crossing, with its arches opening into the nave and transept up to the full height of the center aisle, gives the basic measurement: This module appears three times in the nave, and is stressed by square pillars, between each of which are two

rounded columns with arches (Saxon alternation). The side aisles are on a different scale, being more than half the width of the central vessel. The wall above the pillars, in contrast to Gernrode, is unarticulated, except for a string course above the arcade, and above that the clerestory windows. The galleries in the transepts were of a new type, called "angelic choirs" (95).

97 St. Cyriakus, Gernrode. View of the interior.

98 St. Pantaleon, Cologne. The new Benedictine abbey, built by Bishop Bruno, brother of Otto I (begun in 964, consecrated in 980). The church, made into a three-aisled edifice in the Gothic period, was originally single aisled, and the walls were articulated with blind niches containing windows. There was a transept at the east end that was not fully open to the nave but formed separate apsidal chapels. At the west was the last proper westwork to be built according to the Carolingian pattern, with a tower over the western crossing and deep porch flanked by stair turrets.

112

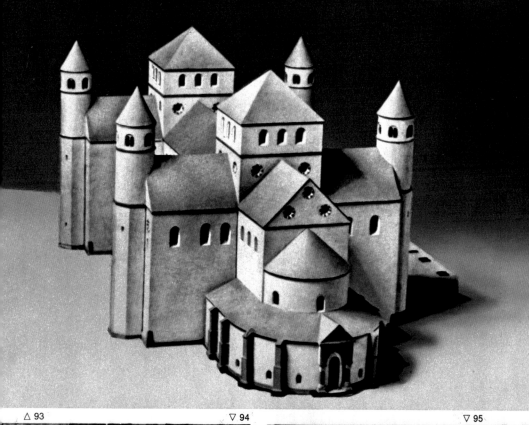

△ 93

▽ 94　　　　　　　　　　　　　　　　　　　　▽ 95

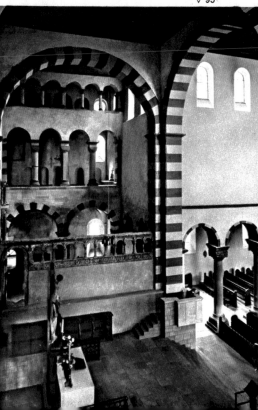

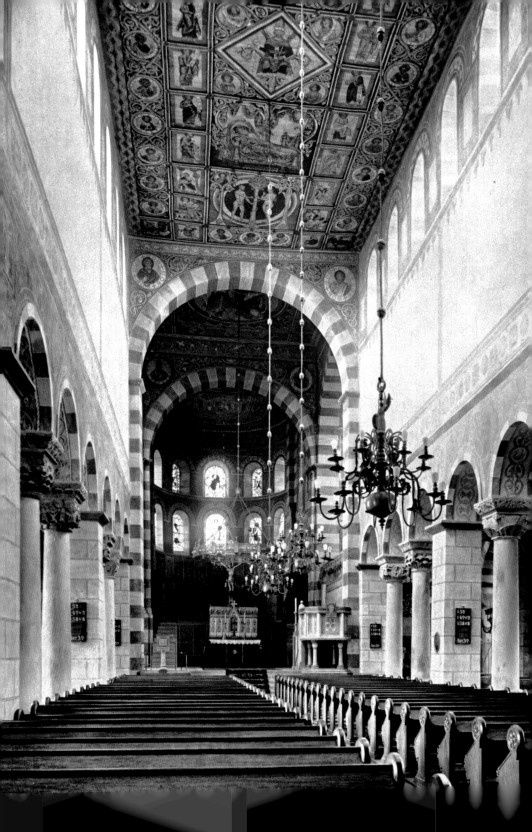

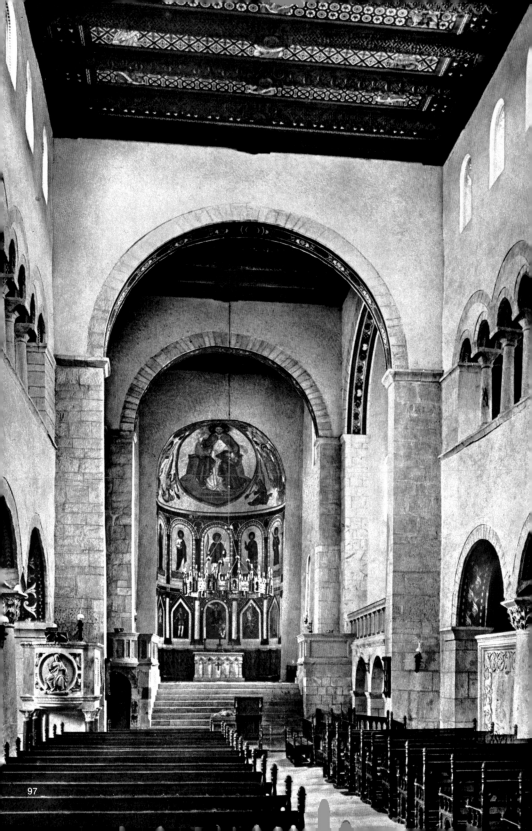

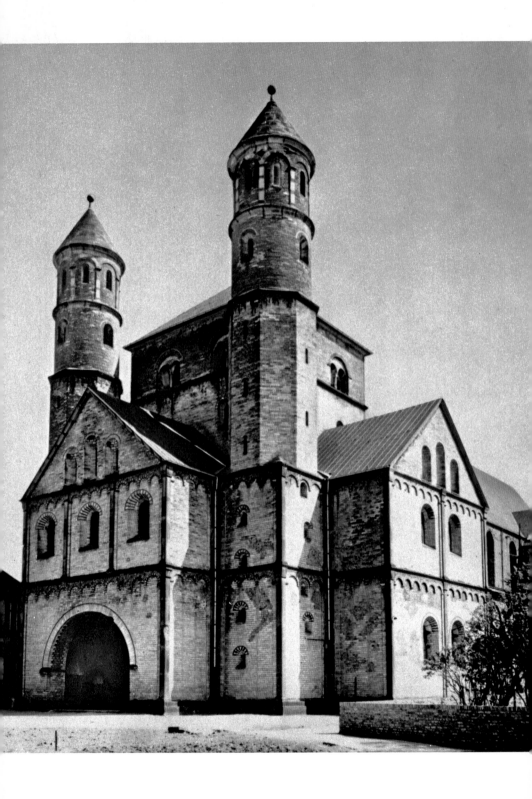

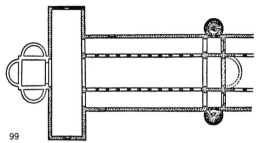

99

99 MAINZ CATHEDRAL. Ground plan. Built by
Archbishop Willigis after 975. The founda-
tions of the Ottonian building can still be
traced in the present cathedral, which was
built in the 12th and 13th centuries. The
ground plan is very similar to that of the
Carolingian abbey church of Fulda (25), a
three-aisled columnar basilica with west tran-
sept, and an east end with a central tower and
round stair-towers at each side. It is not
certain whether the original building had an
east apse.

100 PADERBORN CATHEDRAL. Tower over the west
choir. 11th century.

100

During the last quarter of the 10th century, moreover, a spiritual renewal took place
in Europe. The Cluniac reforms disciplined the monasteries and encouraged intellectual
and religious activity. Both the rebirth of the imperial tradition and the religious
revival influenced the realm of art, but for a time the continuation of the Carolingian
tradition under the Ottonian emperors was the more important factor; the Cluniac
reforms were felt later.

The new blossoming of the arts took place a century after the Carolingian era,
which had ended so suddenly with the deposition of Charles the Fat in 887. Carolingian
models still were available, but artistic aims had meanwhile radically, though gradually,
changed. Ottonian illuminators started off by copying Carolingian codices, and the
new mood did not at first come to light. As the political topography had altered, so
too had the location of the art centers. Places that had been on the outskirts of the
sphere of Carolingian influence and civilization were now at the hub of new activity.
Art around the year 1000 was a European phenomenon, with more marked differences
in regional styles, which were no longer tied to individual workshops. The threads were
more closely woven, insularity was, relatively speaking, at an end, and art had a
firmer foundation for development. Thus, a special kind of apocalypse illustration that
had been developed by Spanish Christians had an impact equal to that of Ottonian
98 developments and had as great an influence on future trends as the Anglo-Saxon

117

illuminations around the year 1000; the latter, in turn, derived from Carolingian and Hiberno-Saxon models. They were very important and, in their influence on the Continent, surpassed the Ottonian output. On the whole, the old Frankish workshops gave way to the new Ottonian, Spanish, and English syntheses, and Italy remained as before the source of classical form and arsenal of the late antique tradition.

The changed topography of art had its counterpart in the rapid growth of artistic means. For the first time major works were made in every field. Among the first pieces of monumental sculpture created were the Gero Crucifix (*134*) and the sculptural works commissioned by Bishop Bernward of Hildesheim (*135, 140, 141, 142*). But miniature painting was still the leading art form. It remained so until the 12th century, when in spite of increased production, it lagged behind the other arts, particularly monumental architectural sculpture, which it had so greatly influenced.

OTTONIAN ARCHITECTURE

The most important innovations in Carolingian architecture had been the westwork, the double choir, and developments and transformations in the basilican form, which were consciously adopted into the basic structure of Ottonian cathedrals.

The first building of this kind, commissioned by Otto I himself, was built in Magdeburg in 955: a three-aisled columnar basilica, probably with two transepts.

In Mainz Cathedral, begun about 975 by Archbishop Willigis, a trusted member of the imperial circle, the proportions of the great Ottonian building can still be detected (*99*). A direct relationship with Fulda is certain (*25*). Mainz Cathedral follows the same plan of a three-aisled columnar basilica with a large west transept. There is some doubt about the shape of the west apse.

The cathedral of Bishop Meinwerk in Paderborn (*100*), which was consecrated in

101 CONVENT OF THE HOLY TRINITY, ESSEN. (Minster.) A new church built for a Carolingian foundation which was probably begun under the Abbess Matilda at the end of the 10th century. The original west end has been preserved, but the nave has been altered. From the outside, the west end appears to be a westwork with a central tower and two side stair turrets, but, in fact, the west front is a rectangular adaptation of a west choir. Thus, there is here a mixture of two different traditions. The inside is clearly influenced by the Aachen Palace Chapel (*28*).

102 CONVENT CHURCH, OTTMARSHEIM, FRANCE. The convent was built in the first third of the 11th century and consecrated by Pope Leo IX in 1049. It is closely dependent on Aachen in plan and elevation: There is an eight-sided ambulatory around an inner octagon. At the west end there is an entrance tower, and at the east end a rectangular choir.

1

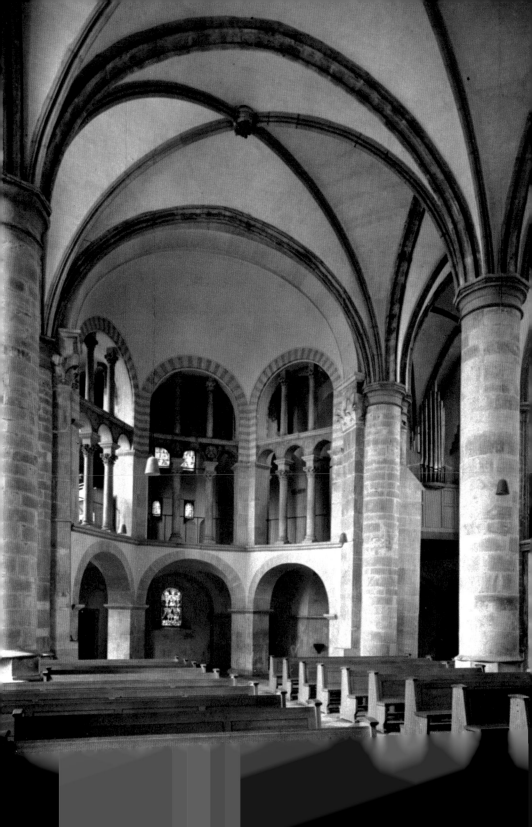

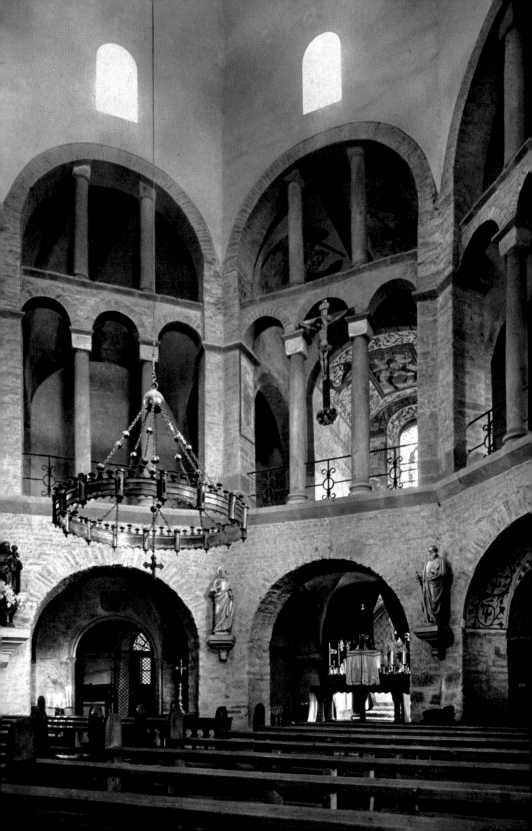

1015, also had a west apse, with two stair turrets, a rectangular front, and a giant central tower, in Carolingian style. (The minster at Reichenau-Mittelzell [Switzerland]—founded in the 9th century, enlarged in the 11th—has a similar west façade; a single-towered west end was indicative of a later parish church.) Strasbourg Cathedral, which was begun in 1015, was also in the tradition of Fulda and Mainz; parts of the original crypt are still intact.

One of the oldest large buildings of the Ottonian era that has been preserved is the convent church of St. Cyriakus in Gernrode, Saxony (*88, 91, 92, 97*), which was founded by the Margrave Gero; later the enterprise was continued under Otto II and his Byzantine wife, Theophano. It is a three-aisled basilica with a continuous transept, a square chancel, and an apse, and has a fairly new interior construction. There are double arcades between pillars, supported in the middle by columns. Above these there is a gallery that shows a Byzantine influence: six double arcades open into the central nave. At the west end there are two round stair towers at the ends of the side aisles, between which was originally a straight wall. The hall crypt at the east end was the first of many (in Germany).

About the year 1000 a building was erected whose carefully calculated measurements and proportions and quite un-antique conception of space differed from anything that had previously been built. The church of St. Michael at Hildesheim (*89, 90, 93–96*), built by Bishop Bernward, was basically a three-aisled basilica with west and east transepts and polygonal towers with rounded upper stories at the ends of these transepts. There are square towers over the crossings. The east choir, now destroyed, had the form of a short chancel with an apse, and there were also two side apses on the east walls of the transept. The west choir, much altered, stands over a hall crypt, where Bernward is buried.

St. Michael in Hildesheim is still a building compounded of different parts, in Carolingian style, as can be seen from the sharply defined construction of each area, but the "additions" follow a system that determines the proportions of various parts. Nave and transept have the same width and height (the ratio of height to width is approximately 2:1). The crossing, where the spaces merge, is equally open on all sides and square in plan. This "separate" crossing, therefore, belongs to both nave and transept equally, and forms an independent unit of space. This was a significant innovation. The size of the crossing is the basic measurement, and the nave is three times as long. St. Michael represents the first systematic division of space, with the whole reflecting the size of the various parts. The plan of the monastery at St. Gall (*21*) had previously shown an attempt to relate the proportions of the various parts, but the plan had not been executed. The rule was not slavishly followed at Hildesheim, and the formalism that would have been the logical conclusion was avoided. The side aisles are more than half the width of the central aisle. With their low flat ceilings and

columns deep into the transept walls, they are also to some extent divided off from the nave.

Marking the corners of the squares of space on the plan with pillars was also an innovation. They strengthened the systematic design. The three arches between the pillars in the nave were supported by columns. This arrangement—pillar-column-column-pillar—is called Saxon alternation. It served further to enhance the clarity of the whole. (The alternating square and cylindrical supports have been preserved partly in their original form.) The cubic capitals, which are a combination of cube and half sphere (94), were used at Hildesheim for the first time. They make a logical bridge between the spherical columns and the square base of the arches.

Above the columns runs a cornice, and in the unbroken wall above (which one must imagine as painted), there are clerestory windows that are not aligned with the columns below. The nave has a flat ceiling.

One important result of this design is that the nave, because of the arrangement of supports, has three segments, although it is not actually divided into separate spatial compartments. The flat upper walls and flat ceiling create the impression of a single spatial unit. Another feature found at Hildesheim for the first time are the transept galleries; these were set above the double arches of the ground floor in two stories, with four arches over the two on the ground floor, and six above those (95).

The function of the westwork, which was to add a feature from a noble's private church to the Roman type of basilica, thus making visible the "double polarity of the City of God" (G. Bandmann), was gradually taken over by the second choir, usually at the west end. Westworks, however, continued to be built in the Ottonian period. A church based on Corvey was built at Minden (Westphalia). Consecrated in 952, it was a three-aisled pillared basilica with a triple-towered westwork, which was later, after the middle of the 12th century, converted into the closed form of gabled west end. We know of the original form of this church only through excavations. Later triple-towered structures, which continued to be popular in Saxony, were reduced versions of this type of building, usually with only one gallery over the narthex.

St. Pantaleon in Cologne (98) has a real westwork. The original single-aisled nave with blind arcading had the cell-like kind of transept and a semicircular apse at the east end, and a westwork with its own altar. On the exterior of the church there is interesting blind arcading between the stories, a feature that would become of great importance in the subsequent architectural style called Romanesque.

Churches directly descended from the Palace Chapel at Aachen were Ottmarsheim, consecrated in 1049 (102), an octagonal central-plan church with an entrance tower, St. Nicholas's Chapel in Nimwegen, built in the middle of the 11th century (a central octagon with sixteen-sided outer wall with two-storied ambulatory), and the west end of the convent of the Holy Trinity, Essen (101), which was built between the end of the

10th century and beginning of the 11th. The ground plan of the west end of the latter forms a half-hexagon. It is possibly a mixture of westwork and west choir, since the west end opens onto the nave in a large gallery, and the polygonal shape is built up to a rectangular shape on the outside.

OTTONIAN PAINTING

The number of tolerably undamaged frescoes that have survived from the Ottonian period is very small. The cycle in the church of St. George at Reichenau-Oberzell (*127*), which was probably painted in the last quarter of the 10th century, can only give us an idea of all the others. It is, however, one of the most important works of the period. The frescoes show miracles performed by Christ and are painted in a large format, in epic style. Cycles of this kind were in the tradition of fresco painting and had not often made an appearance in illuminations; it was not until the Ottonian period, about the time the St. George frescoes were made, that illuminated manuscripts began to include the stories of miracles and other narrative scenes from the Gospels. This presupposes a use of models from similar cycles in manuscript illumination from the 5th and 6th centuries. In wall painting, on the other hand, especially in the Alpine districts, there appears to have been a continuous tradition of painting of this sort from the time of the Italian works of the 6th century. The St. George frescoes are a further example in the line that also includes the 9th-century fresco at Müstair (*76*), which was based on pre-Carolingian southern patterns that had no counterpart in the art of the court school. The Reichenau frescoes are certainly of a higher artistic order than their provincial precursor in Müstair. They are also "Ottonian": clearly arranged, with the stress on the climax of the story and a new type of neutral background composition. There are fewer illusionistic elements, and the space serves above all as a stage for the figures. The landscape background has been replaced by colored horizontal stripes, and the figures stand on the bottom layer, or ground. Buildings are reduced to signs. They do not define an illusionistic *space,* but signify the *place* of the event. The whole *mise-en-scène* of figures and scenery serves to enhance the importance of the figure of Christ, who dominates the composition with his healing and miraculous glance and gestures. The border is as interesting as the picture proper: These epic paintings are linked at the bottom with a strip of meander decoration painted in perspective, which, with its effective coloring, architectural construction, and precise rhythm, is one of the most delicately executed pieces of Ottonian painting.

The narrative scenes in such manuscripts of the period as the Codex Egberti (*104*) and subsequent cycles have the same concentration on expression and gesture, and here, too, backgrounds are more abstract. But one cannot deduce from the Reichenau

frescoes that there was a workshop executing illuminations there. Fresco painters were travelers who carried out a job and went on their way. Frescoes at the neighboring St. Sylvester's Chapel at Goldbach near Überlingen show a style similar to the Reichenau frescoes. They are in poor condition, but they were probably painted toward the end of the 10th century. The figures, as in the manuscripts, are harder, sharper, and more metallic in style. The cycle contains miracle scenes, portraits of the apostles, and portraits of patrons.

Less important, but interesting as additional examples, are the frescoes at the church of St. Andrew, Neuenberg (near Fulda), which were painted some decades later. These are a few of the fragments of paintings remaining in the north. There are not many more in Italy. The frescoes in S. Pietro in Civate, near Como, tower above all the others. The famous Battle with the Dragon (see A. Grabar and H. Schrade) alone confirms the importance of fresco painting and reveals its special qualities, particularly the link with architecture. This work, which fits the round arch both in form and content, belongs to the genealogy of Romanesque carved tympana in Languedoc (France).

103 St. Bartholomew's Chapel, Paderborn. Built in 1017 by Bishop Meinwerk, "with Greek builders." The only church of its kind in the west of Europe: a three-aisled hall church, with the aisles separated by columns. At the same time, it has the appearance of a central-plan church, since each compartment made by four columns is vaulted by a dome on pendentives.

104 The Deposition and Burial of Christ. Codex Egberti. Trier. c. 980. Stadtbibliothek, Trier. Cod. 24, fol. 85, verso. The painting belongs to the first great narrative cycle of the Ottonian era. It follows a pre-Carolingian, late antique tradition. The clear, cool forms of the figures and the subtlety of the details are new, as is the concentration on facial expressions and gestures.

105 Otto III (?). Aachen Gospel book of Otto III. Trier. c. 1000. Domschatz, Aachen. Fol. 16, recto. A complicated painting, rich in allusions. The Emperor sits enthroned like Christ in a mandorla, surrounded by the symbols of the evangelists, and crowned by the hand of God which appears at the apex of the picture. The throne of the imperial and Christlike ruler is born aloft by Earth in the attitude of

Atlas (see 51). The scroll-like fabric held by the four evangelical creatures refers to the four Gospels. On the opposite page is a painting of Liuthar, who is giving the book to the Emperor, and the inscription *Hoc Auguste Libro Tibi Cor Deus Induat Otto* ("May God invest your heart with this book, Otto Augustus"). Two kings make obeisance near the mandorla, and below are two warriors and two monks.

106 St. Matthew. Aachen Gospel book of Otto III, fol. 21, verso. Matthew is writing—a tall, slim, elegant figure in a thoughtful attitude. An angel places a scroll with writing on it around his halo: This is the Gospel according to St. Matthew, the spoken word of the angel who has inspired him. It is a variation on the theme of inspiration through the vehicle of the nimbus. All differences of style to one side, this miniature is related to pre-Carolingian, Hiberno-Saxon concepts. (Compare this with the Lindisfarne Gospels miniature, 19.) The painterly Liuthar style is a development from the style of the Master of the Registrum Gregorii and that of similar manuscripts.

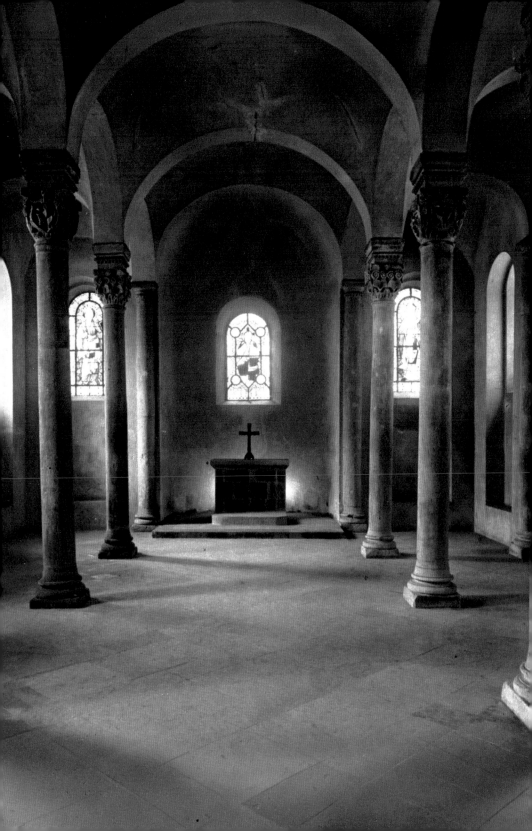

IOSEHP NICODEMUS

HORTUS

NICODAMUS · Z · IOSEHP

104

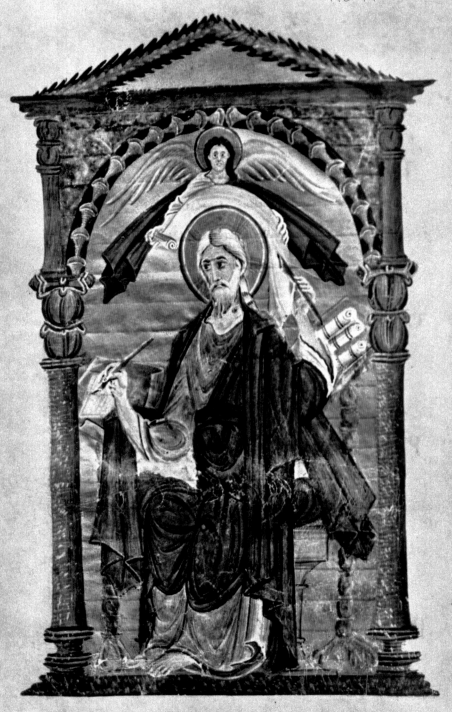

Much more has come down to us in the field of Ottonian manuscript illumination. As in the Carolingian period, it was the focal point of artistic development. At first the artists concentrated on copying Carolingian masterpieces. From the start these works were used as prototypes and models, providing the raw material for new trends and serving as a quarry of useful motifs. But the original rationale of composition vanished. Thus, in the Gero Codex (*118*), a copy of the Lorsch Gospels of Charlemagne's court school (which was then at Lorsch; now the two parts are in Rome and Bucharest; *117*), the structure of the illuminations has lost its equilibrium. The order of the architectural framework has been destroyed, and the figure of Matthew, for example, stretches up into the zone within the arch; the prototype has been misunderstood. New trends were being formulated, but were as yet still uncertain.

It is dimly recognizable from the Gero Codex that there existed a new concept of figures and composition, and this can be seen unmistakably in other works; in the Codex Egberti (*104, 107*) and the Sainte-Chapelle Gospels (*119*), both from the workshop of the Master of the Registrum Gregorii, one of the greatest artists of the end of the late 10th century, and then in the Liuthar group of manuscripts.

The Liuthar group was formerly thought to have been executed at Reichenau, as were the Gero Codex and those parts of the Codex Egberti not associated with the Master of the Registrum Gregorii at Trier. There has been considerable argument about the localization of the earlier work in recent times, and much is veiled in uncertainty. Reichenau is almost a sacred concept: When speaking of Ottonian illuminations, people refer to the Reichenau style. The difficulty lies in the fact that the whole Liuthar group of manuscripts was considered as the product of Reichenau, while the Master of the Registrum Gregorii, who was important for this group, worked at Trier. The Codex Egberti, as can be seen from the title of the dedicatory illumination, was produced by two Reichenau monks, but Carl Nordenfalk has shown that some of the paintings are the work of the Master of the Registrum Gregorii. The Codex Egberti was produced for the Archbishop of Trier, Egbert. It is also an indisputable fact that the Master of the Registrum Gregorii painted a portrait of the emperor (*109*) that was one of the recurring models for the Liuthar group of manuscripts.

James Dodwell has solved the problem conclusively. He maintains that there is no real proof that there was a school of painting at Reichenau, but a good deal of proof that there was a workshop at Trier. The key work, the Codex Egberti, was probably executed at Trier. One of the arguments for Reichenau as the place of origin of the Liuthar manuscripts was their similarity to the Codex Egberti, which was thought to have been painted there. If this was *not* the case—and Dodwell's argument appears irrefutable—then all the other points in favor of Reichenau can be disposed of and there seems no reason to suppose that there was, in fact, a school of

painting there. Most of the works can then be taken to have originated in Trier, where most of the more important models were to be found, and to have been executed in those monasteries most closely associated with Trier and Archbishop Egbert.

So many works belong to this very varied "Trier group" that one must conclude that some of them did indeed originate in other workshops. The Gero Codex (*118*), formerly attributed to Reichenau, does not belong to this group. It has little in common with the other major works, and Dodwell suggests that it was executed in Lorsch, where the manuscript on which it was modeled was to be found. A simple solution that holds water is preferable to a theory overburdened with hypotheses. There is much to support Dodwell's theory and nothing to contradict it.

The style of the Master of the Registrum Gregorii, who also worked on the Codex Egberti and in whose circle the important Sainte-Chapelle Gospels (*119*) originated, is easy to identify. The most important works of this master from Trier are two originally facing pages from the Registrum Gregorii, a portrait of Pope Gregory the Great (*108*), and a portrait of an emperor (*109*). Pope Gregory sits enthroned under an arcade near the center of the miniature, and is listening to the words of the Holy Spirit, who sits on his shoulder in the shape of a dove. He is dictating. A scribe sits behind a curtain, to preserve the secrecy of the Pope's inspiration; but he is curious and uses a pause in the dictation to open a hole in the curtain and see what is going on. Legends of this kind were not uncommon; secrets breed curiosity. Curiosity of the kind shown here had a double significance: It represented a frivolous attempt to discover hidden secrets, but also served to provide an eyewitness. The inquisitive man who had seen it could testify to the truth of a miracle.

The role of the architecture in this miniature is interesting. It is the image, in shorthand, of a church. It is a symbol of a real church and a reference to Ecclesia, whose center is the Pope. It also indicates his rank. But the symbolism was not clear enough; it was necessary to have a framing arch to denote his majesty. An arch was therefore included in the architecture, blended into, or developed from, the existing shapes. A meaningful frame has been made for the central figure within the composition, and this, of course, is the opposite of the method of the Carolingian court school. There, the symbolical architecture was always *inside* the arch.

This miniature can be regarded as the true beginning of Ottonian painting because, although there were forerunners, nothing can compare with it for the precision with which the artistic means have been formulated and because it was influential at the time. The artists at Cologne were influenced by it, and the trend culminated there in the second phase of the Cologne workshop, with such works as the Gospels now in the Priesterseminar in that city (*122*).

In the Liuthar group one finds the same arrangements of architecture and architectural frames again and again in the paintings of narrative scenes, and also the com-

bination and doubling of elements, so that inner arcades and outer framework correspond. There was a continuation of some of the methods of the Master of the Registrum Gregorii in the Liuthar group (*111*).

The portrait of an emperor from the Registrum Gregorii (*109*), with its baldaquin architecture, was directly copied in the major work of the Liuthar group, the Gospels of Otto III (*111*), and in a fragment at Bamberg. It is significant that the architecture in the Pope Gregory miniature is meant to be a church (*108*), whereas the baldaquin of the emperor represents a centrally planned building, of which the four pillars (only three are shown) are the world. These are complemented by the four parts of the kingdom rendering homage, each bearing a sphere as symbol of the imperial orb, the token of the ruler of the world. There is also an echo of the Venerable Bede's view of the universe in the baldaquin architecture, and its meaning is related to that of the real architecture of the Palace Chapel at Aachen.

A manuscript that has much in common with these two pages from the lost codex, but which is also dissimilar in many ways, is the Codex Egberti (*104, 107*), executed by different, clearly discernible hands. One of the artists was the Master of the Registrum Gregorii. The workshop was a highly developed one, with a rich store of models from long-forgotten manuscripts in the late antique tradition upon which to draw. The dedicatory painting showing two monks from Reichenau handing the book to their patron Egbert is distinctive, as are the miniatures of the evangelists (*107*). There are precedents for the flat screenwork backgrounds—for example, the miniatures in the Egbert Psalter in Cividale, in which one can clearly see traces of Carolingian and pre-Carolingian figural styles handed down via St. Gall. The ornamental background of latticework could have been used in bronze and iron decoration.

Another work that influenced the Codex Egberti was the Poussay Gospels from St. Gall (Paris, Bibl. Nat. lat. 105/4), a late 10th-century work in the tradition of the Ebbo Gospels. Here, in line with the Ottonian tendency, architectural and landscape elements have disappeared or are reduced in scale. The cosmological meaning is not so important, and the symbols of the evangelists point down diagonally from the corners of the paintings into the picture from a zone outside the framework. This motif was picked up by the Cologne school and also by the Salzburg workshop. In the Codex Egberti, with its greater emphasis on symmetry, there was a further development. The inspirational being descends directly over the figure of the evangelist from the center of the upper frame. This can most clearly be seen in the miniature of St. John (*107*), whose stiffly upright figure parallels the arrowlike descent of the symbolical eagle. The evangelist's eyes are fixed and staring, unearthly and compelling. The intense glance of these evangelists of the Codex Egberti was repeated in the manuscripts of the Liuthar group and was characteristic of them, especially of the evangelist miniatures in the Gospels of Otto III (*113*). Its precedents, however, are found

in late antique works—for example, the colossal 4th-century portrait of Constantine in the Palazzo dei Conservatori in Rome. Even more closely related are the wide-open eyes of the evangelists in Hiberno-Saxon illuminations (*17*) and of similar figures from St. Gall.

The Liuthar group of manuscripts contains the works that are the most characteristic of Ottonian art. They represent the highest flowering of art and thought, giving visual form to the symbolical concepts of the era. One of the manuscripts in this group is the Aachen Gospels of Otto III (*105, 106*). The so-called Liuthar group to which it belongs includes a Commentary on Isaiah, a Daniel manuscript (*110*), and a troparium, three works now in Bamberg (originally the Munich codices Clm. 4452, Clm. 4454, and Clm. 4453, also named the Gospels of Otto III, were in Bamberg as well). At the end of the series comes the Bamberg Apocalypse (*114*). Additional manuscripts are connected to the group, for example, the Codex Barberini in Rome (Bibl. Vat. Barb. lat. 711), which helps to elucidate the meaning of the Gospels of Otto III, and the later, compilatory Gospels from Limburg in the Cologne Cathedral library. These and a few other works, with the earlier codices of Egbert, form an interrelated group.

For some of the paintings of evangelists in this group, the Sainte-Chapelle Gospels (*119*), on which the Master of the Registrum Gregorii worked, served as a model, and the group certainly led directly to the stiff magnificence of the Echternach workshop products. Then again, the trends of this group mingled with those of the Cologne school, where the style begun by the Master of the Registrum Gregorii blended with the more painterly style of the Cologne workshop. The fields of influence were now wider than in the Carolingian period, and stylistic changes spread more rapidly, partly because of the greater number of traveling artist-monks and workshops. Regional styles thus developed without difficulty and they spread over larger areas than the isolated workshops had done.

Thus, "Liuthar group" denotes a complex range of works; it is a convenient term, describing an artistic development unparalleled in the early Middle Ages. It is characterized by various features that remained fairly constant from the Aachen Gospels to the Bamberg Apocalypse. And among the different styles and developments one can pick out various definite phases.

The style of the Aachen Gospels of Otto III is characteristic of the first phase: fine, delicately drawn, elongated figures (*106*) and rich, painterly nuances of tone, which, with their watercolor-like transparency, serve to enhance the elegance of the figures and do not blur the precise drawing or the contours. We find an assured grasp of pictorial aim and a keen imagination. Although they sometimes appear absurd and fantastic, the symbols were carefully chosen to embody certain complex abstract ideas and were not intended to represent reality. Thus it many seem strange that the evangelists in the Aachen Gospels of Otto III have scrolls around their halos,

held by their symbols behind them and grasped by the evangelists themselves. The highly material parchment scrolls serve as the symbol of something immaterial, the Word. There had been many precedents for denoting inspiration by showing the halo being touched. The St. Luke page in the Würzburg Gospels (40) was one of the most dramatic, but there had been earlier examples in Hiberno-Saxon works; there were also miniatures showing the symbols of the evangelists behind and above the nimbus, as in the Lindisfarne Gospels (19). The changing degrees of reality closely follow the Hiberno-Saxon tradition, as handed down by such monasteries as St. Gall. Details of this sort were developed in the Gospels of Otto III.

One of the most interesting miniatures in the Aachen codex is the one depicting an emperor (probably Otto III) with the attributes of the Cosmocrator, surrounded by a mandorla (a symbol of the universe as well as an attribute of Christ) and by the symbols of the evangelists, the visible signs of likeness to Christ and of lordship over the world (105). The symbols also carry a scroll of fabric that implies, as the inscription on the opposite page indicates, that the all-powerful emperor bases his rule on the gospels, the book that "invests his heart." Many of the details of this unusual work can be traced back to Carolingian or, more precisely, Tours school models, and to the miniature of Charles the Bald in the Moutier-Grandval Bible.

The mandorla was not only the attribute of Christ, however. It had had several meanings in Carolingian times, including a cosmic symbol and "space around the figure," and these were carried over into the Ottonian era, when variations became even more numerous and complex. Thus, a round mandorla surrounds the two Fathers of Music in the Bamberg troparium; one, Jubal, represents instrumental music, and the other, Boethius, vocal music, both forms of sacred music together representing the harmony of the spheres. The inspirers of heavenly music hover in another round mandorla as cosmic apparitions above the musicians and singers. Both pictures are related to the David as a Cosmic Musician (*Rex et Propheta*) of the Bible of Count Vivian (67). The symbolism is more generalized, however, and from the mandorla of Boethius rays fall upon the singers, resembling the inspiration of the Holy Spirit in Ottonian Pentecost scenes. There the rays come from concentric circles, symbols of the cosmos and of the harmony of the spheres; the same symbol could serve for vocal music and the inspiration at Pentecost, for a sung text and the gift of tongues of the mission of the apostles, at one and the same time. Abstract concepts for which pictorial signs already existed in another context could thus be represented. The symbols in Ottonian illuminations are as numerous as the "real" objects and serve to convey swiftly and clearly the analogies and formulas. They also allowed for a certain freedom of thought within the limits of a world view based on the process of salvation.

The Commentary on Daniel contains several illuminations rich in fantasy, such as

the initial letter showing the Inspiration of Daniel (*110*), a flowerlike, twining design in which Daniel sits with his angel. The inspiration of the prophet is a continuation of an ancient theme—inspiration through the muses, through Athena or Sophia, and through the angel of St. Matthew. In the Ottonian era, initials became as important and varied as they had been in the pre-Carolingian period. (In Carolingian art they had seldom been the subject of such complex designs, although the Drogo Sacramentary [Paris, Bibl. Nat. lat. 9428] is an exception.)

In works of the following phase of the Liuthar group these traits were developed—and conventionalized in the miniatures of evangelists in the books of Pericopes—but, on the whole, linear treatment became more defined and the color less subtle. Contrasts became harsher, contours sharper and more metallic, the colors flatter, the whole effect harder and less spatial. Softer tones disappeared. The feeling for form remained, however, and treatment of the figure was the same, indeed more accomplished. The paintings tended to be divided into two layers—an action- and figure-filled foreground

107 St. John. Codex Egberti, fol. 6, recto. An upright figure with eyes fixed in a rapt, piercing gaze, against a flat screened background. The composition is a synthesis of elements used before. The throne of the evangelist is the one found in Rheims or Tours manuscripts; the staring eyes have been seen in Hiberno-Saxon illuminations. The figures in the latter were different, but there was probably a direct influence from that quarter via St. Gall. There are other post-Carolingian styles at work here as well. The gaze is the leitmotiv of the workshop.

108 Gregory the Great. Page from the Registrum Gregorii. Trier. c. 983. Stadtbibliothek, Trier. The Master of the Registrum Gregorii, one of the most outstanding artists of the Ottonian era, also worked on the Gospels of Sainte-Chapelle and the Codex Egberti. His style can be recognized by its draftsmanlike precision, clarity of composition, and cool, light coloring with an unusual subtlety of nuances. The role played by the architecture is interesting: It is representational and also forms a symbolic frame for the figure of the inspired Pope, so that the large arch

becomes a frame within the painting. This idea of an inner frame to betoken majesty, built up from representational architectural elements, was further developed in the second phase of the Cologne school (see *122*).

109 Emperor. Page from the Registrum Gregorii. Musée Condé, Chantilly. Originally, this was the page opposite the Gregory miniature (*108*). Together they represent spiritual and worldly power. The Emperor sits enthroned with the insignia of his rank—crown, scepter, and orb—under a baldaquin, surrounded by the figures personifying parts of his realm: Germania, Alemannia, Francia, and Italia. Adaptations of this design were used twice in the Liuthar group of manuscripts (*111*).

110 Inspiration of Daniel. Daniel Commentary. Trier (?). c. 1000. Staatsbibliothek, Bamberg. MS Bibl. 22 IIb, fol. 32. An unusual combination of the initial 'A' with a scene showing the inspiration of a prophet, linked by ornamental motifs. The concept is typical of the early Liuthar manuscripts. The painting is also closely related to the Aachen Gospels of Otto III (*105, 106*) in composition, coloring, and linear drawing.

1C

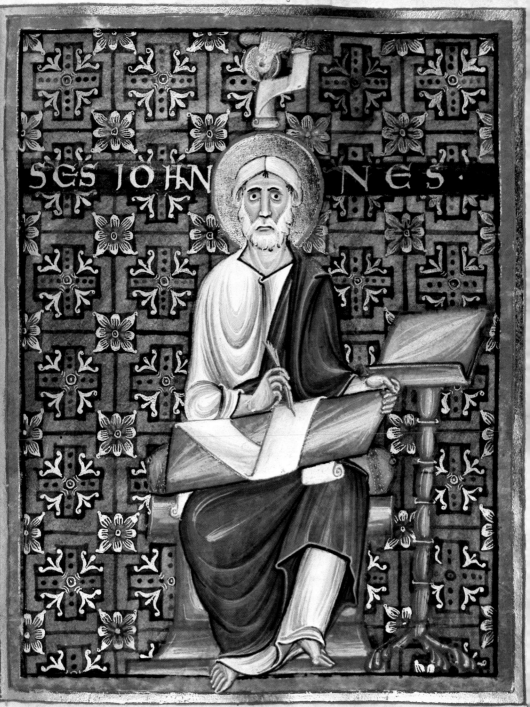

SCS IOHANNES.

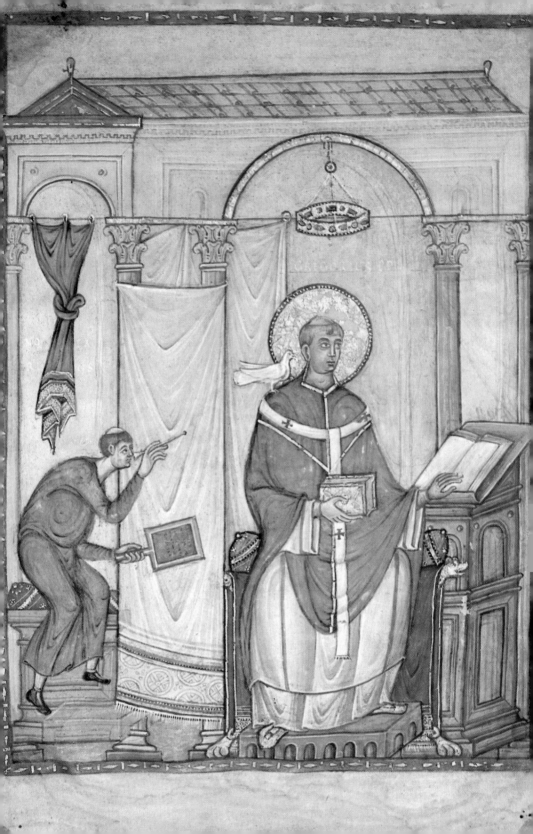

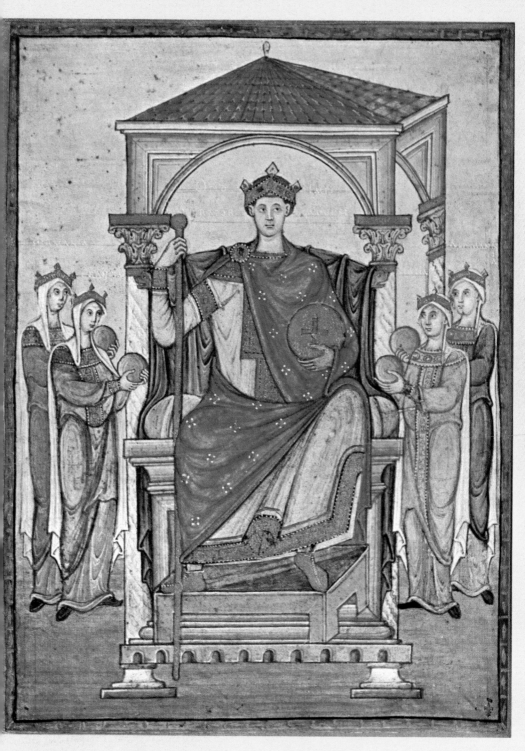

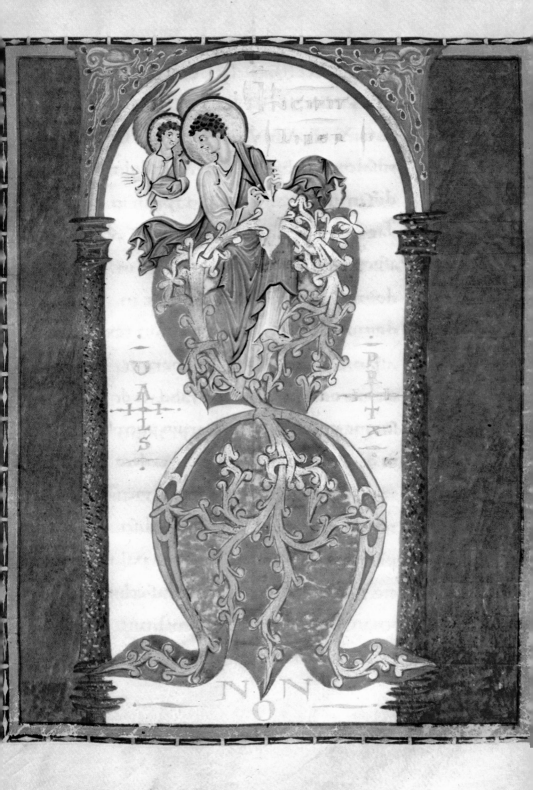

blending with a less defined background, which was no longer illusionistic but reduced details of space to signs. This led to a preponderance of gold grounds, as the monochrome glitter aptly represented an abstract, sacred, and objectless space. The culmination of this trend can be seen in the Bamberg Apocalypse (*114*).

The increased hardness of outline and the brightness of color is manifest in a comparison of the miniatures portraying the emperor from the Registrum Gregorii (*109*) and the Gospels of Otto III (*111*). In the cycle of evangelist miniatures in the latter book one sees Ottonian art at its most characteristic, and the painting of St. Luke is its culminating point (*113*).

The illuminations in this cycle have often been discussed in terms of their bold and imaginative combination of symbols and their expressiveness. The evangelists in the miniatures have been described as "visionary," an allusion to the power of their eyes, which seem to see as an outside picture what is behind them. The paintings are strange—the product of Ottonian thought expressed in formulas that were not usable either earlier or later. Descriptions, controversy, and interpretations abound (the most recent: K. Hoffmann). The illuminations were influenced by Carolingian attempts to portray the four gospels as one (the Adoration of the Lamb and the Fountain of Life from the St-Médard Gospels and also the various canon tables). The forms of the mandorlas in the Otto Gospels represent their fourfold unity. That the evangelists are Christlike figures is corroborated both by the inscriptions and the scenes at the bottom of the page (*113*).

The analogy is not with Atlas figures here, although the idea is one that does occur in this group of manuscripts—in the Codex Barberini, for instance. What Matthew, Mark, and John are touching and Luke is bearing aloft with his arms outstretched are visionary scenes composed of revolving clouds in which appear busts of prophets with the evangelist symbol in the center (*113*). The clouds have several meanings here. They are a symbol of Epiphany, of the cosmic manifestation, which is also indicated by the busts of the prophets. The whole scene implies the unity of the Old (prophets) and New (symbols of the evangelists) Testaments and of the four Gospels.

The expression and gestures of the saints, the identification of the evangelist with a vision above him, and the symbolic beings had earlier been attempted in the Aachen Otto Gospels, in the Codex Egberti, and in the Book of Kells, and the manifold meaning of the mandorla was not new. The evangelists appear as the four manifestations of the Word, of Christ as Cosmocrator, and this they had been in the past.

The last major work of the Liuthar series was the Bamberg Apocalypse (*114*), which presents the vision of St. John in a flat, symbolic fashion enhanced by the use of gold. With this cycle the possibilities of the style were exhausted. The basic patterns were used widely and handed down, but not radically altered or developed. The colors remained intense, flat, and sharply contrasted. Late antique and Carolingian

illusionistic technique was ignored. Lacking corporeal reality, the figures were reduced to vehicles of gesture and expression. In place of the springy lightness in the earlier works, the contours have a stiffer and harder, almost static quality.

At no time was early medieval art further from the classical ideal, or more unreal, abstract, and determined to represent that which cannot be portrayed. In the following decades this extreme position was very rapidly abandoned, for it had only come about as the result of unusual concentration, in special circumstances.

Echternach was an offshoot of the Trier workshops. The miniatures of evangelists in the Echternach Gospels (*120*) derive from the Gospels of Sainte-Chapelle (*119*). The more magnificent manuscripts of this workshop are characterized by great richness and luxury of decoration and expert use of existing symbols, with few innovations. They are more "imperial" than any others but less intellectual, and therefore more representational and less speculative than the Liuthar group. Symbols of ecclesiastical rank and the use of architecture to represent hierarchical structures "churchify" the contents of the paintings.

The Regensburg style of illumination (*121*) is clearly distinguishable from the other Ottonian styles. This workshop concentrated on the geometrical designs that had been developed at Tours and adapted them in an artistic, screenlike net of circles, diamonds, squares, rectangles, and arcs to form an allegorical system in which the geometrical elements supplied all the major features of the composition and visual references, combining biblical with cosmological symbolism. It was—as Georg Swarzenski has pointed out in his great text on this workshop—pictorial scholasticism.

During this period a network of workshops stretched from Salzburg to Bremen— older ones still active and new ones that quickly reached an average degree of competence. The more extreme schools characterized above were highly inventive. Curiously, the scriptorium at Hildesheim had a very middling output, considering the importance of this center in the fields of architecture and the plastic arts.

The Cologne productions were the only ones to equal the Trier group and the Liuthar group. Although dealing with the same themes, they provide a sharp contrast. One can compare the relationship between the styles to that which existed between Charlemagne's court school and the Rheims workshop productions. The roots of the difference lie partly in the choice of prototypes: Every Ottonian workshop picked up the style of a Carolingian one; while adding other elements and adapting the style to their own purposes, the groups' endeavors were guided by the style of the chosen school. Nevertheless the various workshops were linked by a common preference for narrative paintings, and all worked to increase the range of themes and allegorical possibilities.

This increase in the range of subject matter is quite clearly reflected in the manuscripts by the Cologne artists. Their work is differentiated by its painterly style. A typical work, and the masterpiece from that city, is the Hitda Codex (*116*). The colors are

strong and luminous: vermilion, greens, blue and yellow, and, less frequently, such in-between colors as ocher and brown; the colors dominate and form strong contrasts. Areas of white, slightly shaded at the edge, are used to link areas of color. The paint is applied thickly, without too much attention to the outlines. There are few geometrical or architectural details in the composition and there is no architectural framework; the miniatures are given panel-painting frames, following the Carolingian tradition of using this kind of framework to define landscape, space, and the non-architectural content. The colors form holes, make divisions, fold into one another, and the figures overlap the frames as if coming in from outside the painting, so that the various areas do not make up a rigid illusionistic whole but flow around the figures, separating them from one another and at the same time linking them together. This is a continuation of the technique used in the Ebbo Gospels and the Utrecht Psalter. The composition is determined by the moving figures, forming their aura as a continuation of the nimbus, and providing a special zone in which the action can take place.

In the succeeding phase of Cologne painting this technique was abandoned, but there was a skillful development of the interplay of frame and architecture. When the symbolic being cuts across the frame that surrounds an evangelist, the artist is indicating that something is entering the evangelist's territory from another sphere not more exactly defined in the painting. Figure and frame form a definite unit, and the supernatural being breaking in from outside finds himself at the same time outside the frame that defines this terrestrial space.

In this next phase the center was at its zenith, with such works as the Gospels in the Cologne Seminary (122). In the Luke miniature the painted frame surrounds an architectural composition that clearly represents a church. One of the large arches in the center has been made into an inner frame around the figure of the evangelist, who sits enthroned. His appropriate symbol appears from a window, cutting across cornices and pushing under the edge of the roof and gable in a most unusual way, with no regard given for his traditional cosmic significance, which is here invested in the church building.

111 PORTRAIT OF THE EMPEROR. Gospels of Otto III. Trier (?). c. 1000. Bayerische Staatsbibliothek, Munich. Clm. 4453, fol. 23, verso. This miniature of the Emperor with dignitaries makes a pair with the miniature on the opposite page showing the provinces paying homage. Its prototype is the emperor miniature in the Registrum Gregorii (*109*). The flatness of the architectural structure is a further development from the pope miniature (*108*). The greatest change is in the colors: They are harder, colder, flatter, and more contrasting; instead of the subtle sureness of touch of the Master of the Registrum Gregorii, we have here a more stylized and regimented approach.

112 THE WASHING OF THE FEET. Gospels of Otto III, fol. 237, recto. The Ottonian development of the narrative scene and dramatized figures culminated in paintings of this kind. As with the emperor miniature, the architecture is interesting: Pillars and architrave frame the figure of Christ. His centrality is also stressed by the gold leaf. In the heavenly zone there is an elegant model of the Heavenly Jerusalem, an interesting Ottonian mixture of antique and "inverted" perspectives.

113 ST. LUKE. Gospels of Otto III, fol. 139, verso. The visionary evangelists of this codex are among the most scholarly and symbolic expressions of Ottonian art (K. Hoffmann). The evangelist here is seated like Christ in a mandorla and gazes out with a piercing expression. His arms hold aloft various spiritual symbols: His ox is in the center of the overlapping cloud circles, and around it are busts of the prophets David, Nehemiah, Nahum, Habakkuk, and Zephaniah, with rays of light shining forth from them. This is thus a double vision, with the evangelist himself being part of it. It is the achievement of this workshop to have successfully and impressively symbolized two crucial theological concepts of the early Middle Ages: the unity of the Old and New Testaments, and the unity of the four Gospels as a fourfold manifestation of the Logos, or Christ as Creator.

114 THE WOMAN CLOTHED WITH THE SUN AND THE DRAGON. Bamberg Apocalypse. Trier (?). c. 1020. Staatsbibliothek, Bamberg. Cod. bibl. 140, fol. 29, verso. The Bamberg Apocalypse, a late work in the Liuthar group, shows a growing rigidity of style in the hardness and flatness of the composition. The motifs in this first great north European Apocalypse cycle (based on Carolingian models) are related to the Spanish Beatus Apocalypses (see *145*).

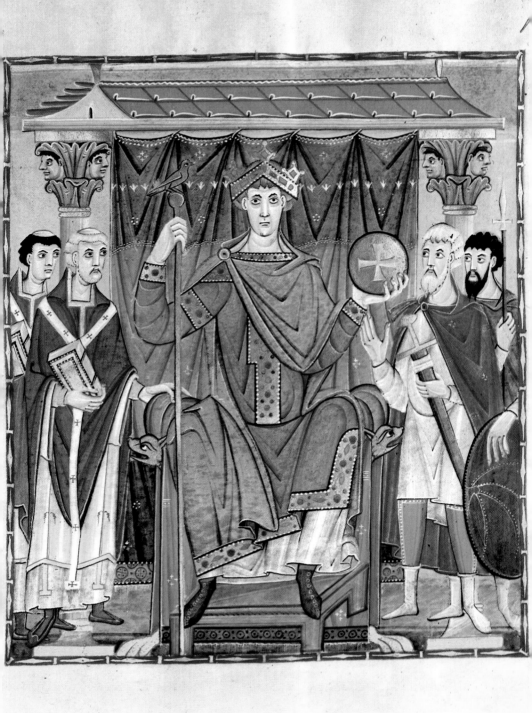

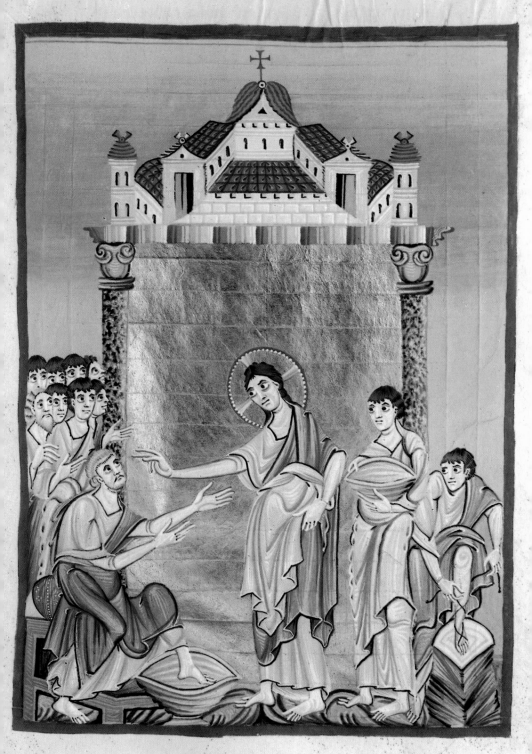

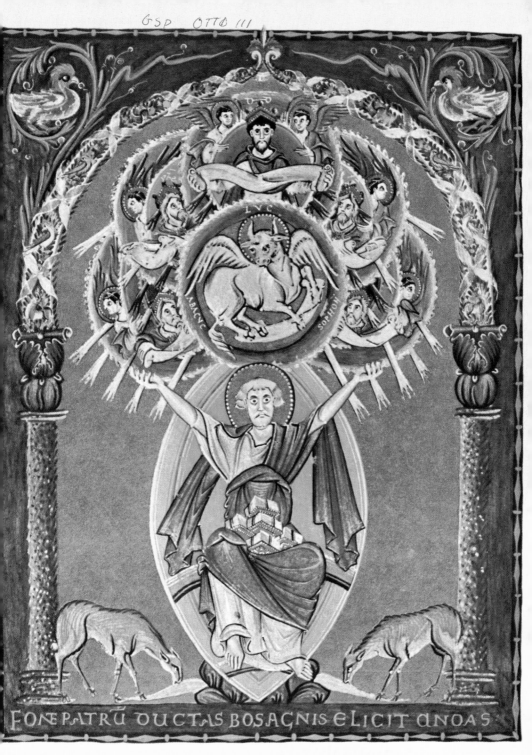

FONSPATRU DUCTAS BOSAGNIS ELICIT ANOAS

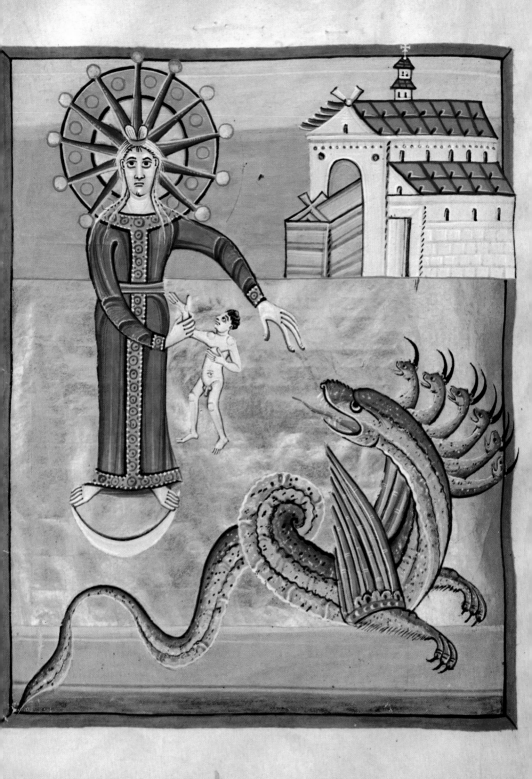

OTTONIAN SCULPTURE AND METALWORK

In the Ottonian era ivory carving became less important, possibly because more exciting possibilities existed in other fields of plastic art, and possibly because ivory carving could no longer closely imitate illuminations or re-create the painterly and linear techniques of the age, as had been the case in the Carolingian era. Ottonian relief work was very much flatter and more draftsmanlike than the Carolingian. However, outstanding pieces were made, and these show that there were different tendencies in effect. A carving showing Pope Gregory the Great (*123*), which originated in Trier and is now in Vienna, is attributed to the Master of the Registrum Gregorii. It has clear outlines with no unnecessary detail; the writer is seen at work and receiving inspiration, with three other scribes below. The architecture and curtains are in the Trier-Echternach style, although the details are less delicately executed than in the miniatures.

An Echternach piece in a different style shows—in the long, narrow field formed by an arched niche and columns—the figures of Christ and Doubting Thomas (*125*). Christ stands on a raised plinth, and there is no space at the sides. The figures have a vertical emphasis; and the action takes place in the upper third of the composition. Yet the figures are not unduly elongated or very abstract. The narrow framework has been used to stress the sculptural intensity of Christ and St. Thomas, and the realism of the details—the clutching hands and posture of the saint. Because a small and narrow space is completely filled by the figures, they make a greater dramatic impact. This practice was developed further in other ivory carvings, and it led to the Romanesque style. The individual style of the Trier Master is also unmistakable in other works, such as a book cover now in Berlin (*124*) and in the cover relief of the Echternach Gospels (Codex Aureus Epternacensis; *126*).

The art of the Ottonian goldsmiths must be considered separately. The material forms a special category, and perhaps here more than anywhere else the materials influenced the style. Works in gold were very important in the Ottonian era; they became far more numerous, and most of the important artifacts were gilded. But although gold, gilded, gold-covered, and gold-framed articles were frequently produced, and although gold had an extensive range of meanings, the importance given to the material seems to stand in inverse relation to the artistic ability and profundity of thought expended in working it. There is nothing to compare here with the symbolic richness of the evangelist miniatures of the Gospels of Otto III or the powerful expressiveness of the Ringelheim Crucifix. The real creative achievements were being made in other fields.

The tendency of the Carolingian goldsmiths of Charles the Bald's time to work in high relief, which casts deep shadows and creates a sculpted or architectural and

spatial effect, was marked. The same trend can be seen in the Tours miniatures and Rheims ivory carvings. In the Ottonian era, chased relief was flat, and more akin to drawing. More works were produced, but there was a slackening off of sculptural development, and the artists still derived a great deal of their inspiration from illuminations and ivory drawings. The flat Ottonian works in gold were generally decorated with enamel rather than with massive precious stones. The ornamentation had the same significance, however: The colors correspond to those of precious stones. The cover of the Echternach Gospels (*126*) is typical of this kind of delicate low relief, with its gold and cloisonné enamelwork surrounding the ivory group in the center. The contrast between the flat gold surround and the powerful characterization of the carved figures is striking. There is, on the one hand, refinement of form, with figures melting into the reflective ground and, on the other hand, the portrayal of realistic muscular figures in a style that is not concerned with beautifying or spiritualizing the subject matter.

Works in chased and embossed gold are the only ones we know for certain to have been made in Trier by artists working while Egbert was archbishop. One of the finest of these is the Reliquary of the Sandal of St. Andrew (*128*) now in the Cathedral Treasury of Trier—a reliquary that contains the relic of the Apostle Andrew's sandal. A golden foot with a sandal encrusted with jewels is shown on the coffer. This was the usual way of indicating what the invisible, miraculous contents of a reliquary were, and it represents, as H. Keller has pointed out, a guiding concept of medieval plastic art, since a relic of the sandal of St. Andrew, for instance, indicates not only his sandal but also represents his whole person, so that the remains of his footgear is

115 ST. LUKE. Gospels from St. Gereon, Cologne. End of 10th century. Stadtarchiv, Cologne. MS 312, fol. 110, recto. The painterly style of this workshop had Carolingian antecedents (Rheims, Corbie). In proportions and composition, the figures are also fairly similar to illuminations from Trier (Codex Egberti), whose influence can be presumed here. The division of the landscape and sky into variegated stripes is usual, but the manner of painting is quite different from that of the Master of the Registrum Gregorii, for instance: It is looser, more sketchlike, and the graded colors are laid on in such a way that each brushstroke and fleck of paint remains distinct.

116 THE ANNUNCIATION. Hitda Codex (gospel book of the Abbess Hitda of Meschede). Cologne, first quarter of 11th century. Hessische Landes- und Hochschulbibliothek, Darmstadt. Cod. 1640, fol. 20, recto. The Hitda Codex is the most distinctive work in the painterly style of Cologne. The contrasting red, blue, and brown tones and almost impasto white highlighting are characteristic of this school, as is the heightening of the contrasts by means of the free composition. Colored and white outlines divide up the area and link the figures and objects. In this painting the white, cloudlike streak indicates that the angel is entering Mary's world from his own heavenly realm. For this reason he also steps into the painting from outside, across the frame.

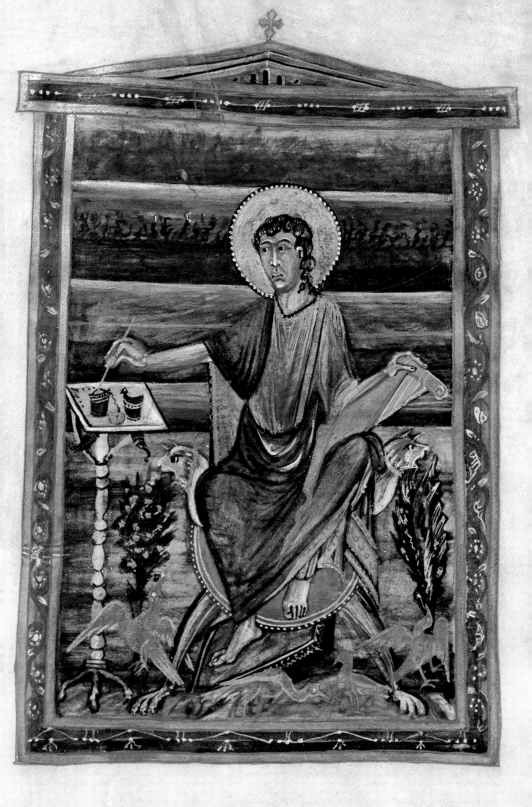

a *pars pro toto,* a part representing the whole. Thus, the reliquary, as H. Schrade says, usually shows a detail rather than the whole figure. There are other Ottonian reliquaries belonging to the same Trier group: the Reliquary of the Holy Nail in Trier and the Cover of the Staff of St. Peter in Limburg Cathedral.

Besides reliquaries and book covers made for a special purpose that often affected the design, there were other special commissions, which more nearly approached monumental sculpture. The most important of these works is the Basel Antependium (*129*), an altar frontal now in the Musée de Cluny in Paris. Emperor Henry II presented the work to the Cathedral of Basel (consecrated in 1019). It consists of a panel with five arches; the central one, in which Christ stands bearing the globe, is higher than the others. Prostrate at his feet are the tiny effigies of Henry II and Empress Kunigunde; in the side arches are the archangels Gabriel, Raphael, and Michael, with St. Benedict on the left. The clear outlines and metallic sharpness of the figures suit the material and the technique but are also indicative of a particular style that does not derive solely in response to the material: The same clarity of outline can be seen in the Liuthar group of illuminations, and an angel from the Bamberg Apocalypse in beaten gold would look very much the same. The Basel Antependium was probably made at Fulda.

A whole series of works in gold has been preserved. They reflect the styles current in illuminations and ivory carvings. Besides Trier, such other workshops as the one at Fulda must be mentioned, and it is interesting that Bishop Bernward of Hildesheim was a skilled goldsmith.

The art of the goldsmith was important because it translated the basic trends of miniature painting into a plastic form; following the general stylistic trend, Ottonian relief work became flatter. Because of its subject matter, it played a part in the development of monumental sculpture, which increased about the year 1000. Cult images became important, and they had to show the whole figure instead of a part. The first of these new cult images were also reliquaries.

The development of monumental sculpture had been a slow process. Artists were quite capable of producing large-scale works, and at no time during the period under discussion had there been valid practical reasons why they should not do so. Technically difficult work such as bronze casting was practiced when necessary. But the sanctioning of monumental figure sculpture was a current theological problem. The possibilities and limitations of art, and its aims, had to be taken into consideration, and also the role of the cult images themselves. Sculpture—and life-size statues particularly—was more controversial in this respect than the other arts. The danger of idolatry was inherent in it, since one might regard an image as identical with the subject it portrayed and worship it as the bearer of miraculous powers. The discussion had been carried on from various points of view ever since the Byzantine Iconoclastic

117 ST. MATTHEW. Fragment of a gospel book from Lorsch (Lorsch Gospels). Court school of Charlemagne. c. 810. National Library, Bucharest, pag. 26. Compare *118*.

118 ST. MATTHEW. Gero Codex. Lorsch (?). c. 975. Hessische Landesbibliothek, Darmstadt. MS 1948, fol. 1, verso. The model for the Gero Codex was the Carolingian Lorsch Gospels. A comparison of the two Matthew miniatures (*117*) quickly shows that Carolingian elements have been misunderstood. The architecture has been disrupted so that the balance is lost and the figure of St. Matthew dominates the painting; his angel has been pushed up to the top of the arch zone. (Compare also the St. John of the Codex Egberti, *107*.)

119 ST. JOHN. Gospels of Sainte-Chapelle. Trier. c. 980. Bibliothèque Nationale, Paris. Lat. 8851. The Master of the Registrum Gregorii had a hand in this work, and this miniature of St. John is possibly by him. The Sainte-Chapelle Gospels was the prototype for the evangelist miniatures of the Echternach scriptorium (*120*).

120 ST. JOHN. Echternach Gospels (Codex Aureus Epternacensis). Echternach. Between 1053 and 1056. Germanisches Museum, Nuremberg. K.G. 1138, fol. 122, verso. The Echternach Gospels is the most lavish work of the period, but it is less rich in innovation than manuscripts from other workshops. The Trier repertoire of motifs was heavily relied upon. The evangelist miniatures are variations on the Sainte-Chapelle cycle, but several motifs are used at one time. This St. John is similar to the one in *119* in attitude, for instance, but his head is based on the St. Luke prototype (*113*), and the triple-arcaded arch derives from the Trier St. Matthew image of the Sainte-Chapelle type.

121 ST. JOHN. Uta Codex. Regensburg. 11th century. Bayerische Staatsbibliothek, Munich. Clm. 13601, fol. 89, verso. Typical of this workshop is the latticelike geometrical design, with its frames around the figures, and scenes and ornamentation intricately worked to make a rich, carpetlike tapestry of symbols.

122 ST. LUKE. Gospels. Cologne. c. 1030. Priesterseminar, Cologne. Cod. 1a, fol. 122, recto. In the second phase of the Cologne output the painterly landscape disappeared and was replaced by symbolic interiors and architecture. The building here represents a church, as in the Registrum Gregorii Gregory miniature (*108*), whose late influence can be felt. A frame has been made for this figure, too, out of the architecture, so that there is a picture within the picture. The inspirational ox enters the inner frame from without (see *107*), coming from the church, which is also surrounded by a frame. These superimpositions are executed in an interesting manner.

123 INSPIRATION OF POPE GREGORY THE GREAT. Book cover. Ascribed to the Master of the Registrum Gregorii. Trier (?). End of 10th century. Kunsthistorisches Museum, Vienna. Ivory. 20.5 x 12.5 cm. The "curious onlooker" is missing here, and Pope Gregory is not dictating but writing himself (compare *108*).

124 MAJESTAS DOMINI. Book cover. Trier. Late 10th century. Staatliche Museen, Berlin. Ivory. 21 x 12.4 cm. The individual and expressive style of this artist (called the Trier Master) is unlike anything in other fields of art at this time or in other ivory carvings. One can find models for the composition, however: For the shape of the mandorla see *59*, and for the contorted and dramatic representation of the inspiration of the evangelists see the Tours prototypes (*61, 63*).

125 CHRIST AND DOUBTING THOMAS. Trier. End of 10th century. Staatliche Museen, Berlin. Ivory. 24 x 10 cm. The panel, with its companion showing Moses receiving the Law, is also held to be by the Trier Master (*124*). The facial types are similar and the limbs are enlarged in the same way. The tall, narrow framework in which the figures are boldly placed heightens the dramatic and plastic intensity of the scene.

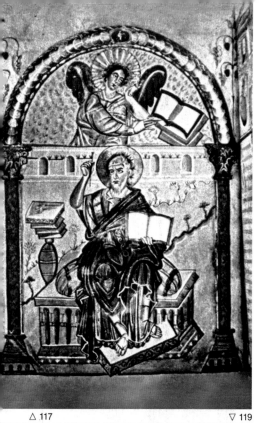
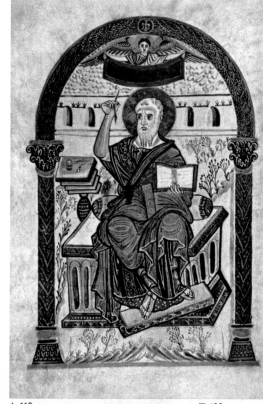

△ 117 ▽ 119 △ 118 ▽ 120

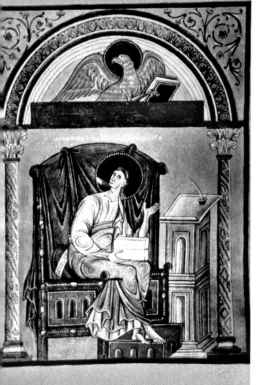
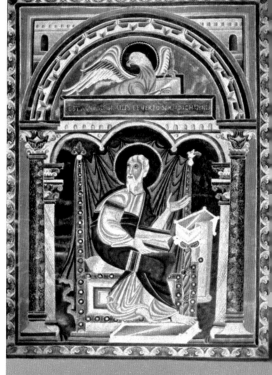

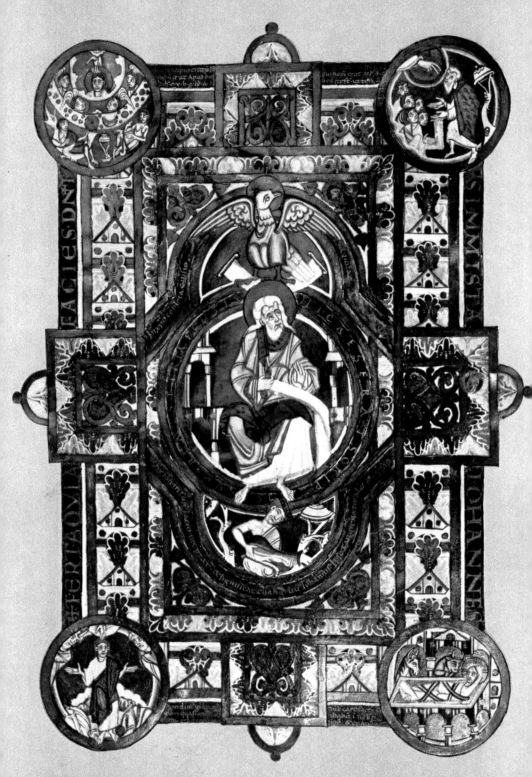

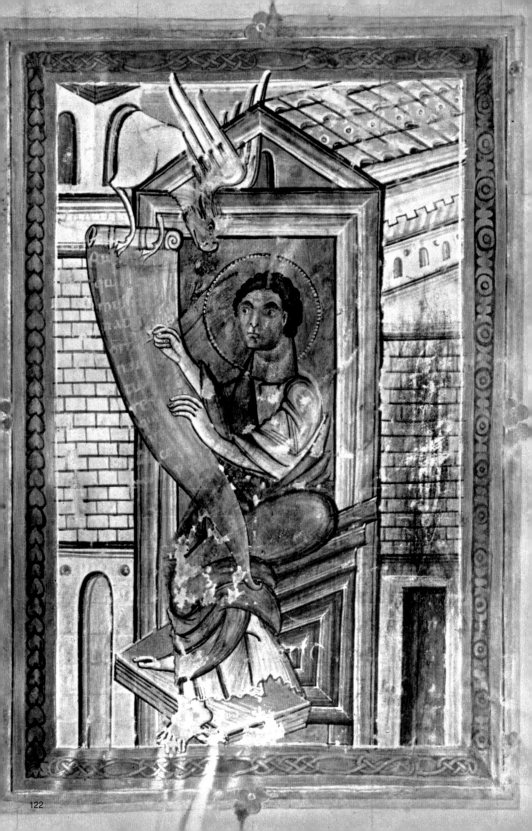

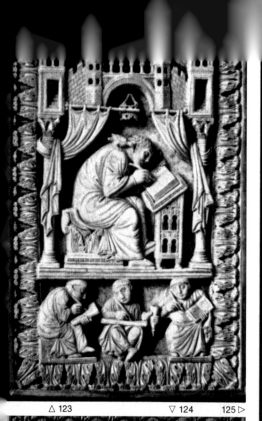

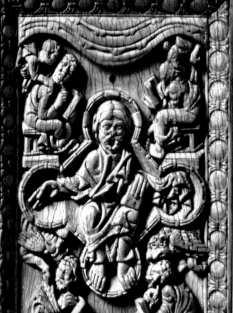

△ 123　　　　▽ 124　　　125 ▷

Controversy and the Carolingian response to it in the *Libri Carolini*. Arguments changed, but theologians and laymen alike remained united in an abhorrence of idolatry.

Around the year 1000 the artistic conditions changed. The repertory of themes became more varied, and the increase in the number of workshops seems to have led to more commissions. Whatever the reason, it appears that the general desire for more monumental representations of holy figures was stronger than earlier scruples against them. Determining factors were the belief in miracles and magic and the cult of relics. The cult of relics was widespread and led to a flourishing trade; since, naturally, there were not enough to go around, forgeries abounded. The belief in the miraculous enlarged the range of subject matter in the arts, and so in the great New Testament narrative cycles, scenes from the Gospels showing Christ performing miracles dominate. These two aspects of the miraculous go together. Relics were holy objects, with magical, wonder-working powers, and were therefore worthy of veneration. The early sculpted images contained the relics of the person portrayed and thus were reliquaries, and the image was held to possess the powers of the relic that it enclosed. We only have accounts from literary sources and an 11th-century drawing of what was possibly the earliest piece of monumental sculpture of this kind, a statue of the Virgin which was set up in the third quarter of the 10th century at Clermont-Ferrand, in Auvergne. The earliest work that has been preserved is the statue of Ste. Foy at Conques (*130*); it was followed, a little later, by the Essen Madonna (*131*). Neither work is outstanding artistically, and both fail to show in the least the achievements made in illuminations and ivory carving. They are gilded, bejeweled, stiffly staring images, or idols, that spring from exactly those states of mind that wise theologians had condemned. Yet both saint and Madonna, although they appear as fetishes, show unmistakable signs of the artist's desire to achieve something more subtle. The precious materials are the dominant element, but Ste. Foy has a classical countenance—a late antique gold mask has been fitted onto the statue—and great trouble has been taken with the drapery folds of the Essen Madonna. However, neither piece is nearly so refined as works in the other fields of art.

The whole figure could now be represented in sculpture, but at first only as a figure-shaped container. Even so this field soon provided an outlet for all the tendencies that had found no means of expression in the Carolingian era. Now at last the figures of Christ, the Virgin Mary, and the saints could be shown. Artists were eager to portray them, but their creative impulse centered not so much on figures of saints or statues of the Madonna, although both these themes became popular, as on the figure of Christ, and above all Christ on the Cross.

The earliest extant crucifix is the Gero Crucifix, although we know of earlier crosses from literary sources (*134, 138*). Here all the artistic skill developed in other fields

is displayed. The Gero Crucifix is only one of many, but it surpasses most other works of this time in intensity of expression and precision of form. It shows the dead Christ held by the nails, His body hanging to one side with its weight supported by His tautly stretched arms. The head has fallen slightly forward, and the eyes are closed. The modeling follows the anti-naturalistic style of the period. The realistic portrayal of anatomy was not important but stance and gesture were. Yet the representation is obviously based on very careful observation. The face is the focal point (*138*). It is earnest, lonely, withdrawn, and somber; and one can see resignation in the bleak expression, and even scorn. This work, by a master in full command of his artistic means, marks the real beginning of medieval monumental sculpture.

Some decades later, while Bernward was bishop of Hildesheim, the Ringelheim Crucifix was made. It is one of the finest Ottonian works of art (*135, 139*). In its narrative style, it corresponds to the Hildesheim bronze door reliefs, with their vivid use of face and gesture, but there is nothing comparable to this face there. It is not the countenance of a dying man but a face full of resignation, all-seeing, thoughtful, with the corners of the mouth bitterly drawn down.

126 BOOK COVER OF THE CHRIST CRUCIFIED. Echternach Gospels. Trier. 983–991. Germanisches Museum, Nuremberg, K.G. 1138. Ivory, sheet gold, enamel, pearls and precious stones. The cover originally belonged to the Sainte-Chapelle Gospels (*119*); then, in the 11th century, it was transferred to the Echternach Gospels (*120*). (Compare this Christ with the Ottonian crucifixes, *134–39*.) Longinus and Stephaton stand at the foot of the cross. Beneath, like Atlas, is Terra, the personification of the Earth. (Compare the Atlas motifs in *51* and *105*.) Above are Sol and Luna, weeping at Christ's death. Contained within the cosmological symbolism is the cross rising up to the heavens from the earth. The powerfully modeled relief of this artist (to whom the carvings *124* and *125* are also attributed), perhaps the most important Ottonian ivory carver, contrasts strongly with the flat golden surround (damaged) and the colorful cloisonné border decoration. Shown on the gold relief are the four rivers of Paradise and the symbols of the evangelists (which indicate the contents of the book). The motifs also extend the cosmological context as the heavenly zone beyond the spheres. (See *86*, which has the same border symbols in a different form.) Also shown are Mary, St. Willibrord, St. Peter, St. Boniface, St. Benedict, St. Liudger. Below are the Empress Theophano and the Emperor Otto III (which gives us the date of the piece).

127 THE HEALING OF JAIRUS'S DAUGHTER. Nave of the church of St. George, Reichenau-Oberzell, Germany. Detail of a fresco. Last quarter of 10th century. This early medieval fresco is as accomplished as the miniatures. Similar in composition to the Codex Egberti, Ottonian in style as to the importance of gesture and glance. However, the fact that there are important frescoes at Reichenau does not prove that there was a school of illuminators there. The two art forms are quite separate and the Reichenau frescoes continue a long tradition of Alpine fresco painting, as the frescoes at Müstair of the previous century show (*76*).

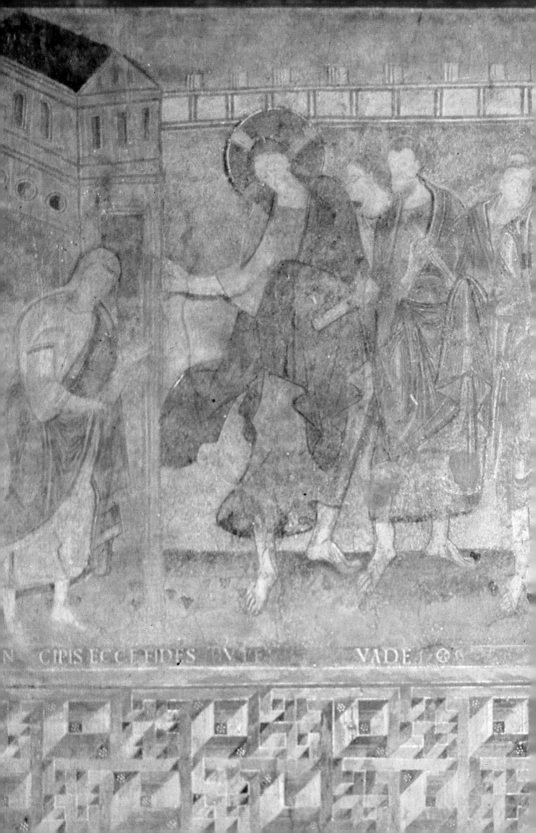

N CIPIS ECCE FIDES TVL VADE OS

The two other crucifixes executed under Bernward's administration are small-scale works (*136, 137*). Markedly different, they show the range of expression achieved by this workshop. The bodies of these two metal figurines are similar: softly modeled contours with sinews and folds sharply marked; bone structure indicated in an abstract and stylized way, geometrical rather than organic. The composition of the figures is different, however, and shows the range of what could be done: The copper Ringelheim Christ is standing upright, with arms outstretched rather than hanging; the silver Hildesheim Christ is shown falling forward, hanging on his arms and stretched to one side. He is bearded, thickset, a little peasantlike in appearance, staring before him with wide-open eyes, whereas the youthful Ringelheim Christ has an almost elegant face, with closed eyes and an appearance of rapt withdrawal. Christ was portrayed both realistically and in an idealized way, and statues of Him were not limited to a single type. These two works are far removed from the Liuthar illuminations, with their reduction of expression to a few suggestive lines and their desire not to portray observed reality but to invoke a mystery, whether it be theological abstraction or religious concepts that transcended all earthly experience. There, facial characterization was not an object; here it was achieved with amazing effectiveness.

Nothing is created out of a vacuum, and there must have been works that went before these four crosses and the few others about which we know. The artists must have learned their trade, although the creative impact which they achieved in these pieces was probably their own contribution. Comparable works must have also been made in the period between the Gero Crucifix and the wooden Ringelheim Crucifix; there must have been a tradition of carving in wood and intense artistic activity. But nothing has been preserved. What we can learn about representations of the crucifixion from miniatures and frescoes cannot tell us what we want to know, because the painters were working along different lines; nor was there an antique or Byzantine tradition for representing the subject. Ivory carving, it is true, carried on the sculptural tradition and served as a bridge, but here, too, there was nothing comparable in Ottonian times, and the Carolingian ivories were not prototypes for the new sculptural styles.

Crucifixes like the small copper crucifix at Ringelheim and the silver one at Hildesheim had been made for a long time, in beaten metal or cast bronze, gold, and copper. But the two wooden crosses under discussion bear little relation to them. The general body structure—the geometricized anatomy with the shield-like shoulder and breast area, which serves as a bridge to the arms as well as providing a socket for neck and head, is an abstraction of the Carolingian type of rendering.

Bernward of Hildesheim, in whose workshop these small crucifixes and the large Ringelheim Crucifix were made, was very influential as a politician, tutor of the young Emperor Otto III, and adviser to the Empress-Regent Theophano and ally

against her opponents. He was one of the most active and clever men of the era. He was also, as his biographer Thangmar relates, talented in all fields of knowledge and in the visual arts. He probably did not paint miniatures, but certainly was experienced in sculpture and cast-bronze work, and was also renowned as an architect. This tirelessly creative man was also able, thanks to his influential position, to realize his plans. His workshop became a leading center of the arts. A series of works made there have been preserved, and in 1015 the great bronze doors (*140, 141*) were completed and set in the portal of the church of St. Michael in Hildesheim.

There are eight rectangular scenes horizontally placed on each side of the double door; the left side shows scenes from Genesis up to the killing of Abel by Cain, and the right side, beginning from the bottom, shows scenes from the life of Christ, from the Annunciation to the *Noli me tangere*. The theme of the doors is thus Sin and Redemption, represented as two corresponding narrative cycles.

The desire to present a story, and the linking of the scenes, shape the composition. One can see similar things in illuminations. But these reliefs are less like Ottonian manuscript illuminations than Carolingian manuscript illuminations of the Tours school (for example, the Genesis scenes of the Moutier-Grandval Bible, *62*). The scenes here are wholly narrative, and the artist has concentrated on presenting the situations and dramatic actions as clearly as possible. The composition and arrangement, the actions and suffering of the characters, their gestures and their spacing, all follow a careful plan. The figures, and there are never more than three in the Genesis scenes, are rounded and stand out from the plants and architecture, which in turn stand out in low relief from the flat background. The relief is therefore on several planes; the background indicates an open space, and the relief is open in front. The heads protrude almost like sculpture-in-the-round.

The Hildesheim doors stand at the beginning of a long series of bronze doors, culminating at the beginning of the Renaissance with Lorenzo Ghiberti's Gates of Paradise for the Baptistery in Florence. The Augsburg Cathedral door (*143*), of about 1020, is made from separate sheets of bronze. It shows scenes from the Old and New Testaments and church allegories. Later restorations have altered the composition. The figures are in low relief against a flat ground, with clear outlines, and they show a classical influence in the treatment of the transparent drapery.

Like the Hildesheim doors Bernward's Column (*142*) renews an old tradition, but unlike the doors it does not begin a new one. Its precursors were Roman imperial columns with continuous narrative scenes of imperial victories spiraling upward. Similar pillars had been erected in Byzantium. Bernward's Column shows scenes of the life and sufferings of Christ in narrative form. Also cast in one piece, it originally ended in a capital with a large cross. The style of the relief is different from that of the doors: It is sharper, more angular, without the soft modulations, and considerably

flatter; the scenes are also more cramped, as well as more conventional in gesture and movement.

Other works issued from Hildesheim during Bernward's administration; for example, an impressive bronze candlestick and ivory carvings. Bernward's workshop was active in several fields at the peak of its productivity. The main activity was bronze casting, however. One cannot help but admire the skill of the artists who created these large-scale works.

128 RELIQUARY OF THE SANDAL OF ST. ANDREW. Trier. 977–93. Cathedral Treasury, Trier. Gold, cloisonné enamel, and precious stones. 31 x 45 x 22 cm. The resplendent coffer contains relics of St. Andrew's sandal, and therefore his foot with a sandal is shown on the outside.

129 ANTEPENDIUM. Detail. From Basel Cathedral. Fulda or Mainz. c. 1019. Musée de Cluny, Paris. Beaten gold plate. Height of the figures 63.5 cm. The middle panel shows Christ with the Emperor Henry II and the Empress Kunigunde prostrate at his feet. At the sides are the archangels Michael, Gabriel, and Raphael and St. Benedict. The treatment of the panel represents a great advance for its time and makes the utmost use of the material. The figures aim at monumental sculpture.

130 STE. FOY. Last quarter of 10th century. Monastery Treasury, Conques. Gold plate over wooden core, with precious stones and an antique mask. Height 85 cm. The earliest medieval piece of monumental figural sculpture that has been preserved.

131 MADONNA. Cologne. c. 1000. Cathedral Treasury, Essen. Gold plate over wood, with enamels and jewels. Height 74 cm. A very early and provincial example of medieval monumental sculpture.

132 MADONNA. Detail of bronze door. 11th century. S. Zeno, Verona. (Compare with 130, 131.)

133 MARY. Detail of bronze doors. Hildesheim. Before 1015. Hildesheim Cathedral. (See also 140, 141.)

134 CRUCIFIX OF ARCHBISHOP GERO. c. 970. Cologne Cathedral. Oak. Height 1.87 m. The earliest known piece of Ottonian monumental sculpture. There is nothing in contemporary work comparable to the intensity of expression on the face of Christ, and for this reason the piece was formerly given a later date (the end of the 11th century). Recent research confirms an old tradition that this was indeed the crucifix that Gero, Archbishop of Cologne from 969–71, commissioned.

135 RINGELHEIM CRUCIFIX. c. 1000. Parish church, Ringelheim. Linden wood. Height 1.62 m. The date of this important piece of Ottonian monumental sculpture has been confirmed by a document found in a reliquary, which proves its connection with Bernward of Hildesheim. Christ is not portrayed as a dead man, but looks down at the beholder with an expression of grief and resignation.

136 COPPER CRUCIFIX. Parish church, Ringelheim. The cross is missing. These small-scale crucifixes are in the tradition of the numerous crucifixion scenes in contemporary illuminations and ivory carving. Prototypes can be found there.

137 SILVER CRUCIFIX. c. 1007–8. Cathedral Treasury, Hildesheim. Cast silver. Height of the body 12.8 cm. The figure is very different from the Ringelheim copper crucifix in attitude and expression (136). Instead of standing in a graceful upright position, the figure has slumped over and hangs down heavily.

138 HEAD OF CHRIST. Detail of the Gero Crucifix (134).

139 HEAD OF CHRIST. Detail of the Ringelheim Crucifix (135).

140 CAIN AND ABEL. Detail of bronze doors. Hildesheim Cathedral. The finest work of Bishop Bernward of Hildesheim's workshop. The left wing of the doors shows scenes from Genesis and the right wing scenes from the life of Christ. The narrative style stems from Carolingian illuminations but the dramatic impact is stronger here: For example, the highly dramatic blow and falling figure in the scene of the murder of Abel, and the way in which Cain's guilty conscience is portrayed.

141 CHRIST AND MARY MAGDALENE. Detail of bronze doors. Hildesheim Cathedral.

142 BERNWARD'S COLUMN. c. 1020. Hildesheim Cathedral. Bronze. 3.79 m. high. This column, showing scenes from the life of Christ, is based on Roman monumental columns with their ascending spiral of narrative scenes in relief. The relief is harder and more sharply cut than that of the doors.

143 CATHEDRAL DOOR. Detail. c. 1020. Augsburg Cathedral. Bronze. A subtle low relief, almost classicizing in style and quite different from the forceful narrative style of the Hildesheim doors. Here allegorical figures and personified concepts are shown in a symbolic context, but the grouping of the figures has been spoiled by later alterations.

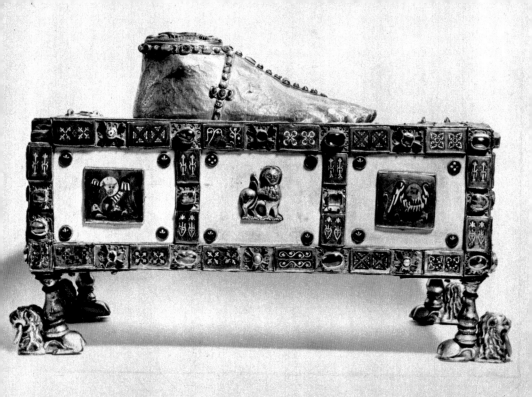

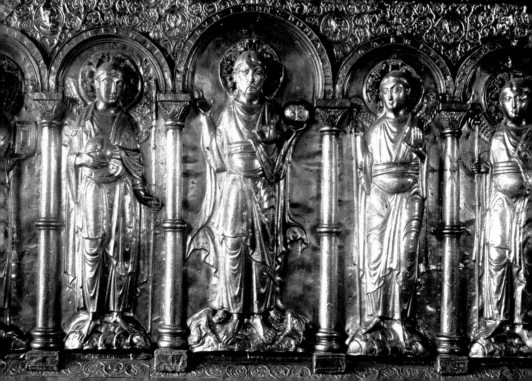

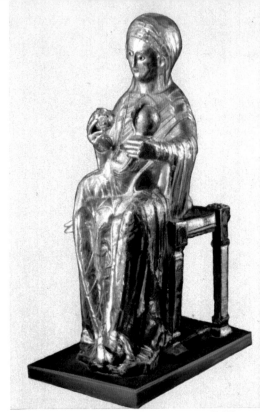

△ 130 ▽ 132 △ 131 ▽ 133

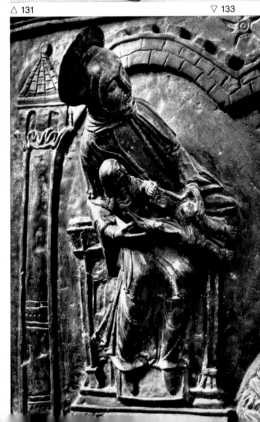

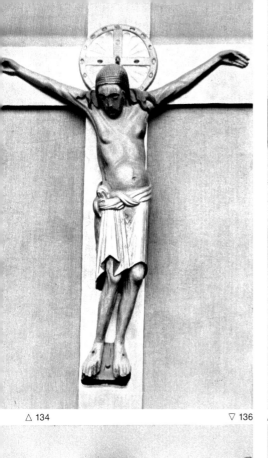

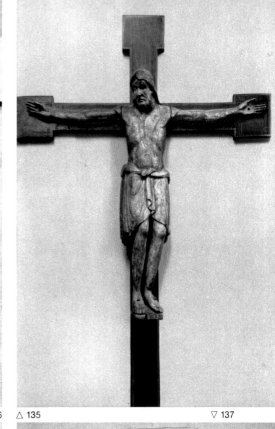

△ 134 ▽ 136 △ 135 ▽ 137

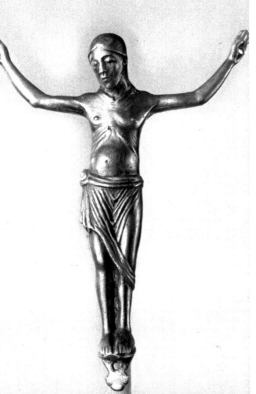

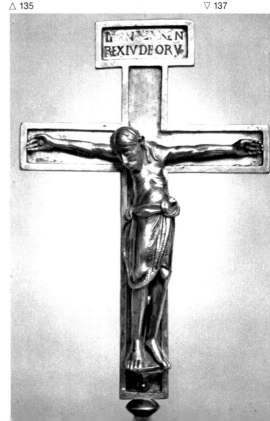

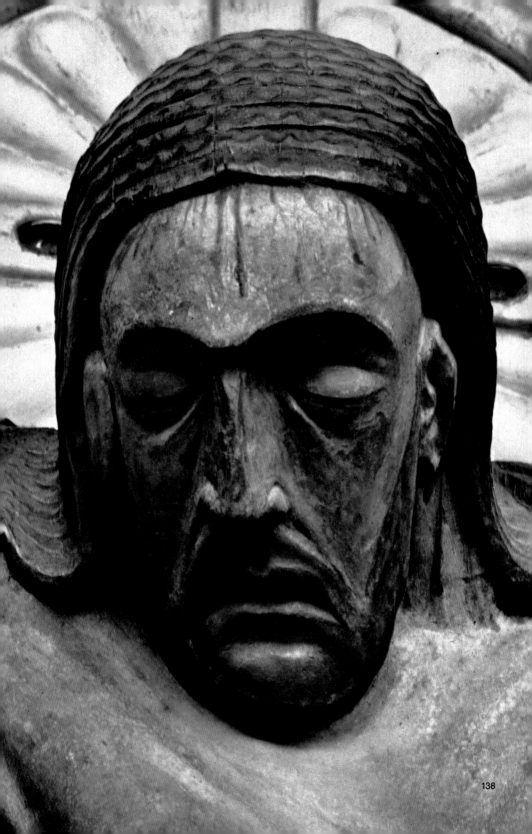

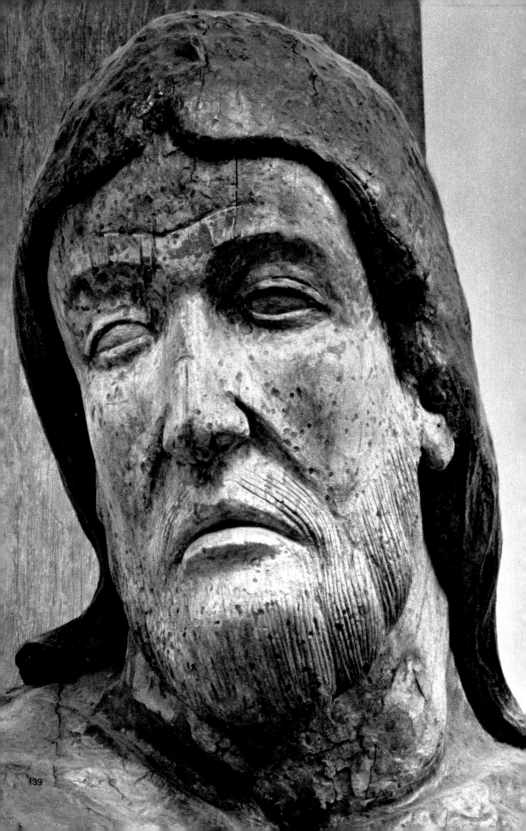

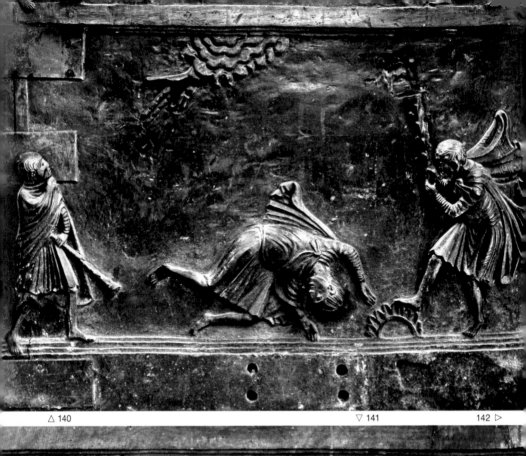

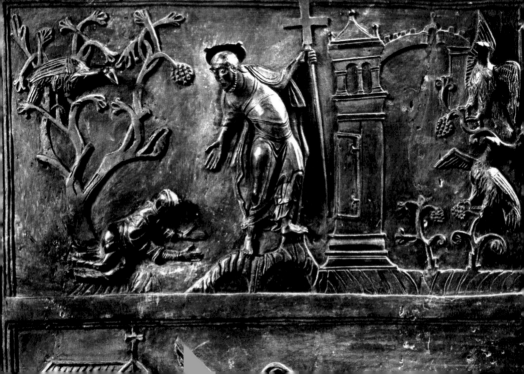

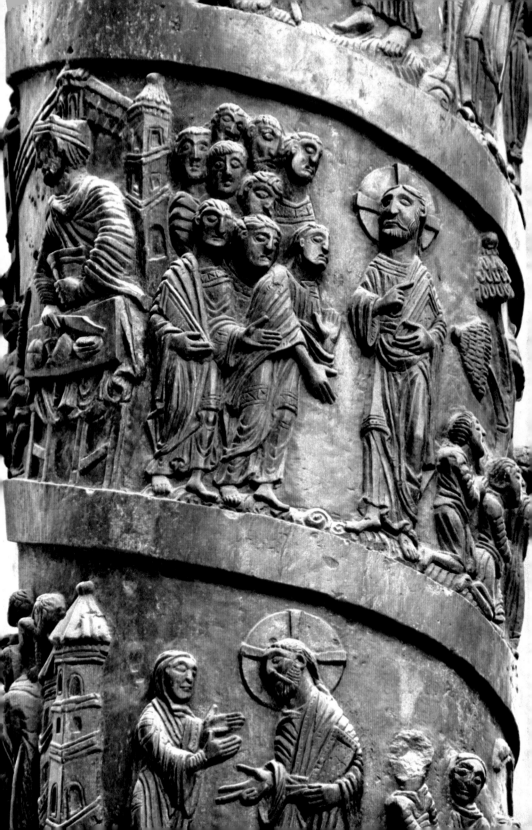

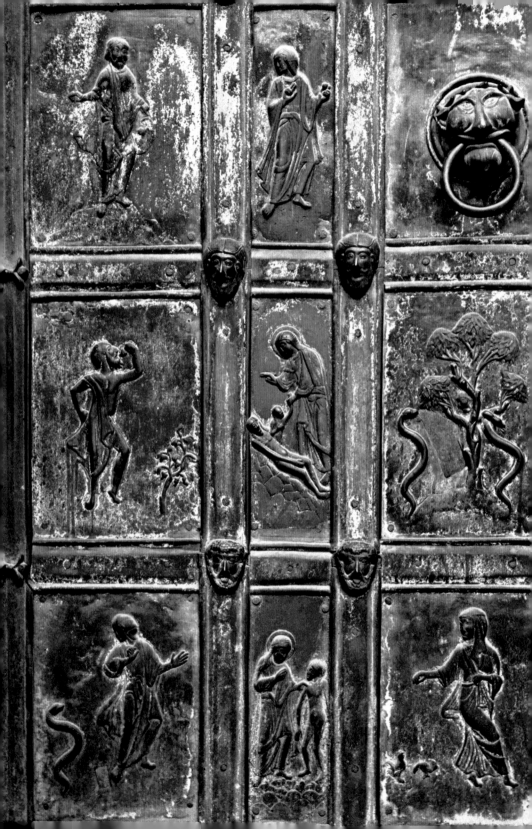

SPANISH APOCALYPSES

The Christians in Spain were not unduly harried under the Arab rulers, who were tolerant and enlightened. Yet neither those under Moslem rule nor the people of Asturias, a northwestern kingdom that had remained unconquered, showed any inclination to come to terms with Arab culture or to assimilate it. At the same time, cut off from the general European development, they were hardly touched by the Carolingian humanist tradition. Unfavorable political circumstances greatly hindered their own cultural development, and on the whole they stuck to the pre-Arab tradition in the arts and sciences and were not influenced by the Moslem scholars. In manuscript illuminations they had long followed the formulas set down in the Ashburnham Pentateuch (*2, 3*). In these circumstances, the artistic flowering that culminated in Spain during the 10th century and at the turn of the 11th century is amazing.

The most important Spanish illuminations were not in Gospels books, as in the north, but in codices of the Apocalypse (*144, 145, 148*). Here the Spanish artists and scholars expressed themselves most clearly. This is remarkable because Apocalypse cycles were not at all common elsewhere during this period, although individual themes from the Apocalypse were often treated in Carolingian art and played a part in the development of the different styles (for example, the symbols of the evangelists, the Fountain of Life, the Adoration of the Lamb, the *Majestas Domini*). In fact, there was an extensive preoccupation with these themes during the 9th and 10th centuries and the old commentaries were refurbished—not because it was felt that the end of the world was approaching, but because the combination of scripture and cosmology in the Apocalypse was the foundation of the early medieval concept of the universe.

Extant Apocalypse cycles from the Carolingian era (four in all, the best known of which are the Trier [Trier, Stadtbibliothek, Cod. 31] and Valenciennes [MS 99] cycles) are not as skillfully executed as the single scenes and are really poor reproductions of older cycles. One can clearly see in them traces of older styles. The iconography became more complex because the symbols were rearranged according to the new commentaries. A century and a half later the Bamberg Apocalypse, which has little in common with the Carolingian precursors, was illuminated. In between came the Spanish Apocalypses. They differ from the other works in richness of variants and the great number of world images in many of the illustrations. They are also richer in themes and allusions, and more scholarly, although, at first glance, the illuminations appear to belong to an exotic folk art tradition, as do most of the other Spanish illuminations of this period, such as the two well-known Léon bibles (Léon Cathedral, Cod. 2 [c. 920] and Cod. 6 [c. 960]).

The Spanish Apocalypses follow the Beatus Commentary. In the second half of the 8th century (about 786), Beatus of Liebana, an Asturian monk, wrote a comprehensive

commentary on the Apocalypse, which included elements from the treatises of the Church Fathers and details from the early medieval theory of the universe and that of Isidore of Seville. A commentary on the Book of Daniel was appended. These commentaries were illustrated. As usual, the illuminations referred to the text and the allegorical meanings and theories of the universe. The original Beatus cycle is lost, but there is an 11th-century copy from St-Sever which is now in Paris (Bibl. Nat. lat. 8878).

The most interesting Spanish Apocalypses were executed in the second half of the 10th century. The center of production was the monastery of San Salvador de Tavara near Zamora; other centers must have existed but cannot be precisely located. Some of the artists are known by name, and about some we have interesting pieces of information (I should like to recommend here the accurate summary given in C. Nordenfalk's *Das frühe Mittelalter*).

The Spanish illuminations are far more colorful than those executed elsewhere, either earlier or at this time. They are as different from the skillful drawing and coloring of the Anglo-Saxon paintings as they are from the subtle contrasts of the Carolingian. Like the Ottonians, the artists were concerned with the stylized representation of the interplay of gestures, but their colors are much brighter—one could

144 THE FOUR HORSEMEN OF THE APOCALYPSE. Apocalypse manuscript. Monastery of Valcavado, near Ovec. c. 970. University Library, Valladolid. Fol. 93. The strong, bright colors (which dominate the earth shades) are typical of these Spanish manuscripts. The striped ground indicates that the horsemen are behind one another. Formalized figures and calligraphic treatment of the clothes. Details (such as the reins, for instance) are handled schematically. They are traditional motifs. There are also realistic details, including the Arabian saddles.

145 THE WOMAN CLOTHED WITH THE SUN AND THE DRAGON. Apocalypse manuscript. Spain. 1086. Burgo de Osma Cathedral. Fol. 117, verso. This late work is little different from the earlier ones, which is indicative of the slow development of Spanish Apocalypse styles. Compare the Ottonian treatment of the same theme in the Bamberg Apocalypse (*114*).

146 ST. JOHN. Manuscript. Rouen or Les Préaux. 11th century. British Museum, London. Add. MS 11850, fol. 138b. A splendid ornamental border with cleverly entwined acanthus

design. The attitude of the evangelist is a variation on motifs that were characteristic of the Tours school (*62*).

147 ST. MARK. Gospels. Northern France (Corbie?). After 1050. Bibliothèque Communale, Amiens. MS 24, fol. 53. An important piece of Anglo-Frankish illumination. The daring yet precise style, distilled from various early medieval trends, furnished the starting point for later developments and was one of the important formal influences on the development of French Romanesque sculpture. There is little in early medieval art to equal the precise draftsmanship of this work. There is also an unusually imaginative use of the traditional motifs. The lion, somersaulting out of the arch to inspire the evangelist, is brilliantly conceived. The spatial effect is heightened by the curtain which is wound around the arch. Yet for all the innovations and virtuosity of style, one can trace elements of Carolingian and Anglo-Saxon trends here. This style is reminiscent of the Ebbo Gospels in particular.

equucon rofeu
eaqui fedeba
fuper eum habe
bat gladium·

equum album eqqui
fedebat fuper eum
habebat arcum·

eqdecumbaque
fuper eum·

equum niger eqqui fe
debat fuper eum habe
bat ftateram·

equum pallidus eq
qui fedebat fuper
eum habebat nomē

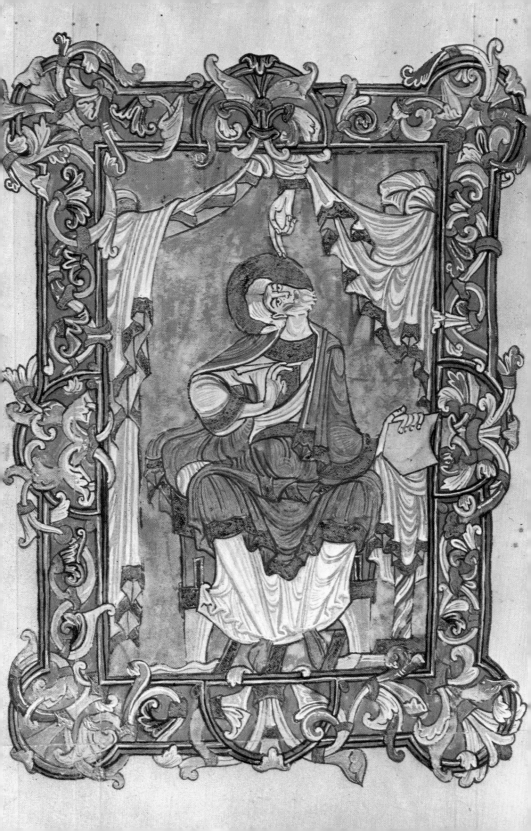

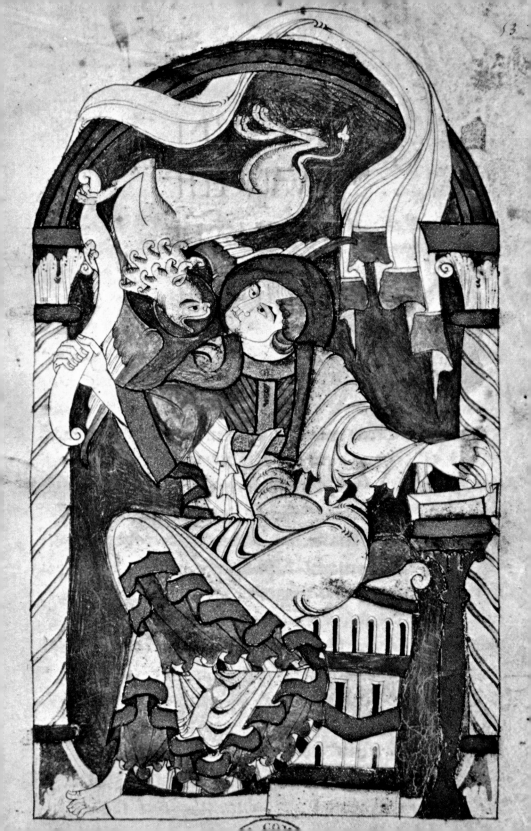

almost call them gay. Stronger, warmer, in fact hotter colors dominate—yellow and red, with contrasting darker shades such as brown, blue, and violet. In the Liuthar illuminations one sees cool, steely tones arranged in an orderly allegorical way, and there is a metallic look about the joints of the figures, as they gesticulate against a background of symbolic gold. In the Spanish illuminations the vibrant contrasts between shrill and earthy colors dominate, producing an exotic effect. Possibly yellow was used instead of gold for the grounds because gold was hard to come by, but if one imagines the yellow grounds as golden and the gold grounds of the Liuthar group as yellow, the difference is less marked; although details are different, the basic principles are the same. There are unusual forms in the Spanish paintings, however, deriving from pre-Carolingian models or Moorish styles—for example, horseshoe arches in the frames and architecture. This was certainly due to the influence of Moorish architecture, compared with which the most advanced Ottonian buildings seem poor affairs. One can find other Moorish details in these southern paintings such as the saddles and weapons of the Horsemen of the Apocalypse.

The chief works that evolved from the Beatus Commentary were the Apocalypse in the Madrid National Archives (Cod. 1240), c. 970; the Apocalypse of Gerona Cathedral (*148*), c. 975; and the Apocalypse in the Pierpont Morgan Library, New York City (MS 644), c. 950. There were also other less noteworthy works (see W. Neuss).

Despite the immediacy of their visual appeal, these cycles of scholarly illuminations are difficult to understand without close reference to the text. The miniatures are full of symbolism, but the details of these symbols are often highly realistic. Apocalypse illustrations of all periods are extremely complicated forms of art. Only artists who could command a complete repertory of symbols could dare to present in a visual form that which cannot actually be seen. In these works we find all the symbols used elsewhere—the circle and the arch, the gestures and figures, the apocalyptic architecture—and here almost more than anywhere else, it is possible to comprehend the full range of early medieval symbolism.

These pictorial cycles, which owe their origin to an isolated development, were not without importance for the future, for paintings of the Apocalypse and commentaries on it were long to maintain a special position among the themes of Christian art. It is also true that these pictorial cycles are not very far removed from Ottonian painting, and certain features are easily recognizable as being shared by both. Besides this isolated artistic tradition, whose influence was lasting, another equally independent school was steadily developing apart from the mainstream, in England.

ANGLO-SAXON ILLUMINATION

Around the year 1000 a network of workshops stretched across all of western Europe, although Ottonian art stands out from the rest because of its variety of form and because it was richer in developed concepts. English painting at this time, though less varied, was as accomplished as the Ottonian works. In architecture, the Anglo-Saxons did not contribute anything markedly new. In monumental figural sculpture the English artists with their stone crosses appear to have been ahead of their contemporaries on the Continent. But the most important English contribution was in the field of manuscript illumination, and in the second half of the 10th century there was a flowering of talent in this field equal to the Ottonian one. The focal point of artistic activity was Winchester.

To all appearances, the English achieved a happy synthesis of Carolingian and pre-Carolingian Hiberno-Saxon styles, as a result of a continuous and constantly enriched transformation of insular tradition—as if the manuscripts executed around 1000 stood at the end of a long line of such works. This was not the case, however. The dislocation had been even more devastating in the British Isles than on the Continent: In Ireland artistic development had been brought to a halt for 200 years, and in England the

148 THE CHURCH OF SARDIS. Apocalypse manuscript. Spain. c. 975. Gerona Cathedral. Fol. 89, verso. St. John speaks to the angel of the church of Sardis. Rhetorical gestures, unambiguous meaning, and bright colors are all typical of Spanish Apocalypse manuscripts. The building contains all the elements the artist felt properly belonged to a church, added without regard for perspective: The upper façade details (gable, gable windows) are combined with allusions to a three-aisled basilica. The horseshoe arches are Moorish details.

149 THE PRESENTATION IN THE TEMPLE. Benedictional of St. Aethelwold. Winchester. 975–80. British Museum, London. Add. MS 49598, fol. 34, verso. In this case, the architectural frame is very important (frame motifs of all kinds were highly developed at Winchester and richly, almost overpoweringly, decorated). Imagining the columns as actual structures and bearing in mind the principles of early medieval representation, we can surmise that the church is a centrally planned,

vaulted building, with a circular tunnel vault around a central pillar, as at St. Michael in Fulda (*31*). Arch and vault represent Heaven, the cosmos, the place of Epiphany. God's hand appears there.

150 PENTECOST. Benedictional of Archbishop Robert. Winchester. c. 980. Rouen, Bibl. Municipale. MS Y7. This manuscript is closely related to the Benedictional of St. Aethelwold. The architecture is continued on the same principle: centrally planned with central pillar, axiality, and rich ornamental detail. The building here has several stories. In the center is the dove of the Holy Spirit, from which the Pentecostal tongues of fire stream forth. Above, in the center of the arch, is God's hand. The axiality is stressed below by the central pillar. Gathered together in a circle are the apostles. Two buildings at the sides in the arch zone (rather like Ottonian buildings in style: see *112*) indicate the Heavenly Jerusalem. The details are late Carolingian in style.

1

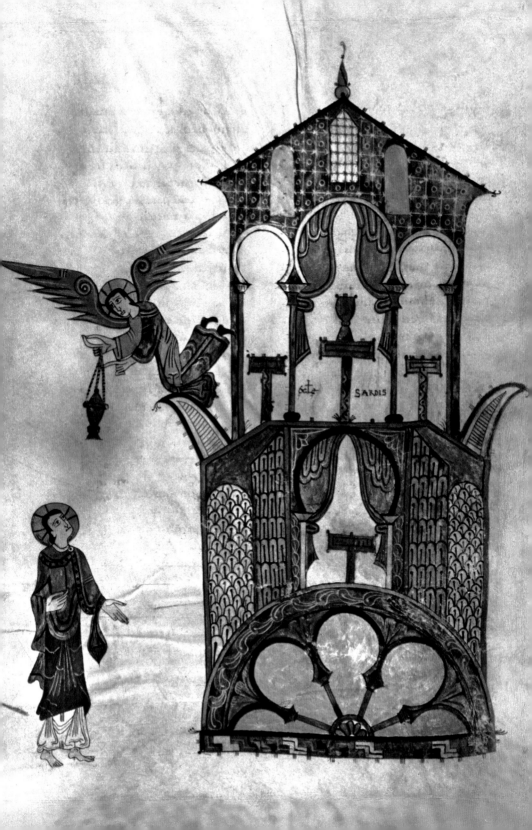

Argentæ albentem sessem · quamsumma rotarum

·i·air t rotarum ·i·fulgensi ·i·circulo
Flexura electri pallentis contingit orbe;

·s·uirautum ·i·tradicionis sponte audentis
TIAM CUNCTA ACIES INDEDITIONIS AMOREM
·a·conuersis· ·i·adliturgriam ·i·uexilli

conprobauit

aldgythæ. æ todoscæ. hydburge. et byrngythæ. eulaliæ ac teclæ
rumore sacras concorditer æclesiam ornantibus: Aldhelmus
segnis xpi cynncola et supplex æclesiæ uernaculus. optabilem per
peme prosperitatis salutem

Viking invasions and Danish conquest had been briefer but no less brutal. The resurgence of art and culture under King Alfred the Great (871–99), who greatly admired the Franks, led to a keen interest in Continental styles—Byzantine and Italian as well as Frankish. The former were systematically collected much earlier than on the Continent. At the same time trends that had lain dormant in England since pre-Carolingian times were renewed. The process was gradual, however. Old elements were slowly replaced by the new. King Alfred, too, had his "Alcuin," as Carl Nordenfalk has pointed out—Grimbald, the monk from St. Bertin in Flanders, who, after Alfred's death, became the first abbot of the New Minster at Winchester.

It was not until the time of King Aethelstan of Wessex (925–39), however, that manuscripts began to reach the Carolingian standard, although in many respects they were based on Byzantine rather than Carolingian models. Changes followed slowly: The Irish script was replaced by Caroline minuscule, decorated initials became less important, and the old interlace and spiral patterns disappeared and were replaced by classicizing ornamentation. Acanthus leaves were a leitmotiv, and the miniature frames, which previously were often only squares formed by four staves, began to luxuriate, split, and sprout medallions and figural scenes.

Under the bishops Dunstan, Oswald, and Aethelwold a reform movement started in the monasteries, instigated at Glastonbury, and it lasted until the time of King Eadred (946–55). Dunstan went to Ghent, Oswald to Fleury, and links with the Continent were strengthened. During the reign of King Edgar (957–75), Aethelwold was Bishop of Winchester, and in the next few decades the most important English works of the 10th century were executed at this scriptorium. Just as with the Trier and Cologne schools, however, a complicated pattern of relationships existed that included the powerful new influences from the Continent.

One of the finest works executed at Winchester was the Benedictional of St. Aethelwold (*149*), which magnificently fulfilled the promise shown by the foundation deed of King Edgar for Winchester (the new Minster Charter). The manuscript has

151 LUXURIA. Prudentius Manuscript. Malmesbury. c. 1040–50. Corpus Christi College, Cambridge. Luxuria (the personification of lust) is shown dancing. The *Psychomachia* (battle of the virtues and vices) of Prudentius was often copied. Here there was probably a Carolingian prototype, but the style of the pen drawing is not like that of the Utrecht Psalter. Rather, it is based on late antique models (which the Utrecht Psalter freely varied). The finely drawn outlines and paint-

erly qualities of the Winchester school are reflected here.

152 BISHOP ALDHELM AND THE NUNS OF BARKING. c. 1040–50. Lambeth Palace, London. Bishop Aldhelm is handing to the nuns of Barking his tract *De Laude Virginitatis* (In Praise of Virginity). The miniature resembles the Luxuria miniature (*151*) in style. The details are almost identical. (Compare the edges of Luxuria's drapery with that of the nun on the far right, for example.)

architectural frames with mighty columns and arches covered with ornamentation, and borders that almost disappear beneath luxuriant acanthus motifs. The figures and backgrounds are also richly ornamental. Drapery is looped in spirals and coils like the acanthus leaves of the borders, and the figures also have a similar convoluted tendency, reminiscent of certain Carolingian styles and of the Lindisfarne Gospels (*19*). The architecture is even more markedly Carolingian, which is not surprising, as the native tradition in this field was less advanced. Later works that continued the same trends include the Benedictional of Archbishop Robert (*150*), the Sacramentary of Robert of Jumièges (Rouen, Bibl. Municipale, MS Y6 [c. 1008]), the early 11th-century Grimbald Gospels (London, Brit. Mus., Add. 34890), and other works from the Anglo-Saxon and Continental scriptoria, which had a powerful influence throughout the century.

The Benedictional of St. Aethelwold and the Benedictional of Archbishop Robert are the best examples of the Winchester style. Given the accomplished, imaginative manner in which they are executed, it is interesting to note that they date from about 980, the same time as the works of the Master of the Registrum Gregorii, whose careful manner contained the seeds of future lifelessness of style. The very different artists achieved equally brilliant results.

It is not easy to trace the Carolingian prototypes for the Winchester style because nearly all the symbolical elements and details from manuscripts ranging from the Ada group to those of Charles the Bald's court school and its followers have been used, but they are combined in a new way and altered (see *150*). However, from the mass of different elements, one clear stylistic pattern stands out, that of the Rheims workshop and its circle: The style is similarly sketchlike and painterly, narrative rather than monumental, and highly decorative. The manner of suggesting clouds and water and the illusion of space show that the Winchester artists and their associates must have studied the works of this Carolingian school closely and based their own style on it to a considerable extent. The Utrecht Psalter was copied several times in England during the 10th and 11th centuries.

About the year 1000 a more draftsmanlike style, which did not owe its beginnings to the Utrecht Psalter but was strongly influenced by it, began to flourish. It is quite different from the more painterly and convoluted styles and elaborate symbolism, but even though it tends to concentrate on a few lines, it bears the same relationship to the more painterly works as the Utrecht Psalter did to the Ebbo Gospels. The most important works in the group were the Caedmon manuscripts (Oxford, MS Junius 11), some Prudentius manuscripts, and various other illuminated works (*151, 152*).

The Winchester workshop and those related to it appear to have developed a uniform style. There were other equally influential scriptoria, such as that at

Canterbury, which was active until well into the 13th century. The English work-shops probably had a more widespread influence than those on the Continent. This assumption is made on the basis of a consideration of later events. The English motifs and styles returned in their new guise to the places from which they had originated, sometimes along the same route. In the early years of the 11th century Anglo-Saxon styles gained acceptance in the monasteries of northern France, in centers such as Fleury and St-Omer. Then they moved on southward and were transformed and transmitted. They influenced Burgundian Romanesque sculpture, were copied in southern France, and provided prototypes for the new tradition of sculpture in the French provinces.

A work typical of these Anglo-Frankish illuminations, which followed on from the Winchester school, is one executed in a scriptorium in northern France (perhaps Corbie; *147*). It is one of the finest works of the 11th century. The complex arrangement of the figures is handled with a precise elegance that is stressed by the treatment of the drapery, which follows the contours of the figures and the direction of the gestures in rhythmic folds, streaming out like banners or circling around the limbs in a manner reminiscent of armor. Because of their deliberately complex style, these figures have sometimes been called mannered, but the illuminations are obviously the work of an artist of the first rank.

Miniatures of this kind are closer to the 12th-century sculpture of Burgundy and Languedoc than to earlier illuminations. Yet one can still see in them, over two centuries later, traces of the Ebbo Gospels and the Utrecht Psalter. They were a meta-morphosis of a Carolingian trend, and it is obvious that each Carolingian workshop influenced future developments in its own particular way. The contrasting styles of the various Carolingian schools can be seen in later works, and the special contri-bution made by the Rheims workshop of the second quarter of the 9th century appears to have been more influential, in an interestingly circuitous way, than that of any other early medieval scriptorium.

GENERAL

Assunto, Rosario. *La critica d'arte nel pensiero medioevale*. Milan: Il Saggiatore, 1961.

Beckwith, John. *Early Medieval Art: Carolingian, Ottonian, Romanesque*. London: Thames and Hudson; New York: Praeger, 1964.

Braunfels, W. *Die Welt der Karolinger und ihre Kunst*. Munich: Callwey, 1968.

— *Karl der Grosse: Lebenswerk und Nachleben*. 5 vols. Düsseldorf: Schwann, 1965–68.

Elbern, V. H., ed. *Das erste Jahrtausend*. 2 vols. Düsseldorf: Schwann, 1962.

Gough, Michael. *The Origins of Christian Art*. London: Thames & Hudson; New York: Praeger, 1974.

Henderson, George. *Early Medieval*. Harmondsworth and Baltimore: Penguin (Pelican), 1972. (Style and Civilization.)

Henry, Françoise. *Irish Art in the Early Christian Period*. Rev. ed. London: Methuen; Ithaca, N. Y.: Cornell University Press, 1965.

Hinks, Roger. *Carolingian Art*. London: Sidgwick and Jackson, 1935. Reprinted 1962 by University of Michigan Press, Ann Arbor.

Jantzen, H. *Ottonische Kunst*. 2d ed. Munich: Münchener Verlag, 1959.

Kitzinger, Ernst. *Early Medieval Art in the British Museum*. 2d ed. London: British Museum, 1960.

Lasko, Peter. *Ars Sacra: 800–1200*. Harmondsworth and Baltimore: Penguin, 1973. (Pelican History of Art.)

Messerer, Wilhelm. *Karolingische Kunst*. Cologne: DuMont Schauberg, 1973.

Morey, C. R. *Medieval Art*. New York: Norton, 1942.

Pickering, F. P. *Literatur und darstellende Kunst im Mittelalter*. Berlin: E. Schmidt, 1966.

Rice, D. Talbot. *English Art, 871–1100*. London: Clarendon Press; Toronto and New York: Oxford University Press, 1952. (Oxford History of English Art.)

Swarzenski, Hanns. *Monuments of Romanesque Art: The Art of Church Treasures in Northwestern Europe*. London: Faber; Chicago: University of Chicago Press, 1954.

ARCHITECTURE

Bandmann, G. *Mittelalterliche Architektur als Bedeutungsträger*. Berlin: Gebr. Mann, 1951.

Conant, K. J. *Carolingian and Romanesque Architecture: 800–1200*. 2d ed. Harmondsworth and Baltimore: Penguin, 1966. (Pelican History of Art.)

Frankl, P. *Die frühmittelalterliche und romanische Baukunst*. Wildpark-Potsdam: Athenaion, 1926.

Lehmann, E. *Der frühe deutsche Kirchenbau*. 2d ed. Berlin: Deutscher Verein für Kunstwissenschaft, 1949.

Saalman, Howard. *Medieval Architecture: European Architecture 600–1200*. New York: George Braziller, 1962.

PAINTING

Anthony, E. W. *Romanesque Frescoes*. Princeton, N.J.: Princeton University Press, 1951.

Bloch, Peter, and Schnitzler, Hermann. *Die ottonische Kölner Buchmalerei*. Vol. I. Düsseldorf: Schwann, 1967.

Boeckler, Albert. "Die Reichenauer Buchmalerei." In Beyerle, Konrad. *Die Kultur der Abtei Reichenau*. Munich: Verlag des München Drucke, 1923.

— *Deutsche Buchmalerei vorgotischer Zeit*. Königstein: Langewiesche, 1953.

Boinet, A. *La Miniature Carolingienne*. Paris: A. Picard, 1913.

Dodwell, C. R., and Turner, D. H. *Reichenau Reconsidered: A Reassessment of Reichenau in Ottonian Art*. London: Warburg Institute, London University, 1965.

Goldschmidt, A. *German Illumination*. London: Pegasus; New York: Harcourt, 1957.

Grabar, André, and Nordenfalk, Carl. *Early Medieval Painting from the 4th to the 11th Centuries*. Geneva and New York: Skira, 1957.

Grodecki, L. *L'architecture ottonienne*. Paris: A. Colin, 1958.

Hoffman, K. *Die Evangelistenbilder des Münchner Otto-Evangeliars* (CLM 4453). Zeitschrift des Deutschen Vereins für Kunstwissenschaft, Vol. XX, No. 1/2, 1966.

Koehler, Wilhelm R. W. *Die karolingischen Miniaturen*, I–III. Berlin: Deutscher Verein

für Kunstwissenschaft, 1930–60.

Merton, Adolf. *Die Buchmalerei in St. Gallen.* 2d ed. Leipzig: Hiersemann, 1923.

Neuss, Wilhelm. *Die Apokalypse des hl. Johannes in der altspanischen und altchristlichen Bibelillustration.* Münster: Aschendorff, 1931.

Nordenfalk, Carl. *Die spätantiken Kanontafeln.* Gothenburg: O. Isacsons, 1938.

—— "Der Meister des Registrum Gregorii." From *Münchner Jahrbuch der bildenden Kunst,* series 3, Vol. I. Munich, 1950.

Schnitzler, H. "Das Kuppelmosaik der Pfalzkapelle." *Aachener Kunstblätter,* No. 29, 1964.

Schrade, Hubert. *Frühromanische Malerei.* Cologne: DuMont Schauberg, 1958.

—— *Romanische Malerei.* Cologne: DuMont Schauberg, 1963.

—— *Zu den Evangelistenbildern des Münchner Otto-Evangeliars.* In *Festschrift Werner Fleischhauer,* 1964.

—— "Zum Kuppelmosaik der Pfalzkapelle und zum Theoderich-Denkmal in Aachen." *Aachener Kunstblätter,* No. 20, 1965.

Steger, Hugo. *David, Rex et Propheta.* Nuremberg: H. Carl, 1961.

Swarzenski, Georg. *Die Regensburger Malerei des 10. und 11. Jh.* Leipzig: Hiersemann, 1901.

Werckmeister, O. K. *Irisch-northumbrische Buchmalerei des 8. Jh. und monastische Spiritualität.* Berlin: De Gruyter, 1967.

Wormald, Francis. *English Drawings of the 10th and 11th Centuries.* London: Faber, 1952.

Zimmermann, E. H. *Vorkarolingische Miniaturen.* Berlin: Deutscher Verein für Kunstwissenschaft, 1916.

SCULPTURE AND DECORATIVE ARTS

Goldschmidt, A. *Die Elfenbeinskulpturen.* 4 vols. Berlin: B. Cassirer, 1914–26.

Grimme, Ernst Gunther. *Goldschmiedekunst im Mittelalter: Form und Bedeutung des Reliquiars von 800 bis 1500.* Cologne: DuMont Schauberg, 1972.

Keller, H. *Zur Entstehung der sakralen Vollskulptur in der ottonischen Zeit.* In *Festschrift für Hans Jantzen,* 1951.

Schrade, H. "Zur Frühgeschichte der mittelalterlichen Monumentalplastic." In *Westfalen,* 35, Nos. 1/2, 1957.

Steingräber, E. *Deutsche Plastik der Frühzeit.* Königstein: Langewiesche, 1961.

Wesenberg, R. *Bernwardinische Plastik.* Berlin: Deutscher Verein für Kunstwissenschaft, 1955.

INDEX

Descriptions of the illustrations are listed in italics